19TH CENTURY FRENCH ART
1848-1905

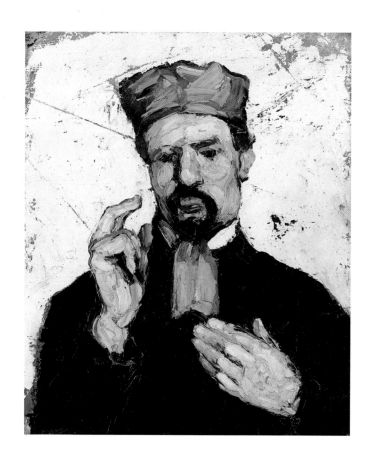

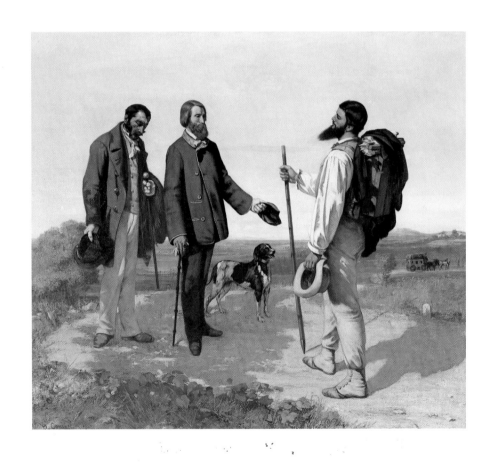

19TH CENTURY FRENCH ART

1848-1905

Nicole TUFFELLI

CHAMBERS

For the English-language edition:

Translator
Gearóid Cronin

Art consultant
Dr Patricia Campbell, University of Edinburgh

Series editor
Patrick White

Proofreaders
Stuart Fortey
Camilla Westergaard

Prepress
Vienna Leigh
Kirsteen Wright

Originally published by Larousse as *L'Art au XIXc Siècle 1848-1905* by Nicole Tuffelli

© Bordas S.A., Paris, 1987
© Larousse-Bordas, P, 1999

English-language edition
© Chambers Harrap Publishers Ltd 2004

ISBN 0550 10119 5

Cover image: Vincent Van Gogh, *Church in Auvers-sur-Oise*, 1890 (Paris, Musée d'Orsay). Photo © Dagli Orti.

Page 1:
Paul Cézanne, *The Lawyer*, or *Uncle Dominique*, 1966 (Paris, Musée d'Orsay). Photo © RMN.

Page 2:
Gustave Courbet, *The Meeting*, or *Bonjour Monsieur Courbet*, 1915 (Montpellier, Musée Fabre) © RMN.

Typeset by Chambers Harrap Publishers Ltd, Edinburgh
Printed in France by MAME

Contents

INTRODUCTION

Between the years 1848 and 1905 and against the backdrop of a rapidly changing Europe, a succession of inter-related artistic movements sprung up that moved to a new tune, the tune of the modern world. Paris had played an influential artistic role since the reign of Louis XIV and continued to shine brightly with its school of painting that would give rise to the most famous movement of modern times, Impressionism. Transformed during the Second Empire (1852-1870), Paris also came to represent the model of a modern capital city.

However, France was far from being the most industrialized country in Europe. At a time when Europe was becoming divided along industrial lines between those countries where the industrial revolution had begun very early, like Britain (the latter half of the 18th century), and those where it had not started at all, like Spain, France found itself somewhere in the middle. This was also a time when the pecking order of countries was no longer decided on the basis of territorial possessions but economically, and France was a prosperous country with a degree of political stability that allowed artistic life to flourish. It did, however, come a long way behind Victorian Britain, which remained the most powerful country in the world until 1890, although Germany came to rival her from 1875.

Throughout Europe, at the same time as being catapulted forwards into the future by the many radical changes caused by the industrial revolution, people began to become fascinated by history. So some artists and architects looked to the past for artistic answers to the problems of the present, in particular the enormous increase in the population, which almost doubled in the space of 50 years. They also had to satisfy the tastes of the bourgeoisie, as well as the newly created middle and lower-middle classes who were the main beneficiaries of the industrial revolution.

The watchword of the time was progress, an idea that was taken up by some of the political ruling class and made into a manifesto. The idea was given a philosophical framework by the Positivists, like French philosopher Auguste Comte, and the scientific and technical advances of the age made it a reality. It resulted in a greater confidence in man's ability to effect changes that everyone could witness around them, such as the introduction and then the growth of the railway. These changes were seen as benefits to which "work" and "learning" gave access.

Individuals therefore had a role to play in our common history, a history that concerned the progress of mankind. This notion of progress is a socialist ideal of a better world for everyone. It began in the middle of the century amongst philosophers like Karl Marx and Proudhon who saw the wretched conditions in the towns and cities for those people who had flocked there to work in the factories. Its influence in the world of art was first seen in Britain, and later France. As well as affecting Realist painters, it also came to form the foundations of Art Nouveau.

Positivist ideals were, however, soon threatened by the many wars in

Europe around 1870. As the end of the century approached, although more and more people were able to enjoy the benefits of an industrialized society, the mechanized world began to seem increasingly troubling. At the same time as faster means of communication and colonial expansion were "opening up" the world, the beginnings of a need to turn in on oneself began to be felt. Some artists used symbolism to express their concerns and confusion.

At the same time, man's interior life became a subject for exploration by philosophers and doctors. Bergson investigated consciousness and Freud the unconscious; memory (Bergson's *Matter and Memory*, 1896, trans. 1911) remained the bedrock for the imagination for the second half of the 19th century. What makes this period in art history so original is that there had never before been such a pressing need to confront the past with the present, although the success of Impressionism did partially overshadow this need. Amid all the fighting, scandals and falling-outs between the modernists and the traditionalists (who clashed violently when it came to painting), ever newer trends in architecture, decorative arts (which today still suffer from a lack of comprehensive studies) and, to a lesser extent, sculpture began to appear.

The period under study here extends from 1848 (the year of the revolutions that shook many European countries) to 1905, the end of Art Nouveau, although politically and socially it was Word War I that signalled the most profound and irreversible changes.

This book takes a thematic rather than chronological approach and, as is the custom, has assumed the prime importance of painting. However, the relatively recent interest in architecture and sculpture, as well as in Symbolism and Art Nouveau, has led us to alter slightly the conventional view of the latter half of the 19th century.

MODERNITY

Paradoxically, it was in the 19th century, a century obsessed with the past, that a group of artists began to feel the need to create a modern art, something entirely new. They embraced the phenomenon of 'modernity' (a term first used in the middle of the century) whilst many other artists were either unaware of it or actively opposed it. This involved more than just a mere disagreement about aesthetic principles, as was the case with the debate about the use of line and colour in painting in the 17th century. It reflected a schism within the art world, between an official art which was still governed by rules established in the past, and a living art that claimed to express the soul of the contemporary world.

Charles Baudelaire provided a definition of modernity in *Les Curiosités Esthétiques* (1868), a collection of critical essays, reviews and reflections on the art of his time: 'The transitory, the fleeting and the contingent make up half of art, the other half is made up of the eternal and the immutable ... In order that any form of modernity may be worthy of becoming antiquity, the mysterious beauty that human life involuntarily instils in it must be deliberately extracted from it.' Baudelaire – author of *Les Fleurs du Mal* (1857) and translator of Edgar Allan Poe – was in fact himself painted by Gustave Courbet (1819-77), the first truly modern artist: he is portrayed seated on the right in Courbet's painting *The Artist's Studio* (1855, Musée d'Orsay, Paris).

Although it influenced all forms of art to varying degrees, this new impulse towards modernity was expressed most vividly in the field of painting: through a new style which was sketchy and unfinished, and through a new form of composition developed under the combined influences of photography and Japanese prints. It was Édouard Manet (1832-83), the archetypal painter of modernity, who – reformulating a dictum from Diderot's *Salons* (writings on art that were published until 1857) – articulated the modern principle: 'You must be of your time and paint what you see.'

'Being of one's time'

To 'be of one's time' – the motto of modern artists struggling against the domination of the Académie's aesthetic theories and principles (see 'The Salons', p.10) – implied having a new sense of time. Like society itself, time was believed to be immutable, and yet it seemed to have accelerated with the advent of the industrial revolution and the changes and advances this had brought about. The present, which had been weighed down by the past, now turned towards the future. This new preoccupation with the future, fuelled by the idea of progress, led to a heightened awareness of time. This in turn meant that, since the past was no longer seen as fixed or confined within a given tradition, the artist felt free to find inspiration in sources other than antiquity or classicism. Since the end of the 18th century, artists had increasingly sought inspiration in other areas of the past, and this exploration of archaic cul-

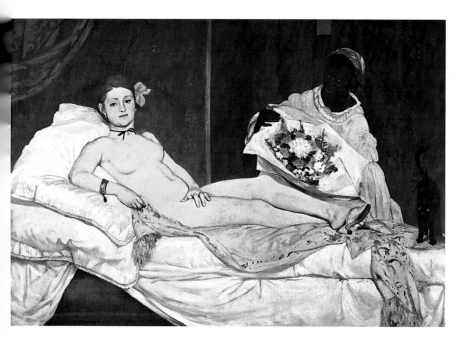

Édouard Manet,
Olympia, 1863 (Musée d'Orsay, Paris). Françoise Cachin, the chief curator of the Musée d'Orsay, writing in the catalogue for the 1983 Manet exhibition in Paris, highlights the humour in the picture, which is no longer obvious to modern viewers. She suggests a possible element of 'parody' conveyed by the model, Victorine, who 'symbolizes the painter's blithe insolence in making her imitate the pose of a model from the past, while allowing her to retain her own individual personality'. *Photo H Josse* © *Archives Larbor/T*

tures now culminated in the artist's discovery of man's primitive past. Gauguin, in particular, exemplified the artistic discovery of this 'new' past. The time of modernity was the present, distinct from both the past and the future, while at the same time encompassing both. This new concept of time led people in the latter half of the 19th century to attribute a distinctive value to the era in which they were living.

For artists, this meant producing works of art that corresponded to their own era and not to the art of previous eras, as had been taught hitherto at the École des Beaux-Arts as the basis of academicism. Art should be rooted in contemporary life, not in Graeco-Roman culture and an endless repetition of the aesthetic principles of the great masters like Michelangelo or Nicolas Poussin. What mattered was creating a living art, while also (bearing in mind Baudelaire's definition quoted on p.8) elevating this to the status of classical art.

And so, far from turning their backs on tradition – it is a common error to consider modernity as first and foremost a rejection of the past – artists took it as the yardstick by which they measured their own achievements.

The picture *Burial at Ornans* (1849-50, Musée d'Orsay, Paris) testifies to the importance that Courbet accorded to tradition, as well as to his desire to create an art that was of his time. In the massive size of the painting, and in the frieze composition of figures reminiscent of classical bas-relief, the painter was alluding to the conventions of history painting as typified by Thomas Couture (1815-79), a future teacher at the École des Beaux-Arts, who had had a huge success at the 1847 Salon with his *Romans of the Decadence* (Musée d'Orsay, Paris). But Courbet was challenging this tradition as well, not only by choosing to depict a

The Salons

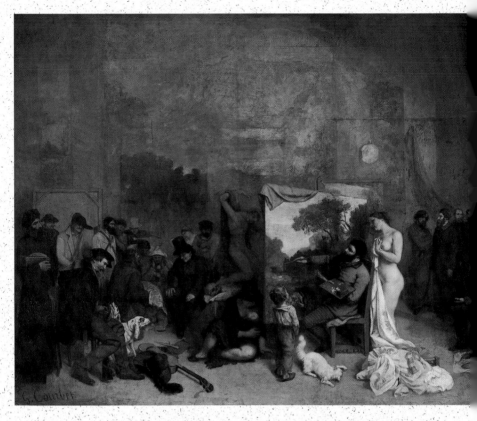

Since 1791, the Salon had been a state-organized exhibition open to all artists, whether French or foreign, painters, engravers, draughtsmen or sculptors, on condition that they had been accepted by the judges. In 1848, a change came about in the way the Salon was organized. It no longer took place in the Salon Carré in the Louvre (from which it derives its name). From 1857 until the end of the century, it was held at the Palais de l'Industrie, built in the Champs-Élysées for the World Fair of 1855. Sometimes an annual and sometimes a biennial event, the Salon was an ongoing source of rivalry and scandal, continually generating protest and controversy.

There was a lot at stake in the Salon. It was the sole opportunity for artists to exhibit their work, attract buyers and receive public or private commissions. The situation for painters was different from that of sculptors. The latter depended totally on commissions in order to be able to produce their works. However, no important sculptures were rejected by the Salon during the Second Empire (1852-70), and, so leading sculptors obtained recognition. The more adventurous or innovative painters, on the other hand, were ostracized. The reason most of their paintings were easel works was because commissions for large-scale decorative works went only to award-winning painters.

The jury of the Salon, which since the reign of Louis Philippe had been made up of members of the Académie des Beaux-Arts, selected artists who would pay homage to the distinguished art of painting, an art based on the study and imitation of classical art, whose rules must be diligently applied. For academicians, painting was primarily history painting (foremost of all genres) and was dominated by the importance accorded to line, contour, relief and chiaroscuro – a whole set of principles which experimental painters were about to do away with.

The Académie des Beaux-Arts was attached to the Institut de France, a state body. Created in the aftermath of the French Revolution, it had nothing in common with the Académie Royale de Peinture et de Sculpture, which was an association of an unlimited number of artists grouped together to defend their professional freedom. The art prescribed by the

Gustave Courbet,
The Artist's Studio.
A true allegory
concerning seven years of
my artistic life, 1855
(Musée d'Orsay, Paris).
Courbet exhibited this
painting, which was
rejected by the panel of
judges at the World Fair,
at the Pavilion of Realism
at the Place de l'Alma.
Delacroix noted in his
diary: '... I have
discovered a masterpiece
... The only defect is that
the picture he [ie the
painter portrayed within
the picture] is painting
[...] looks like a real sky
in the middle of the
picture. One of the most
remarkable paintings of
our time has been
rejected.' This painting,
with its capacity for
multiple and diverse
interpretation and its
rich pictorial qualities, is
regarded as a major work
of French art.
Photo H Josse
© *Archives Larbor*

Académie des Beaux-Arts had an immense and undeniable influence on the taste of a whole section of the middle classes, who were anxious to consolidate the legitimacy of their power and position, and to this end commissioned work from established artists. This happened to such an extent that confusion grew up around the terms 'art académique' (academic art, ie the art of the Académie) and 'art officiel' (art which was publicly commissioned).

The rejection of two paintings that he submitted for the 1855 World Fair, *The Artist's Studio* and *Burial at Ornans*, drove Courbet to organize his own private exhibition, under the heading 'Realism', in a purpose-built venue at 7 Avenue Montaigne in Paris. In 1863, 3,000 artists submitted 5,000 works for exhibition at the Salon; only 2,000 of these works were selected. In response to the volume of complaints that ensued, Napoleon III, motivated more by a spirit of generosity than love of art, suggested that an exhibition of the rejected works be organized in an adjoining salon in the Palais des Champs-Élysées. This would allow the public to judge for themselves whether the artists' protestations were justified or not. One thousand two hundred artists exhibited works at this salon, which was dubbed the 'Salon des Refusés'.

More rejections followed (for example, Manet's *The Fifer* in 1866) and this led experimental artists to exhibit their work in their studios or, increasingly, in art galleries. In 1867, both Courbet and Manet had temporary galleries built at their own expense near the Place de l'Alma in Paris, on the fringes of the World Fair.

After the Franco-Prussian War of 1870-71, when the Ministry of Fine Arts was being established, the composition of the jury altered. Advocates of academic art were replaced by a new generation, of which the majority were genre and landscape painters. Moreover, the official Salon had begun to be sidelined by Impressionist exhibitions; indeed, from the 1880s, salons created by associations of artists were competing directly with the official Salon. One of the most famous of these was the Salon des Indépendants, which held its first exhibition in 1884.

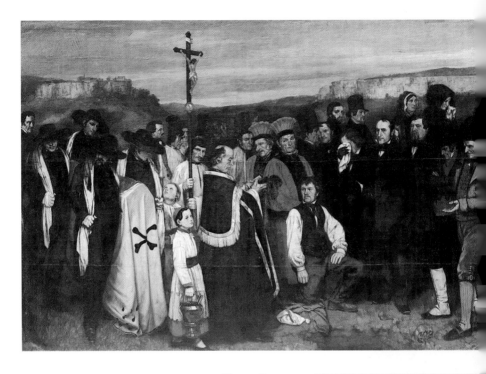

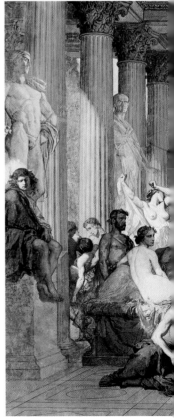

Thomas Couture, *Romans of the Decadence*, 1847 (Musée d'Orsay, Paris). This huge canvas, acquired by the state when it was exhibited at the Salon, is typical of mid-19th-century history painting. The aesthetics of this style were modelled on the Italian masters, in this case the Bolognese and Veronese Schools. Photo © H Lewandowski/RMN

Gustave Courbet, *Burial at Ornans*, 1849-50 (Musée d'Orsay, Paris). In the list of submissions for the Salon, this picture has the title *Painting of Human Figures: Record of a Burial at Ornans*. Almost 50 inhabitants of the town of Ornans, varying in social rank, are represented in the picture, including the mayor, parish priest, judge, burghers and landowners, but also agricultural labourers and workers. The severity of the picture is in stark contrast to the sentimentality in vogue at the time. It was the first of Courbet's monumental paintings and was to become the standard-bearer of realism.
Photo Hubert Josse
© Archives Larbor

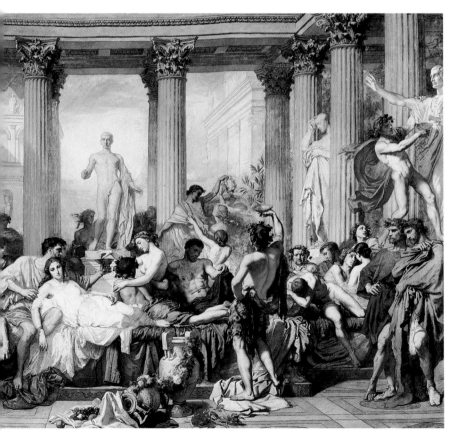

13

scene from contemporary history, but also by depicting people who did not belong to the nobility. In this painting he makes modern heroes out of his kinsfolk and the villagers of Ornans: the heroes of a real-life funeral. They were also destined to be the heroes of the 'funeral of Romanticism', in his own words, and of 'the beginning of a concrete, authentic, non-idealized art'.

A picture which created one of the biggest scandals during the Second Empire, Manet's *Le Déjeuner sur l'Herbe* (Musée d'Orsay, Paris) (see *'Scandals and modernity'*, p.16), shows how an artist could 'copy' an old composition to create a modern work of art. Not only did Manet draw his inspiration from Titian's *Pastoral Symphony* (formerly attributed to Giorgione) but his painting also reproduced elements of Raphael's *The Judgement of Paris*, from an engraving by the Italian Renaissance engraver Marcantonio Raimondi. However, rather than invoke Renaissance idealism, as an academic painter would inevitably have done, Manet – like his older counterpart and rival Courbet – subverts tradition through his use of a well-known painting, cleverly emphasizing the present-day spirit and setting of his picture by focusing on the realism of the non-idealized nude.

When Edgar Degas (1834-1917), adopting a rather more reticent stance than Manet in his early period, declared 'I want to be the classical painter of modern life', he meant that he sought to endow modern subjects with the eternal, timeless aspects of classical art. Although a post-Impressionist, he refrained from experimental research on landscape and light, being interested essentially in movement. Degas painstakingly set out to reproduce the instantaneous quality of gestures and movements, seeking to imbue them with an immortal dimension through the subtlety of his drawing. His work – as painter, sculptor and draughtsman – is another illustration of Baudelaire's definition of modernity.

'Paint what you see'

One strikingly innovative aspect of modern painting was the absence of references to subjects outside the visible world, something to which it would later owe its success. Based on the visible and not on the ideal, it was diametrically opposed to academic painting (see opposite for an academic painter's 'Remarks on art'). The academic tradition perpetuated subjects drawn from mythology – for example the two versions of *The Birth of Venus* (Musée d'Orsay, Paris), one by William Bouguereau (1825-1905) and one by Alexandre Cabanel (1823-99) – and historical subjects, such as *The Plague in Rome* (1869, Musée d'Orsay, Paris) by Elie Delaunay (1828-91), *Vitellius Dragged through the Streets of Rome* (1882, Sens) by Georges Rochegrosse (1859-1938) or *The Death of Saint Genevieve*, a mural by Jean-Paul Laurens (1838-1921) in the Pantheon. Subjects drawn from contemporary history were also favoured, the most notable examples being a series of paintings on the Napoleonic wars by Ernest

Remarks on art

Alexandre Cabanel, *The Birth of Venus*, 1863 (Musée d'Orsay, Paris). The idealized nudes of academic painters, depicted under the guise of mythology, often appear today as thinly disguised erotic fantasies. In fact, they were highly acclaimed, whereas the undressed or naked female figures of Courbet or Manet were considered to be obscene.
Photo H Josse © Larbor/T

William Bouguereau (1825–1905), who played a prominent role in the Salon, became, along with fellow academic painter Alexandre Cabanel (1823–89), one of the bitterest opponents of Manet and the Impressionists.

Throughout his career, Bouguereau was the recipient of a string of awards: he obtained the first Grand Prix de Rome and a scholarship at the Villa Medici in Rome in 1850; he was made Chevalier of the Legion of Honour in 1859, a member of the Académie des Beaux-Arts and Officer of the Legion of Honour in 1876, appointed professor at the École des Beaux-Arts in 1888 and made Grand Officer of the Legion of Honour in 1902. This was a characteristic career trajectory for artists who obtained commissions for murals in churches or public buildings.

Eugène Tardieu, a journalist with l'Écho de Paris, recorded Bouguereau's remarks on art in his article 'Painting and Painters':

'In painting, I am an idealist. I only see the beautiful in art and, for me, art is the beautiful. Why reproduce the ugly things that exist in nature? I see absolutely no need for it. I see no point in painting what one sees just as it is, unless it can be done by someone who is immensely talented.

'A new art? Why, to what end? Art is eternal, it is unique! Our art is the same as the art of all other times.

We do the best that we can, and when we equal the achievements of our masters, then we are happy indeed.

'We must seek Beauty and Truth, Sir! As I always tell my pupils, one must work to the finish. There is only one kind of painting. It is the painting which greets the eye with perfection, the kind of beautiful and flawless enamel that you find in Veronese or Titian.'

The subjects of academic painting were inspired by history or mythology. The languid, idealized and conventional nudes produced by academic painters were the very antithesis of the concern for honesty which was integral to realism and the desire to capture fleeting impressions that was characteristic of *plein-air* Impressionist painting.

It is therefore not surprising that Cabanel and Manet did not see eye to eye. The art critic Jules-Antoine Castagnary understood clearly that the central issue here was modernity. In his Salon of 1875, commenting on Manet's *Argenteuil* and Cabanel's *Absolom*, he remarked:

'When the time comes for the developments and innovations of French painting in the 19th century to be described, M. Cabanel may be omitted, but M. Manet will have to be taken into account.'

Scandals and modernity

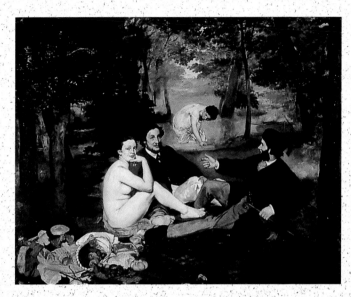

Selecting contemporary subjects from everyday life and depicting reality as it was, or as the painter apprehended it, with scant regard for the conventions of painting, could only incur the disapproval of the official art establishment. At every Salon, the submission of pictures that did not conform to the aesthetic principles set out by the École des Beaux-Arts inevitably resulted in a series of scandals, the most notorious of which created quite a stir under the Second Empire.

The 1853 Salon. Empress Eugénie, having expressed surprise at the ample size of the horses' posteriors in Rosa Bonheur's *The Horse Fair* (The Metropolitan Museum, New York), exclaimed upon seeing Courbet's *The Bathers* (1853, Musée Fabra, Montpellier): 'Another big-haunched creature!'

The 1857 Salon. The Romantic aesthete Théophile Gautier dismissed *The Young Ladies on the Banks of the Seine (Summer)* (1856-7, Petit Palais, Paris) as an attempt by Courbet to create publicity for himself, while the socialist-anarchist Pierre-Joseph Proudhon saw it as informed by a high moral purpose.

The 1863 Salon des Refusés. Critics upbraided Manet for the subject he had chosen to depict in *Le Déjeuner sur l'Herbe* (Musée d'Orsay, Paris) 'in view of the scandal'. 'We cannot agree that to portray a young woman in a woodland glade, clad only in the shade of the trees and surrounded by male students wearing berets and jackets, is a particularly chaste work of art.' The critics preferred *The Pearl and the Wave* by Paul Baudry (1828-86) and *The Birth of Venus* by Alexandre Cabanel (1823-89), which they described as 'in exquisite taste'.

The 1865 Salon. The technique used by Manet in *Olympia* (1863, Musée d'Orsay, Paris) was judged, as in *Déjeuner sur l'Herbe*, to be sketchy and unfinished, and this was considered as shocking as the subject of prostitution: '*Olympia* [...] is utterly vile and loathsome', one critic commented.

In 1869, *Dance*, a marble group sculpted by Jean-Baptiste Carpeaux for the façade of the Paris Opera, was criticized, as Manet's paintings had been, for depicting women figures dancing in wild abandon, this being considered too undignified for the Opera. The artist was taken to task for not successfully eliminating 'the imperfections of the individual human type'.

After the defeat of France by Prussia in the 1870 war, which led to the collapse of the Empire and the violent events of the Paris Commune, traumatized citizens no longer paid so much heed to the established socio-cultural order. In the France of the Third Republic (from 1870), scandals would no longer create quite the same stir as they did under the Second Empire.

Meissonier (1815-91) — whose most famous painting on this theme is
Napoleon on Campaign (1864, Musée d'Orsay, Paris) — and paintings on
the 1870 Franco-Prussian War by Alphonse-Marie de Neuville (1836-85)
and Édouard Detaille (1848-1912). Religious subjects were also the pre-
serve of academic painters. Until the advent of Symbolism and Maurice
Denis (1870-1943), these were not treated by experimental painters,
despite the large number of churches that were built in France during the
Second Empire and the Third Republic. This can no doubt be ascribed to
the fact that religious paintings were commissioned works, and it was
the painters who had won awards at the Salon who obtained the com-
missions.

These subjects, firmly rooted in the past and going back as far as
ancient times, seemed to have existed before painting had even been
invented. They were not treated by modern painters, who preferred to
paint contemporary subjects. However, modernity was not necessarily
synonymous with contemporary life. Although the modern painters drew
some of their inspiration from the contemporary scene, they never
recorded actual incidents or real-life events in their paintings. On the
other hand, Romantic painters had found inspiration in contemporary
themes and events, as testified by their precursor Théodore Géricault
(1791-1824), whose *The Raft of the Medusa* (1819, Musée du Louvre,

Gustave Courbet,
The Young Ladies on the
Banks of the Seine
(Summer), 1856-7
(Musée du Petit Palais,
Paris).
Photo © Giraudon/T

Paris) was painted only three years after an actual event – the sinking of a ship and its tragic aftermath – which had horrified the public at the time. But during this era contemporary incidents were sublimated and dressed up as history.

As for modern painters, they were recording not history but the transformation in contemporary life wrought by the industrial revolution. When the revolutionary generation of 1848 – or at least a part of it, including painters like Gustave Courbet, Jean-François Millet (1814-75) and to some extent the painter and sculptor Honoré Daumier (1808-79) – deliberately selected their subjects (whether beautiful or ugly, noble or vulgar) from the 'social reality' decried by the revolution, this was a truly revolutionary act.

Courbet was labelled a realist and himself said in 1855: 'The title of realist has been thrust upon me in the same way as the title 'Romantic' was imposed on the men of 1830'. (He was referring to a loose grouping of artists who, inspired by the revolution of 1830, had sought out new directions in landscape painting.) Even if the way in which the term was applied gave rise to some controversy, the realist movement, which in 1848 was at its zenith, aimed to elevate genre painting to the same level as history painting. However, especially in the case of Courbet, the approach to the subjects was so innovative that it no longer seemed possible to think of painting or sculpture in terms of a hierarchy of genres, even though these categories did of course continue to exist.

In the past in France, painters had first of all decided within which category they wished to be acknowledged – history painting, portraiture, landscape, genre and so on – and the category to which they were assigned then dictated the subjects chosen. At this period, the foremost position at the top of the hierarchy was occupied by history painting. For Courbet, however, the subject did not exist until it had been painted. And although he portrayed typical genre characters, for example in pictures illustrating trades and working life – countrywomen in *The Grain Sifters* (1885, Musée des Beaux-Arts, Nantes), labourers in *The Stonebreakers* (1849, destroyed in the bombing of Dresden in 1945), later regarded as a seminal realist painting – he portrayed them in a wholly unidealized way. He emphasized the humanity of his subjects, not depicting them in the heroic vein which can sometimes be found in Millet's paintings nor with the added political or social subtext of Daumier's works.

In addition, Courbet proclaimed (in remarks that were of crucial significance for the younger generation) that he envisaged a revival of art that would 'teach the people real history by showing them real painting ... What I mean by real history is history untrammelled by the superhuman events that have warped morality throughout the ages and crushed the individual. By real history I mean history unsullied by fiction. In order to paint truthfully, the artist must have his eyes open on the present, he must see with his eyes and not through the back of his head'. He set himself the goal of 'rendering the customs, ideas and appearance of my era as I perceive them; to be not only a painter, but also a man; in short to create a living art'.

METZ LIBERTY TURNER DE CHIC INGRES PISSARRO LANDSEER AN LACROIX LIEBL DESSUS OPIE DAUMIER HODLER SICKOVIC LE DON'T STEVENS AUBELICH VETER DELDEN HUNT BLAKE REGNAULT CANOVA BOCKLIN C EL MUNKACSY METER GUIGNET MESS THIEK MEUNIER MULLER MUNCH FANTIN LET REGNAULT MORSE MUNCH VAN DER VELDE ANREM FONTIN PERHEP DESSAU PATI IN JUN DURAS DELACROIX EIFEL ENSOR FANTIN LATOUR FANTIN FLAMENG GAELE GELLEE KAUFLO GAUDY GAUGUIN GRAS SET GUIMARD HAUSSMAN HODLER HOFMANN FICHU

Courbet had a profound influence not only in France (on Théodore Ribot, 1823-91, and Alphonse Legros, 1837-1911, who transmitted Courbet's ideas to Britain in 1863) but also elsewhere in Europe, especially in Belgium (on Charles de Groux, 1825-79, and Constantin Meunier, 1831-1905, a sculptor who started out as a painter) and in Germany following his visits there in 1858 and 1869 (especially on Adolph von Menzel, 1815-1905, Wilhelm Liebl, 1844-1900, and Gotthard Kuehl, 1850-1914).

Deference to the real

Thus, from Courbet on (even if the works he produced after 1855 come close to a kind of 'proto-symbolism'), the subjects of modern painting would be taken from contemporary reality. Peasants and labourers featured in these paintings, as did menial workers: washerwomen in the pictures of Degas, Toulouse-Lautrec (1864-1901) and Pierre Bonnard (1867-1947); women ironing in the work of Degas and Toulouse-Lautrec; and women spinning, sewing, embroidering or reading. These were the sights of everyday life – 'choses vues', to quote the title of a work by Victor Hugo.

It was only later that realist subject matter, such as the representation of work, would appear in sculpture, with the exception of the statuettes by Max Claudet (1840-93), a friend of Courbet's. During the 1880s the Third Republic, anxious to extol the concept of work, erected monuments with realist subjects that would convey a political message in a way that painting could not. For example, Henri Chapu (1833-91) provided the first of these images of work in his *La Reconnaissance*, a monument

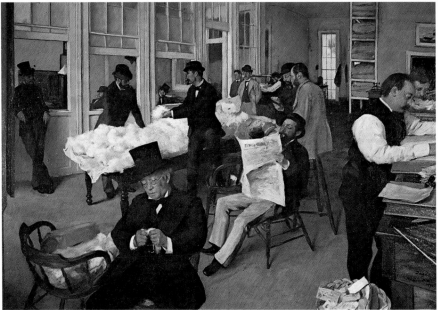

MODERNITY

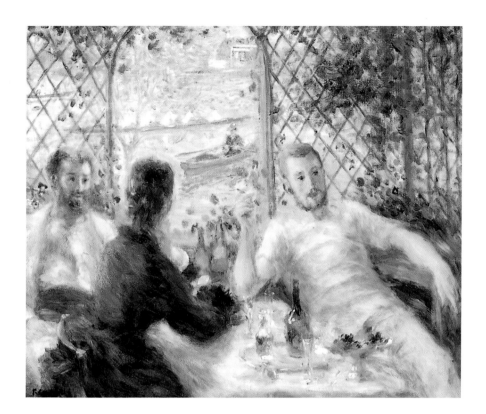

Auguste Renoir, *The Canoeists' Luncheon*, c.1879 (The Art Institute, Chicago). This picture appears to have been a prelude to *Luncheon of the Boating Party* of 1880-1, in the Philipps Collection in Washington, and is often wrongly referred to by that title. Painted most probably at Chatou, the picture shows Parisians relaxing during a Sunday outing on the banks of the Seine. *Photo J Martin* © *Larbor/T*

erected for Eugène Schneider, founder of the Creusot foundry works, and unveiled in 1879 after being paid for by subscriptions from the workers. A later example of a representation of work, full of authentic detail, can be found in the figure of the blacksmith in *Triumph of the Republic* (1880-99) by Jules Dalou (1833-1902) at the Place de la Nation in Paris. Elsewhere in Europe, the Belgian Constantin Meunier was the main realist sculptor, along with Dalou. Meunier's *The Hammerer* (1890, bronze, Calais) is a life-size work whose energetic and synthetic style is used to express the worker's struggle with matter. Sculptures involving landscape themes did not appear until towards the end of the century with Paul Richer (1849-1933) and Jean Baffier (1851-1920).

In contrast to the world of work, modernist painters focused on the world of the urban middle classes to which they belonged: Paris with its crowded main boulevards (Monet, Pissarro); people at leisure, whether depicted at the Opera (Manet, Degas, Renoir), strolling in the Tuileries Gardens (Manet) or in cafés (Manet, Degas, Renoir); working-class places of entertainment; open-air cafés on the banks of the Seine or the Marne (Monet, Renoir); swimming scenes (Manet, Cézanne, Renoir, Seurat); brothels (Manet, Bazille, Degas), a subject which would become the favourite theme of Toulouse-Lautrec, an independent artist belonging to a younger generation than the Impressionists; dances (Renoir); cabarets (Manet, Degas); luncheon parties (Renoir); garden walks or gatherings (Bazille, Monet); horse racing (Monet, Degas); and numerous portraits of

their friends and acquaintances. All of these subjects reflected the everyday world of the Impressionists.

Still lifes in the pure tradition of realist painting (evident in the work of Monet and Cézanne especially) and landscape paintings were also to undergo a remarkable transformation at the hands of the Impressionists.

In painting what he saw, the artist was deferring to reality and his vision of reality. The artist wanted to 'paint truthfully', to quote Courbet, who defined himself as the 'sincere friend of real truth', that truth which inheres in reality, and not the truth of art believed in by the academics. The more the artist deferred to reality, the more he must be sincere. In the preface to the catalogue for his exhibition at the Avenue de l'Alma in 1867, Manet expressed (perhaps with more detachment than Courbet) this fidelity of the artist to his own perception of reality: 'It has never been M. Manet's desire to protest [...] and he has claimed neither to be overthrowing an old style of painting nor to be creating a new one. He has simply tried to be himself and not somebody else [...]. It is sincerity which gives paintings an air of protest or defiance, when in fact all the painter wanted to do was record an impression.'

The true vision of reality was transmitted by sensation, and by the impression that the artist attempted to convey. The artist did not set out to describe reality, for photography now fulfilled this purpose. Photography, as Paul Valéry would later say, committed artists to 'stop trying to describe what can now be recorded automatically'. This same preoccupation with truth and sincerity was to motivate Toulouse-Lautrec from 1880 onwards, who said 'I tried to paint truthfully and not to idealize'.

The 'unfinished style'

A new style – whereby a work of art was executed so as to give the impression of being unfinished – developed when painting and sculpture

Édouard Manet,
Racing at Longchamps,
1864 (The Art Institute, Chicago). This is a dazzling treatment by Manet, using the *fa presto* oil painting technique, of a subject dear to the 19th century and of which Degas was particularly fond.
Photo J Martin
© *Larbor/T*

MODERNITY MODERNITY MODER
DERNITY MODERNITY MODI
MODERNITY MODERNITY M
MODERNITY MODERNITY MOD
NITY MODERNITY MODERNITY
RNITY MODERNITY MODERNITY

MODERNITY

began to be viewed no longer in terms of ideals and the application of set rules, but primarily in terms of subject matter. By working in this way, modern artists aimed to give expression to reality, which they considered to embody an essential truth reflecting either an external or an internal reality.

In their use of this sketchy unfinished style, Manet and the Impressionists were trying to be as faithful as possible to the way in which they perceived reality. They attempted to render the overall impression, without analysing the details of what they saw. They were trying to transmit to the viewers of their paintings the vibrancy of life in its ever-changing flux, and this manner seemed to them the most appropriate for the purpose. It was also the most appropriate for achieving as perfect a match as possible between the artist's vision and the artist's method, thus not only bringing reality closer to the gaze of the viewer, but also making it visible and thereby eliminating the distance between the viewer and the work of art.

In contrast, a highly finished style, in which reality was reconstructed in the mind of the artist, created a distance between the painting and the viewer, in the same way that the classical subject, for example, created a historical distance. Courbet may have been the first to abolish the distance between subject and viewer, but it was Manet who was to abolish distance both in terms of subject and technique. This meant that the

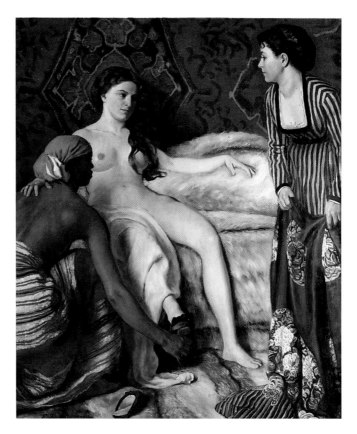

Frédéric Bazille, *La Toilette*, 1870 (Musée Fabre, Montpellier). *Photo Claude O'Sughrue* © *Larbor/T*

FLANGE ACHERE DALLAYEAN BEAMER DEL'S DECADENT EHLING ESSEN FANTIN LATGUR VICTOR FLANGES GAUDE THEODEN DEL'S AUTO CLAUD PELLAN FROST COLL
EMMANUEL MEIER LE NEES METSON DECO RUE VIREN MILLET NUNE EL MOREAU MORRISOT MORRIS MUCHA MUNN EL MATROUGE NALDEL JOSS LE FANTIN THE PIER VASSAT EL COLL
EMANUEL NETTL LETTSE FIELRE LES SARKARI LAEGEN MATRICE ANGELE BARTLET MONTE PIER DENTREMONT EL FIN LLE RUIN UEN COLL REN DUT PIERRAND DETENT
FJORDS DELACROIX EHLI EL ENSOR FANTIN LATGUR FATTORI FLAMENG GAILLE GALLEN KAELLO GAUDT GAUGUIN GROSSET GUINARD HAUSSMAN HODLER HOFFMANN FIORDS

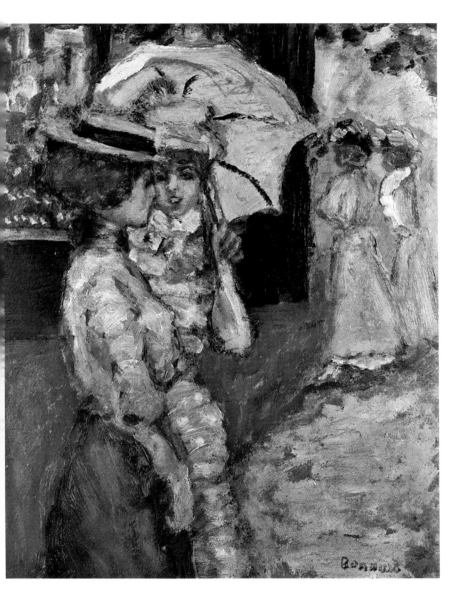

Pierre Bonnard,
La Promenade, 1899
(private collection).
From Courbet
onwards, the aesthetics
of the unfinished style
meant that the painted
texture of pictures
often took on greater
depth and richness.
Photo © Giraudon/T
© ADAGP, 1999

work of art now existed in the very act of perception, in the vision of a picture in the very process of being created – like the world itself in the aftermath of the industrial revolution. The active participation of the viewer was required so that, through a combination of the painter's brushstrokes and the viewer's gaze, true reality could be made visible.

Brushstrokes made plain the reality of the painting process, and viewers found this unsettling. Delacroix, in a spirit of total abandon, had allowed his to remain visible in his paintings. Now Manet was accused of being a 'poor painter', Eugène Boudin was accused of producing preliminary studies for pictures rather than proper pictures and, in general, the public regarded the Impressionist masterpieces as mere sketches. The

constant criticism levelled against the Impressionists' unfinished effects contrasted with the admiration reserved for the manicured, perfectly finished canvases of the officially recognized painters who were certain to win awards at the Salon.

In a work of art described as 'finished', line and contour were clearly delineated, like sculpted stone, marble or bronze: there was no trace of the artist's labour. This complied with the precepts of Ingres (1780-1867), which were also those of the Académie: to erase 'anything that betrays the workmanship of the artist'. The way in which the work of art was executed was to remain concealed. As part of the mechanics of the creative process it must remain invisible, as otherwise it would subvert the illusionistic effect of representation, one of the objectives of academic art.

It was only when academic painters began to adopt the new methods that a professor at the École des Beaux-Arts, Gustave Moreau (1826-98) advised his pupils, from 1892 onwards, to 'forsake the smooth and polished manner of execution', for 'the modern trend is towards simplicity of technique and complexity of expression'.

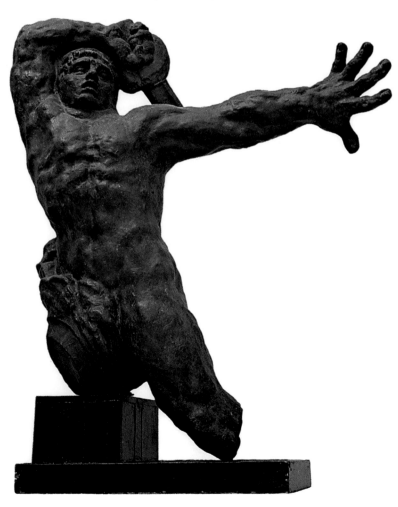

The aesthetic principles underlying the unfinished style implied that the work of art derived from the artist's spontaneity. It attested to the artist's creative freedom, in the same way as a drawing might.

In this new approach to painting, the outline of a given shape or figure was not defined by line but by colour. The colour was not blended so that the shades and tones corresponded to the object, but was applied in juxtaposed patches, resulting in an optical blending of the colours. The picture was not painted in separate stages, in the way that Delacroix, for example, still painted his pictures, but all at once over the entire surface of the canvas. Movement and the rhythm of movement were therefore of considerable significance in the overall impression that the artist sought to create and reproduce.

However, the technique used by Manet, the Impressionists and Toulouse-Lautrec, and later by the academic painters as they gradually adopted the new methods, was different from the unfinished style used by Symbolists such as Henri Fantin-Latour (1836-1904) or Eugène Carrière (1849-1906), in whose paintings blurred effects predominated.

In sculpture, the energetic, emotionally charged style of the experimental terracotta pieces of Jean-Baptiste Carpeaux (1827-75) is not found in his finished works; neither is it evident in the works of his contemporaries. It was only towards the end of the century that the aesthetics of the unfinished style were reflected in sculpture. Some bronze sculptures by Auguste Rodin (1840-1917) show, as with Degas, an Impressionist influence in the way movement is conveyed; while in Rodin's marble sculptures, closer in style to Carrière's statues, the sculptor suggests that the form is surging out of the stone. The sculptures of his pupil, Émile-Antoine Bourdelle (1861-1929), which are preoccupied with expression, also reflect this manner. However, after 1900 Bourdelle, like his contemporaries Aristide Maillol (1861-1944) and Joseph Bernard (1866-1931), opted for the finished style as he became identified with a new trend in art known as the 'return to style'. This sought to rediscover the elements of harmony and clarity associated with classical sculpture.

Composition

Two major new influences were to encourage artists in their reappraisal of the aesthetic values that had held sway since the Renaissance: photography and Japanese prints.

Based on the principle of allowing light to strike a photosensitive surface, photography had a considerable influence on artists in the second half of the 19th century, although today it is impossible to gauge its exact significance or to identify the precise nature of the interaction between painting and photography in this period. In addition to its role as a practical aid, photography was developing in terms of both technique and imagery, in other words as a vision in its own right for both sculptors (Rupert Carabin, 1862-1932; Henri Greber, 1855-1941; Henri

Émile-Antoine Bourdelle, *The Great Warrior of Montauban, Study with Right Leg*, work in bronze, sometime after 1867 (Musée Bourdelle, Paris). This statue was conceived as a memorial to the dead at Tarn-et-Garonne, scene of a battle during the Franco-Prussian War of 1870, and was unveiled at Montauban in 1902. Bourdelle executed the statue in an expressionistic style, characterized by the unrealistically massive shape and huge hand, and by the play of light achieved by the pattern of hollows and reliefs. *Photo © P L Magnin/T*

Henri Victor Regnault (1810-78), *Photographic Study No 206* (Bibliothèque Nationale, Paris). The director of the Sèvres porcelain factory near Paris, Victor Regnault belonged to a group known as the 'primitives' of photography, active around 1850, which included Gustave Le Gray, Henri Le Secq, Charles Marville and Eugène Cuvelier. Their work was informed by a style and sensibility close to those of the Barbizon School. *Photo © Bibliothèque Nationale/Archives Larbor/T*

Godet, 1863-1937) and painters (Degas, Toulouse-Lautrec) (see *'Photography, the artist's instrument'* p.28). Furthermore, it was to reveal an essential fact to artists: that perspective and chiaroscuro do not exist in nature, but are mere conventions. At the time, it was assumed that the camera would straightforwardly record reality, that the visible world would be reproduced exactly in the photograph. This proved to be far from the case. Although the details of the scene being photographed were indeed reproduced, the various inaccuracies that resulted – from mistakes when the photograph was being taken, from errors made by the photographer in using the equipment or from other mishaps during processing in the laboratory – revealed aspects of visible reality that neither photographers nor artists had ever considered. What had not been suspected, but was revealed in the course of their experiments, was the selective attitude of photographers in relation to reality: their choice of what detail to leave out or to highlight, their choice of light and how to distribute elements of light and shade, their choice of composition. It became apparent that photography did not copy reality, it interpreted it.

A Daguerreotype camera (Société Française de Photographie). *Photo J L Charmet © Larbor/T*

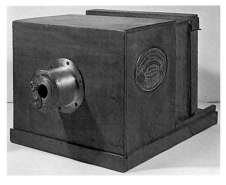

MONET LE MEUR CHARLES SHSS ANDER MEL MIER MAILLET MONET MOREAU MORISOT GUILLAUMIN CEZANNE MARÉE ET MANTE MANZEL DEGAS DAUMI
MONET VAN GOGH WHISTLER DELACROIX MELLIER WAGNER MONET MORESE PISSARRO MARTIN DUBOIS DAUBER LE GRAY MONTE CÉZANNE RODIN SCHIFFER RANFT SCHUFT DEGAS DE DEMI
LUCAS DELACROIX EIFFEL ENSOR PAINTING LATOUR LATOUR PLAMENCO DAILEY O'KEEFE KNAUT FRY GAUDY GAUGUIN GRASSET GUIMARD HAUSSMAN HODLER HOFFMANN HOKUSA

And so it was that photography, which had been considered the most effective means of reproducing nature, was, like painting, to abandon the aim that it had originally sought to appropriate for itself: to provide a perfect mirror image of reality. At the same time, painting as an imitation of nature found itself completely undermined. Photography was therefore drawn into the debate about perception and the analysis of the visual sense – a debate in which painting had hitherto held centre stage. It was in this way that photography came to have a major influence on painting, especially in the development of what painters in the 1860s called 'natural vision'.

The first photographic image was produced by the French lithographer Joseph-Nicéphore Niepce (1765-1833), who had the idea of transcribing an image, originally obtained on stone, onto a thin pewter plate covered with bitumen (and subsequently silver iodine) within a camera obscura. The process was later refined by the painter Louis Daguerre (1789-1851), who fixed photographic images on metal plates known as 'daguerreotypes' by using an apparatus of the same name. In 1847 Blanquart-Évrard (1802-72) introduced into France the calotype negative/positive paper process pioneered by the Englishman William Henry Fox Talbot (1800-77), and published photograph albums consisting primarily of landscape scenes. Photography developed in an extraordinarily creative way between 1850 and 1860, by which date it had become widely known and practised, with almost a dozen specialist magazines devoted to the subject.

Photography did not have the same kind of influence on painting as Japanese prints did. Although it is sometimes possible to identify the

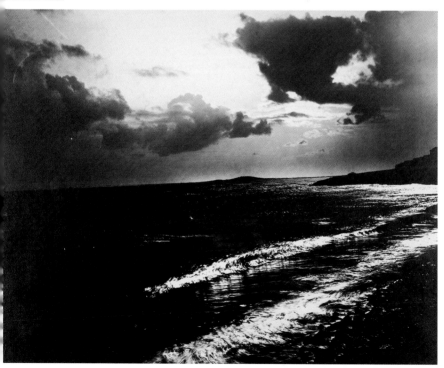

Photography, the artist's instrument

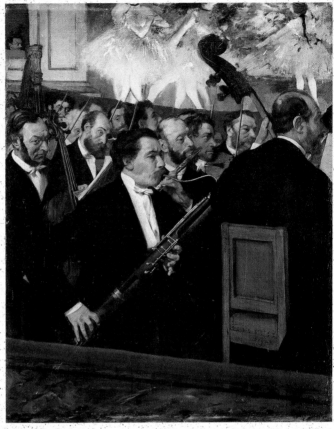

Edgar Degas, *The Orchestra at the Opera House*, 1868-9 (Musée d'Orsay, Paris). Around 1868, Degas attended the Opera almost every evening. In this picture, the radical way in which the composition is framed is reminiscent of both photography and Japanese art: only a section of the orchestra is pictured and the figures are cut off; the horizontal layering of the foreground, middleground and background on three successive levels – defined by the partition which separates the musicians from the audience, the area in which the musicians are placed, and the brightly illuminated stage, where all that can be seen are the swishing frilly ballet skirts of the dancers – draws the eye into what constitutes the very essence of performance in general rather than one particular performance.
Photo © RMN

Edgar Degas, *Dancer with Tambourine*, bronze figure (Musée d'Orsay, Paris). Degas has attempted to capture the instantaneous quality of a fleeting moment.
Photo © H Lewandowski/RMN

For sculptors, photography played an essentially accessory role. Above all it meant that the time spent on sittings could be greatly reduced because photographs were used either as a substitute for a model or in order to have a two-dimensional representation of the outline of the work. Photography could also be used to supply evidence retrospectively of the sculptor's work in progress, from the first stage right through to the last, or to provide reproductions of the finished work of art. Throughout his career, Rodin systematically used photographs to record his work.

For painters, photography replaced the series of initial sketches done from life on which they had hitherto relied, and offered an invaluable set of images of movement and gesture which they could study; but above all they valued it as an aid to perception. This role was fulfilled directly by the photographs of the English photographer Edward Muybridge (1830-1904), which captured in sequence the stages of movement involved in a horse walking, trotting and galloping (1878). These influenced Degas (both in his sculptures and pastel works) and Toulouse-Lautrec, at the same time enabling them to gauge the discrepancy between photographic image and human perception.

Otherwise photography performed this role indirectly: it was not so much the photographs themselves as the images of reality reproduced in journals and magazines that altered the vision of the landscape painters. Similarly, photographic images of society as the theatre of modern life influenced Degas and Toulouse-Lautrec.

enri de Toulouse-

Henri de Toulouse-Lautrec, *The Salon in
e Rue des Moulins,
594 (Musée Toulouse-
Lautrec, Albi). Taking
e brothel (a theme
idely treated by
odern painters) as its
subject, this picture
nows that Toulouse-
Lautrec was another
rtist who had
bsorbed the influences
f both photography
nd Japanese art. The
omposition is
xtremely well-
alanced, based as it is
n a diagonal line that
eparates an empty
rea from an area filled
ith figures. The cut-
ff figures show that
ne picture represents a
lice of life, while the
olours are strikingly
ivid.
Photo © Lauros
Giraudon/T*

original print that a painter used as a model for a given painting, it is less easy to identify specific photographs that may have served as models. Nevertheless, the new approaches to the framing of compositions introduced by photography, as well as unusual angles, the use of close-ups and the relation between the foreground and the background, all contributed to revolutionizing composition in painting. For example, Manet's *Luncheon in the Studio* (1868, Munich), with its figure in the foreground – framed, as it were, in a medium close shot – painted with meticulous attention to detail in contrast with the blurred background, shows a definite photographic influence. Similarly, the tendency towards simplification and the flattening of space originated in photography. On the other hand, photographers like Gustave Le Gray (1820-82) produced landscapes that recalled those of the Barbizon School, for example *Bas-Bréau, Forest of Fontainebleau* (c.1855, Gérard-Lévy Collection, Paris).

A work like *The Great Wave* by Le Gray (1857, Gérard-Lévy Collection, Paris) apparently influenced Courbet, who took from it the idea of timelessness and opacity, running counter to the sense of transitoriness. More markedly, the work of Charles Marville (1816-79) – excluding his documentary style photographs of the demolition and reconstruction of areas of Paris under Haussmann – prefigures the experiments of the future Impressionists. In *Man Resting Under a Chestnut Tree* (1853, André Jammes Collection), he masterfully conveys the effects of the changing light, treating the subject with masses of light and shade without ever allowing the latter to become entirely black.

The all-important 'sense of light' was, however, to be developed by the

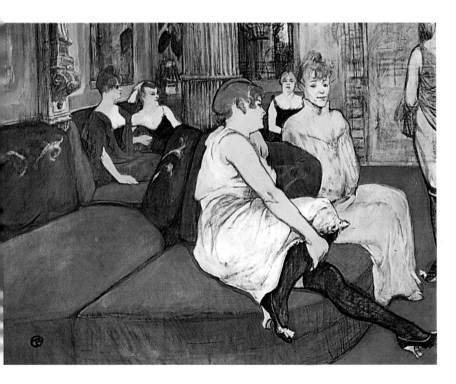

Gustave Courbet

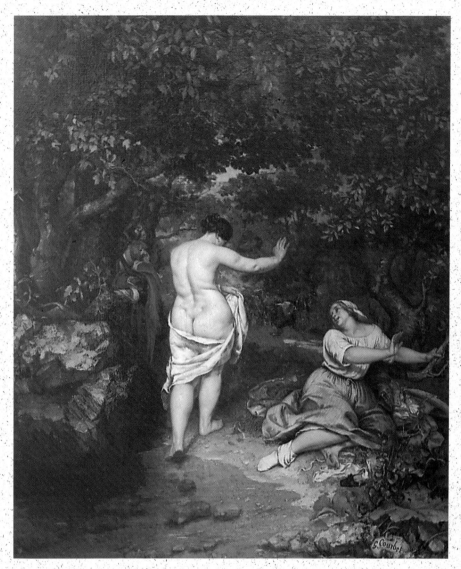

The Bathers, 1853 (Musée Fabre, Montpellier). This picture, which created a scandal when it was shown at the Salon, belongs to the European tradition of bathing scenes featuring nymphs, goddesses or the biblical character of Susannah. Courbet, whose two female figures are depicted here in the rather mysterious poses that frequently occur in his work, subtly contrasts the realism of the nude with the classical setting. Photo © Faillet-Artephot/T

1819. Gustave Courbet is born into a landowning family in Ornans, in the Franche-Comté region of France, the eldest of six children. In later life his four sisters will sit for him as models.
1839. He arrives in Paris, where he copies many paintings in the Louvre.
1848. He joins a group of artists who meet regularly at the Brasserie Andler, described as a 'temple of realism' by the writer Jules Champfleury.
1853. Alfred Bruyas, an art collector from Montpellier, buys Courbet's The Bathers; the pair strike up a friendship that lasts the rest of Courbet's life.
1855. Courbet's exhibition Realism is a failure. He returns to his home town of Ornans, a place he will continually revisit throughout his life.
1860. The art critic Castagnary visits Courbet's studio; in later years he will organize a posthumous exhibition of

the artist's works at the École des Beaux-Arts (1882). Courbet becomes increasingly successful as demand for his work grows at exhibitions both in France and abroad.
1870. He does his best to save works of art while the capital is under siege during the Franco-Prussian War, and is appointed President of the Arts Commission and then President of the Federation of Artists. As the Paris Commune's delegate to the École des Beaux-Arts, he is accused of complicity in the destruction of the column at the Place Vendôme, a monument to Napoleon's victories. He denies the charge but is incarcerated in Sainte-Pélagie prison in Paris.
1877. Courbet goes into exile in Switzerland and dies of dropsy at La Tour-de-Peilz, on Lake Geneva.

HOCKNEY HOLBEIN HOLMAN HUNT HUNT INGRES ISABEY ITTEN JAMIN JONGKIND KANDINSKY KLEE KLIMT KOKOSCHKA LAMI LANCRET LAVERY LEIBL LE NAIN LEPINE LEVY LE POITTEVIN LEWIS LHERMITTE LIEBERMANN LIOTARD LONGHI MAGNASCO MALEVICH MANET MANTEGNA MARC MARQUET MATISSE MAUVE MEISSONIER MENZEL MIGNARD MILLAIS MILLET MONET MOREAU MORISOT MORRIS MUCHA MUNCH NATTIER DE NADAR
DE MARNE LE NAIN RENOIR PUVIS DE CHAVANNES DEGAS DENIS DERAIN DIETERLE DORE DUPRE DYCE ESCHER FANTIN-LATOUR FLAMENG GAELE GAELEN RAFFAELLI GADDI GAUGUIN GRASSET GUIMARD HAUSSMAN HODLER HOFFMANN FICKUS

most famous photographer of the Second Empire, Nadar (the pseudonym of Gaspard Félix Tournachon, 1820-1910), who declared that 'it was not something that can be learnt'. It is therefore no accident that it was in his studio that the first Impressionist exhibition was held. Charles Nègre (1820-80) took an entirely different approach: in order to give an impression of naturalness, he constructed his photographs so that whole areas were defined by light, within which the people he photographed were framed. Before these two, Julien Vallou de Villeneuve (1795-1866) had introduced realistic depictions of the nude, thereby freeing it from the theatricality which characterized academic treatments of the sub-

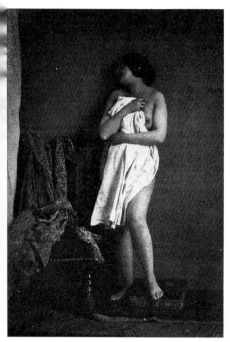

ject. He had become a specialist in artistic nudes, and Courbet used his photographs for *The Bathers*, painted in 1853. Thus, after 1850 visual conventions were established in photography which were to prove useful to painters in the 1860s and 1870s.

Photography was not the only new discovery to challenge painters' vision of things. Japanese art, which presented artists with a new model and a new source of inspiration, also encouraged them to break free from the stranglehold of tradition.

The art of the Japanese print – a popular art form in comparison with classical Sino-Japanese art – had a considerable influence on two generations of painters. First, it spurred the Impressionist generation to reject traditional methods; second, at the time of its greatest influence at the close of the century, familiarity with Japanese art was instrumental in the development of the concept of Synthetism among certain artists. Japanese woodblock prints radically changed their ideas

Julien Vallou de Villeneuve, *Nude Study*, photograph (negative on paper), after 1850 (Bibliothèque Nationale, Paris). This photograph may have been used by Courbet as a model for the nude in his painting *The Artist's Studio*. Other photographs of this type, deposited in the Bibliothèque Nationale in 1853, apparently served as inspiration for the figures in Courbet's *The Bathers*. Photo © *Bibliothèque Nationale/ Archives Larbor/T*

regarding subject matter, line and colour, and composition. The discovery of Japanese art made them more confident about the subjects they chose to paint: everyday life; life as spectacle; people at work; and landscapes treated essentially in terms of daylight (Théodore Rousseau, 1812-67; and American expatriate James McNeill Whistler, 1834-1903), a daylight without shadow (in the work of the Impressionists) and where light is constantly changing. So views of Mount Fuji are echoed by Monet's paintings of haystacks, poplars and cathedrals, and Hokusai's prints are echoed by Degas's scenes of women bathing or getting dressed.

The new status accorded to colour and line led artists to call into question the way they had previously considered these elements. The prints were striking because of their bold, pure colours devoid of subtly nuanced shades, with colour applied flatly without modulation or chiaroscuro and demarcated by lines which were flowing and dynamic rather than rigid and confining. The Impressionists and the Synthetists

MODERNITY

Katsushika Hokusai, *Under the Wave off Kanagawa* (part of the *Series of 36 Views of Mount Fuji*), also known as *The Wave* (Musée National des Arts Asiatiques-Guimet, Paris). 17th-century Japanese painters and engravers like Hiroshige and Hokusai had a major influence on Impressionism and Post-Impressionism. Gauguin, while staying with his friend and fellow painter Claude-Émile Schuffenecker in 1890, hung prints by Utamaro and Hokusai on his walls. In his paintings of reefs and seascapes, Gauguin was inspired by the schematic approach of *The Wave*. Van Gogh's *Irises* was strongly influenced by Hokusai's treatment of the same theme. Monet was a great collector of these prints, which are today preserved in his house at Giverny. *Photo © RMN/Kodansha*

were struck by this startlingly vivid use of colour and followed the example of the Japanese artists in exploiting the contrasting effects between flat, often complementary, colours (Degas, Toulouse-Lautrec, Gauguin).

However, it was in terms of the composition – the way in which the figures were distributed on the canvas or paper – that the Japanese influence was strongest. Not only did the subjects and bright palette characteristic of Japanese prints accord exactly with the experimental concerns of artists at the time, but the Japanese style of composition also introduced artists to a new way of seeing and representing the world. Monet, Degas, Van Gogh, Gauguin and the Nabis, to name but a few, were able to avail themselves of this new aesthetic and use it to free painting from the rigid principles governing perspective, symmetry and compositional harmony.

Following the example of Japanese art, the composition of paintings became asymmetrical and decentred, typically structured around a diagonal line or oblique angles. Figures arranged loosely in groups could be depicted in close-up or from the rear; they could be cut off, suggesting that the scene being portrayed extended beyond the frame and that the picture was a fragment of life and no longer a discrete self-contained entity. The foreground, middleground and background were no longer organized in such a way as to lead the eye into the space created within the picture but – in the paintings of the Synthetists and the Nabis – were superimposed or layered so as to negate the illusion of depth. The angle of viewpoint was different: the scene was generally seen from a high vantage point rather than presented at eye level. Although relief and volume were suggested, this was done through line and not through the modulation of colour or chiaroscuro.

The influence of Japanese art is not comparable to that of the chinois-

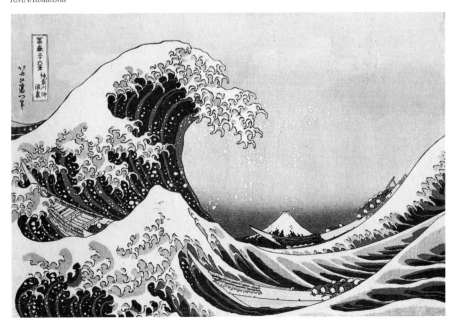

eries which brought a new exotic dimension to art in the 18th century. Japanese art was familiar to the general public in 19th-century France, essentially in the guise of fashionable Japanese curios, but it was for Japanese prints that artists had a marked preference. The most celebrated woodblock prints, known also as xylographs, were by Hokusai (1760-1849), Hiroshige (1797-1858), Utamaro (1754-1806) and former masters of the Ukiyo-e School (Ukiyo-e being the name given to 'images of the floating world', coloured prints done for the merchant classes of Osaka and Edo and which represented geishas and popular actors, interior scenes and landscapes). Although from 1854 onwards Japanese prints were available in the West, it was not until the beginning of the 1860s that Japanese art suddenly became all the rage, a craze which was to last right up to the end of the century. This vogue for Japanese art went through two distinct phases.

During the first phase, from 1854 to 1878, interest in all things Japanese gradually became widespread. Although Japanese works of art were rare in Europe between 1854 and 1862, it is known that Baudelaire owned Japanese prints as early as 1861. The start of this fashion can be traced to 1862 and to the small circle of modern painters who met at La Porte Chinoise, a Parisian shop owned by the Desoye family at 220 Rue de Rivoli. At the 1867 World Fair, the high profile given to the Far East marked the beginning of a new era of two-way travel between Japan and France, facilitated by the opening of the Suez Canal in 1869. It was at another World Fair, that of 1878, that Japanese art became officially sanctioned, and it was from this date on that Japanese prints, rare until that time, began to become better known.

The second phase, the heyday of 'Japonism' as it was officially termed in 1876, was from 1878 to 1895. The term reflects both the significance attached to Japanese art and the extent to which it was integrated into artists' working practices. Countless exhibitions were held: for example, in 1883 a retrospective exhibition took place at the Rue de Sèze in Paris; in 1887 Van Gogh organized an exhibition in Le Tambourin, a café on the Avenue de Clichy in Paris; and in 1890 the art dealer Samuel Bing (1838-1905) held an exhibition of Japanese artefacts and *objets d'art* at the École des Beaux-Arts – an exhibition which was to have a considerable influence on the Nabis. In addition, between 1888 and 1891 Bing published a magazine entitled *Le Japon Artistique*. But at the 1900 World Fair, visitors to the Japanese pavilion were amazed to discover that they had been totally ignorant about the most beautiful Japanese works of art

Pierre Bonnard,
The Little Laundress,
1896 (Cabinet des
Estampes, Bibliothèque
Nationale, Paris). The
second generation of
painters to take an
interest in Japanese art
sought out older prints
such as those by
Hokusai and Utamaro,
which eschewed
perspective or relief,
and from these they
derived important
lessons in the art of
synthesis.
*Photo © Bibliothèque
Nationale-Larbor/T*

MODERNITY

and that Japanese prints were of only minor significance in the Japanese artistic tradition. The aura of mystery surrounding Japanese prints promptly vanished, thereby putting an end to the craze for all things Japanese that had lasted for forty years.

Today, art historians acknowledge the modernist technique and composition evident in all late 19th-century experimental paintings, but critical opinion is divided on the issue of subject matter. On the one hand, those who have studied 20th-century painting – and been influenced by the theories of Georges Bataille – observe in 19th-century modernist painters an 'indifference to the importance of the subject' and see them as the forerunners of abstract painting. On the other hand, art historians specializing in the 19th century consider that the modern painters of the Second Empire and of the early days of the Third Republic essentially developed a new concept of subject matter. By choosing subjects for-

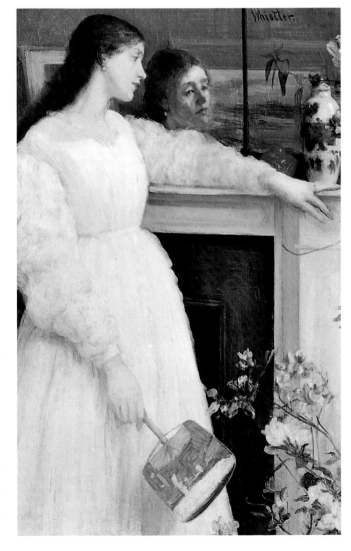

James McNeill Whistler, *Symphony in White No. 2: The Little White Girl*, 1864 (Tate Gallery, London). Whistler had a passion for Japanese artefacts, which he frequently included in his paintings. Along with Rousseau, Manet, Monet and Degas, the American belonged to the first generation of artists to discover the attractions of Japanese prints. However, the prints which were known during this period had been exposed to Western influences; in particular they used perspective, although without showing relief.
Photo E Tweedy
© *Larbor/T*

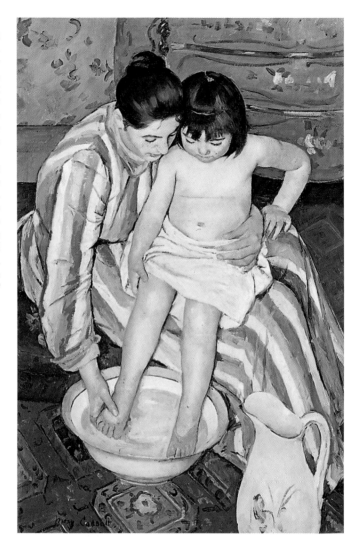

Mary Cassatt, *The Bath*, 1892 (The Art Institute, Chicago). An American, like Whistler, and a friend of Degas, Mary Cassat was also influenced by Japanese art. This is visible here in the everyday domestic interior scene, specifically a *scène de toilette*, the oblique composition emphasized by the stripes of the woman's dress, and the elaborately painted background.
Photo J Martin
© *Larbor/T*

merly considered as less noble than historical subjects, and by portraying them in a non-idealistic way, they called into question the elitist categories of subject matter which had held sway until then and thus established the primacy of the artist's vision. All subjects were now held to be worthy of depiction. Subject matter was therefore not discounted, but continued to be important with regard to the choice of subjects and imagery.

Henri de Toulouse-Lautrec

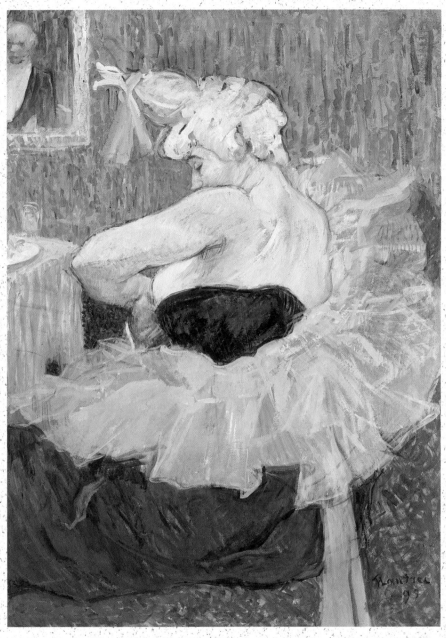

The Female Clown Cha-U-Kao, Artiste at the Moulin Rouge, circa 1895 (Musée d'Orsay, Paris). In the 1890s, Toulouse-Lautrec found himself drawn to the seedy glamour and melancholy charm of the Fernando circus in Montmartre, and did studies of riders, acrobats and clowns. This is one of several pictures he executed of the heavy, luminous figure of the female clown Cha-U-Kao. Photo © H Lewandowski/RMN

1864. Henri de Toulouse-Lautrec is born into an old aristocratic family in Albi in south-western France, where he spends his childhood.

1878-9. He breaks both of his legs, which remain weak and deformed for the rest of his life.

1882. He visits the studios of the painters Bonnat and Cormon.

1885-6. He takes up residence in Montmartre and starts painting people at the cabarets and music halls for which the district is famed: the Moulin de la Galette, the Mirliton de Bruant and the Moulin Rouge, which opens its doors to the public in 1889. Among those he paints are la Goulue,

Yvette Guilbert and Jane Avril – legendary dancers at the Moulin Rouge – and the Prince of Wales, later to become King Edward VII.

1901. Toulouse-Lautrec dies in Paris as the result of a stroke brought on by alcoholism.

His art is the work of a maverick: Impressionism inspired him in his use of pure colours and his technique of juxtaposing areas of hatching; from Symbolism he borrowed the Cloisonnist technique and use of flat expanses of colour; and from Japanese art he acquired his taste for simplified forms and striking compositions.

Edgar Degas

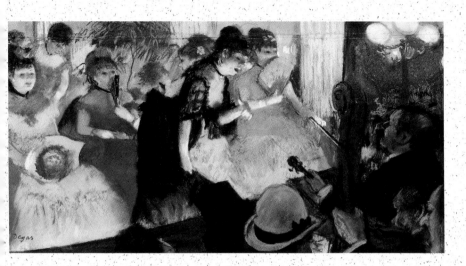

Cabaret, monotype and pastel, c.1876-7 (Corcoran Gallery of Art, Washington).
Photo © Archives Larbor

Woman Washing in her Bath, coloured pencil on cardboard, 1892 (Musée d'Orsay, Paris). In France, a debate about the primacy of colour or line in painting had for a long time been central to all discussion about art, especially since the 17th century. Degas, who was the greatest draughtsman of his time, was also a masterly colourist, as is evident from his coloured pencil drawings and even more so from his pastel works. The importance he attached to colour would pave the way for the Nabis, and in particular Pierre Bonnard.
Photo H Josse © Larbor/T

1834. Edgar Degas is born in Paris, the son of a wealthy banker. His mother is from New Orleans.

1853. A pupil of Louis Lamothe, who was a disciple of Ingres, he enters the École des Beaux-Arts and travels to Italy (1856 and 1858), where he meets painters of the Macchiaioli movement.

1860. He intends to specialize in portraiture and history painting, but after meeting Manet and the future Impressionists (1858-66) he starts to paint scenes of contemporary life and use a brighter, more colourful palette. Having developed an interest in photography and Japanese prints, he starts to produce paintings characterized by radical experimental compositions. His interest in dance and opera takes up a lot of his time in the 1870s.

From 1874, he works on groups of thematic paintings, concentrating on milliners, washerwomen, dancers at the opera, women bathing or dressing, and horse-racing scenes. He still associates with the Impressionists and exhibits with them, but rejects the Impressionist aesthetic and its enslavement to the cult of the open air, preferring to focus on movement and capturing the instantaneous gesture rather than on the fleeting effects of light.

1880. No longer able to use oils because of his failing eyesight, he switches to pastels, thus paving the way for Bonnard's experimental paintings.

1917. Degas dies in Paris.

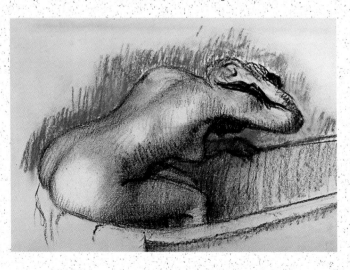

LANDSCAPE PAINTING: THE
CULMINATION OF A GENRE
IN CULMINATION OF A GENRE
N LANDSCAPE PAINTING: THE
AINTING: THE CULMINATIO
E CULMINATION OF A GENRE

LANDSCAPE PAINTING: THE CULMINATION OF A GENRE

In the second half of the 19th century in France, the most radical experiments and innovations in European painting were undertaken in a genre once considered of minor significance: landscape painting. These experiments and innovations would ultimately lay the foundations of modern art.

Landscape painting developed rapidly from the beginning of the 19th century until it reached its high-water mark under the Second Empire (1852-70) and the Third Republic (from 1870). This development derived from the new awareness of nature which was promoted towards the end of the 18th century by the Romantics, most notably Rousseau, Bernardin de Saint-Pierre, Étienne de Senancour and Chateaubriand. They advocated a return to nature, specifically primitive nature, without resorting to idealization. In 1816, classes in landscape painting were introduced at the École des Beaux-Arts and the prestige of the genre was enhanced by the creation of the Grand Prix de Rome, awarded to landscape painters until 1863.

By around the middle of the century, landscape painting had become the national genre. All artists tried their hand at it, all the more enthusiastically given that history painting was the exclusive preserve of academic painters. Landscape painters were encouraged by the fact that they were practising within a genre whose legitimacy had been established and, as a result, more and more of their works were accepted for exhibition at the Salon. Nevertheless, in order to be admitted to the Salon, a painter had to submit landscapes which were specifically historical or pastoral, or paintings which at least displayed an idealized treatment of landscape. Those artists whose paintings showed a return to 'real' nature were rejected. Théodore Rousseau, although he was the leader of the Barbizon School, had his paintings repeatedly rejected by

Georges Michel,
The Mill of Montmartre
(Musée du Louvre,
Paris). The influence of
the Nordic painters can
be seen in this painting
by the father of the
Romantic landscape.
Devoid of picturesque
elements, it is
remarkable for its
dramatic contrasts of
light and dark achieved
with a deliberately
restrained palette.
Photo H Josse
© *Larbor/T*

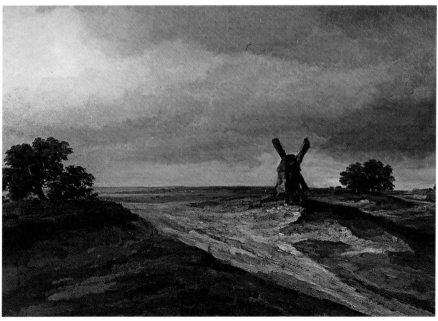

IN MARXE DE MEYER ORSEN MOSS ANDREML MIILE MIER MILLET MONET MOROT MOREAU MORISOT MOROS MUCH MUNINIUM MONTON MUNCH BARABAR AKSELL ENSOR SAMUEL DE SAINT JAM EN DER MER A MERS SANDFEIRE DEC MUIS AMLI WAGNER WATTS WORENBY AND BEE VARIOS MUSEUM MEMBER AND WARE BICKET LOUIK DUCKER KONIGHOFER LARMAINGUR ER DE CAS DELADNOX EFFEL CENSOR HANTIN-LATOUR FRATTON FRAGEENO GAILE GALLEN-KALLEL NOGU-DARGUIN GRASSET UELMARD HALSSMAN HODLER HOFFMANN HORU

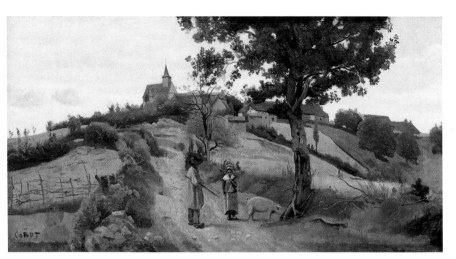

the Salon between 1836 and 1848 – hence his nickname 'le grand refusé'. However, his appointment as a member of the Salon jury after the 1848 revolution proved that some people at least appreciated his importance as an artist. Later, the Impressionists would not receive such a favourable reception. Although their paintings were sometimes accepted by the Salon, the Caillebotte affair at the turn of the century showed how entrenched opposition was within both the Académie and the École des Beaux-Arts to works which revolutionized traditional concepts of painting. (Gustave Caillebotte, art collector and patron of the Impressionists, bequeathed his whole collection to the French government, which only reluctantly accepted part of it.)

Important though it is in the history of painting and landscape painting – a tradition that in France goes back to the 17th century – Impressionist landscape painting should not be allowed to overshadow Symbolist landscape painting, which is characterized by a different sense of nature and a different technical approach.

The French tradition

French landscape painting in the 19th century still respected the traditional distinction between 'heroic' landscape, focusing on a biblical or mythological theme, and 'pastoral' landscape, which depicted a scene of nature. Within this there was another distinction: between Italianate landscape where structure was paramount, constructed around alternately light or dark sections of the painting, and 'lyrical' landscape suffused with light.

Although pastoral landscape prevailed over heroic landscape to such an extent that by 1850 it was the dominant genre, the distinction between 'Italianate' and 'Northern' styles of painting was sustained right up Cézanne's time. Georges Michel (1763-1843) is an example of a

LANDSCAPE PAINTING: THE CULMINATION OF A GENRE

Northern-style painter, sensitive to variations in light and atmosphere. Jean-Baptiste Corot (1796-1875) is a later example of an Italianate painter – up to 1865 at least, after which time he began to historicize or idealize his landscapes. From 1830 on, the influence of 17th-century Dutch painters, especially Jacob Van Ruysdael, Meindert Hobbema, Paulus Potter and Jan Van Goyen, was very strong. This influence, most obvious in the painters of the Barbizon School, was generally mediated via painters of the English School, who had a marked influence on Delacroix. Delacroix was to emerge as a seminal figure because of the importance he attached to colour, to movement in his lines, to shades and tones of colour, and to his use of brilliant local colour and dramatic chiaroscuro effects. Equally important was his technique of 'flochetage'; that is, the application of contrasting colours with small strokes of the brush.

The English School

The early 19th-century English School of landscape painting had a vital influence on the development of Impressionism. This was especially true in the case of three major English painters: Joseph Mallord William Turner (1775-1851), John Constable (1776-1837) and Richard Parkes Bonington (1802-28). Their influence was initially felt indirectly, via Delacroix, who was a friend of Bonington and an admirer of Constable. The latter's painting *The Haywain* (1821, National Gallery, London) was exhibited at the Salon in 1824 and was to make a lasting impression on

John Constable,
Flatford Mill, 1817 (Tate Gallery, London).
Photo E Tweedy
© *Larbor/T*

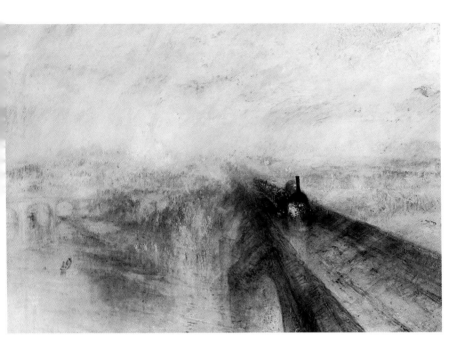

J M W Turner, *Rain, Steam and Speed – the Great Western Railway*, 1844 (National Gallery, London). The Great Western connected the Thames Valley with Devon. In the early 1840s this railway line was the fastest in the world, with trains travelling up to 95mph. Turner delighted in trains and speed at a time when many in England, seeing the Industrial Revolution as the beginning of the end, favoured a return to nature and the world of medieval times. One of Turner's most famous works, this painting made a strong impression on Monet and Pissarro when they saw it in London.
Photo E Tweedy
© *Larbor/T*

the younger generation of painters. Delacroix was also to become an advocate of Turner long after they had first met. Later, French painters were to be influenced by their English counterparts more directly, when the 1870 Franco-Prussian War would force Monet, Sisley and Pissarro to go into exile in England. Furthermore, Delacroix and Gericault greatly admired the Scottish artist David Wilkie (1785-1841) as a 'natural' painter of human emotion.

The English School of landscape artists transformed landscape painting, no longer portraying nature in an idealized or rigidly ordered way and dispensing with the mythological or historical elements that characterized the composite or historical landscape. 'Antiquity has no place here', Théophile Gautier declared in 1855. The English artists also ushered in a new attitude to nature, one founded on the senses as the basis for experiencing and responding to light and colour.

French artists admired Constable's spontaneous naturalism, emotional sincerity and passionate commitment to conveying his impressions of the ever-changing natural world. They were inspired by the fresh atmosphere and loose construction of the small pictures which Turner finished in his studio after doing most of the work on them outdoors. The visible brushstrokes showed the painter's workmanship, while the thin stripes of white showed the mark of the painter's palette knife. They preferred his sketches, but were enraptured nonetheless by the apparently unfinished paintings and 'the multitude of different greens' applied next to each other so as to create, for example, an expanse of green meadow.

Bonington's landscape painting was much more difficult to evaluate. Also known as a genre painter, his pictures, with their vast, luminous

LANDSCAPE PAINTING: THE CULMINATION OF A GENRE

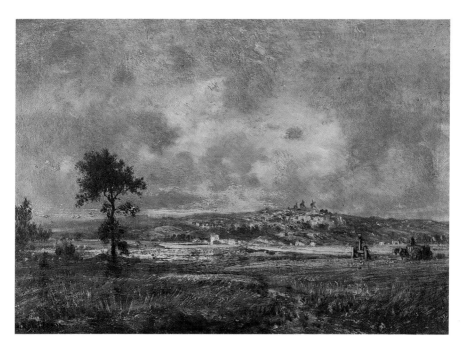

Théodore Rousseau, *Plain of Montmartre*, c.1850 (Musée du Louvre, Paris). Rousseau, nicknamed 'the French Ruysdael', said: 'Our art can only attain pathos through sincerity.' Although pathos was a vestige of Romanticism, a sincere approach to nature was something quite new in art.
Photo H Josse
© *Larbor/T*

skies and rainy, windswept atmosphere, created an overwhelming sense of space and light. They were also remarkable for their exquisite palette and liberal use of paint. *View of the Parterre d'Eau at Versailles* (1826, Musée du Louvre, Paris) is a good example of his art.

Turner is the closest of these English artists to the Impressionists. He is the link between Claude Le Lorrain, to whom he acknowledged his indebtedness, and Monet, on whom he was to have a clear, strong influence in several areas: the use of trains and bridges as motifs, the rendering of light, the blending of land with sky or water, the impression of speed, and the whole craft of creating a magical atmosphere through the blurring and dissolving of forms and the use of iridescent colours.

The Barbizon School

In 1836, Théodore Rousseau moved to Barbizon in the forest of Fontainebleau, not far from the villages of Marlotte and Chailly-en-Brière, which had been the haunts of artists since 1830. He was the most important figure in this group of artists who sought contact with nature as part of their quest for truthful representation.

These artists belonged to the generation born in the early decades of the century: Narcisse Diaz de la Peña (1807-76), Constant Troyon (1810-65), Jules Dupré (1811-89), and Charles Jacque (1813-94). Other painters joined the group, including Charles-François Daubigny (1817-78) and Jean-François Millet (1814-75), who moved to Barbizon in 1849. Even Courbet sometimes came to work there. Under the influence of Dutch

and especially English landscape painting, these artists gradually weaned themselves away from the strictures of traditional landscape painting, as well as from the Romantic concept of the landscape conceived as a reflection of mood or an emotional state. Although they depicted the beauty of nature, they did not idealize it. Each painter had his favourite themes: Rousseau focused on trees and foliage, Dupré on skies, Diaz on forest interiors (using a faceted technique to render effects of glittering light), Troyon on cows and bulls, and Jacque on sheep and hens. They all shared a straightforward approach towards the chosen subject, meticulous and faithful observation of nature, and great attention to the effects of changing light.

These painters worked with their younger counterparts, the Impressionists, at Barbizon, and also at Honfleur, 'the Barbizon of Normandy'.

The Honfleur School

The creation of the Honfleur School coincided with the French discovery of the delights of seaside resorts and sea-bathing. Founded on the initiative of Eugène Boudin (1824-98), it was also known as the Saint-Siméon School after the name of a country inn patronized by the artists and run by la mère Toutain, a farmer's wife. Some of the artists had already worked at Barbizon, such as Diaz, Troyon, Corot, Daubigny and Courbet, who Boudin met in 1859.

In 1858, the young Monet came to take lessons from Boudin, who

Jean-François Millet, *The Gleaners*, 1857 (Musée du Louvre, Paris). Apart from a timeless quality (as seen in the poses of these women harvesters), Millet also sought, in other paintings, to impart a symbolic expressivity to the movements and gestures of his peasant figures.
Photo H Josse
© *Larbor/T*

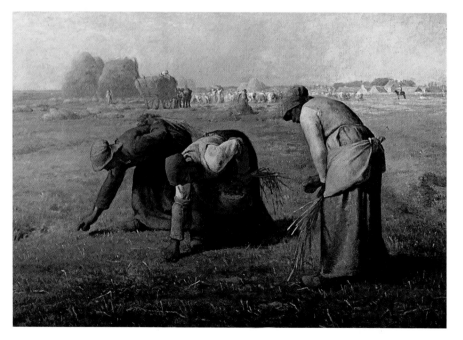

43

LANDSCAPE PAINTING: THE CULMINATION OF A GENRE

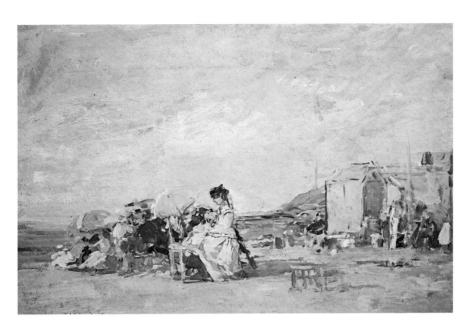

Eugène Boudin, *Lady in White on the Beach at Trouville*, 1896 (Musée des Beaux-Arts, Le Havre). In this landscape, painted late in his career, Boudin remains faithful to his characteristic themes: the beach peopled with middle-class women, the weather and the sky with its myriad hues.
Photo Photorama
© *Larbor/T*

Barthold Jongkind, *Saint-Parize-le-Châtel, near Nevers*, 1869 (Musée du Petit Palais, Paris). This Dutch painter – to whom Monet acknowledged his indebtedness for 'the definitive education of his eye' – was capable of producing watercolours bolder in style than the painting shown here and even bolder than Boudin's watercolours. The art critic Castagnary said of him: 'In his work impression counts for everything.'
Photo H Josse
© *Larbor/T*

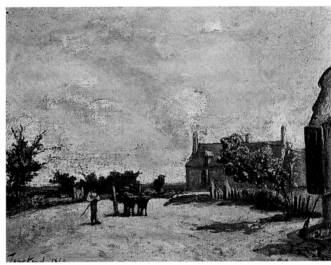

Corot would later refer to as the 'monarch of the skies'. Boudin strove to capture the most subtle variations in weather and atmosphere in his pastel studies, painted entirely in the open air at the seaside. Boudin said: 'Everything that is painted directly on the spot invariably has an impact, a strength and a liveliness in the brushwork that is missing from a painting done indoors in a studio.'

From 1863 onwards, the Dutch painter Barthold Jongkind (1819-91), described by Manet as 'the father of modern landscape painting', came to stay at Honfleur every year. In 1865 he became friends with Boudin, who was to learn from him the spontaneous and fresh sketch-like quality that is so typical of his work. In 1887 Boudin discussed his debt to Jongkind: 'The more you look at these watercolours, the more you won-

LE MARVELLE MEDEV LE POELS MEISSONIER MELANIER MELANIER MILLET MONET MOREAU MORANDI MORRIS MUCHA MUNCH MUNKACSY MUNTINGE NADAR NISBET PAXTON PERRET PISSARRO POTO
JN SORALLA VAN EYCK STEER LE DUC VUILLARD WAGNER WATTS WHISTLER WISBEL BARTSCH BAZILLE BERNARD ANNE BONHEUR BONINGTON BONVIN BRETON BROWN
ON DEGAS DELACROIX EIFFEL ENSOR FANTIN LATOUR FATTORI FLAMENG GAILLE GALLEN-KALLELA GAUDY GAUGUIN GRASSET GUIMARD HAUSSMANN HODLER HOLMANN HUNT

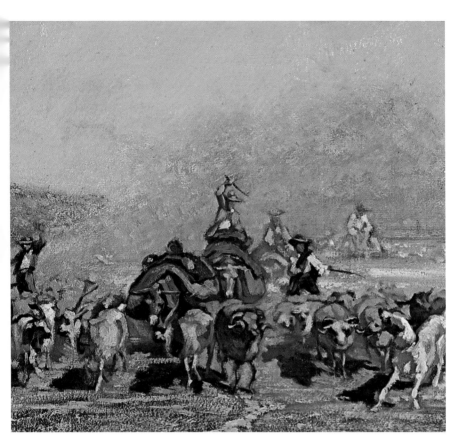

Émile Loubon, *Herd on the Move*, c.1851, detail (Musée Granet, Aix-en-Provence). Loubon was the true founder of the Provence School. An excellent portraitist, he was also a painter of landscapes, in which he showed his extreme sensitivity to variations of weather. He also painted animals. His landscapes, in which he used antithetical colours to convey the sharp contrast between azure blue skies or seas and the greys and ochres of the land, show certain similarities with the early paintings of Cézanne.
Photo © H Ely/T

der how he does it! He does it with nothing, and yet the fluidity and density of the sky and clouds are rendered with incredible precision.'

These painters' investigations into the changing aspects of nature and their practice of painting their studies of weather and light in the open air led to their being called the Pre-Impressionists.

The Provence School

At the same time as the Saint-Siméon School, artists with links to realism and the Barbizon School were experimenting with outdoor painting in the south of France, attempting to evoke the brilliance and intensity of the light there by the use of strong contrasts. Paul Guigou (1834–71) was the most important painter in this group. *The White Road* (1859, Musée d'Orsay, Paris) is characteristic of his style: light colours contrasting with dark areas of shadow, and an impasto technique which would later be adopted by some of the Impressionists. Guigou was a pupil of Émile Loubon (1809–63), who was considered the leader of the Provence School and who was friendly with artists in the Barbizon School, especially Troyon. Loubon declared: 'Look around you, paint the things that

LANDSCAPE PAINTING: THE CULMINATION OF A GENRE

have surrounded you since your childhood, the landscape and the things ... that thrill you.'

The Impressionist landscape

The major innovations of Impressionist landscape painting were out-door painting, the rendering of fleeting aspects of nature – most notably light – and the Divisionist technique.

Daubigny (who from 1857 worked in a studio aboard his boat *Le Botin*) and Boudin are among the immediate forerunners of outdoor landscape painting. However, neither artist had both begun and completed a paint-ing outdoors. The Impressionists no longer countenanced sketches in pencil, watercolour, pastels or even oils to be finished later in the studio. Their mission was to render very swiftly – hence their sketchy, unfinished style – the fleeting aspects of an ever-changing nature. Painting from nature meant leaving the rather dimly-lit interior of the studio and going out with an easel, a canvas small enough to be carried and ready-to-use tubes of paint, whose recent invention meant that artists no longer had to prepare their own colours. The artist set up his easel outdoors, in bright natural light and in accessible and pleasant countryside.

The determination with which artists adopted this new practice of out-door painting demonstrated the extent to which objectivity was now preferred to subjectivity, and visible reality to feeling. Communion with nature was no longer the aim: what was important was to assert the role

Claude Monet, *Wild Poppies,* 1873 (Musée d'Orsay, Paris). Monet produced this painting during his so-called 'Argenteuil period' (1871-8), when his work showed a great freshness of vision. *Photo © Focus/T*

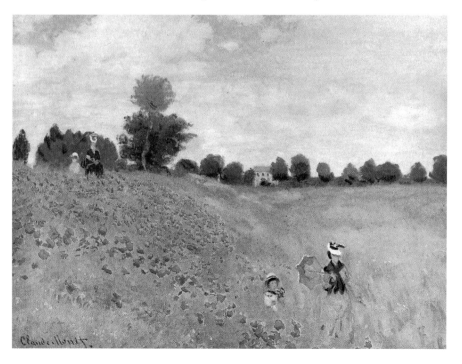

The Impressionist group

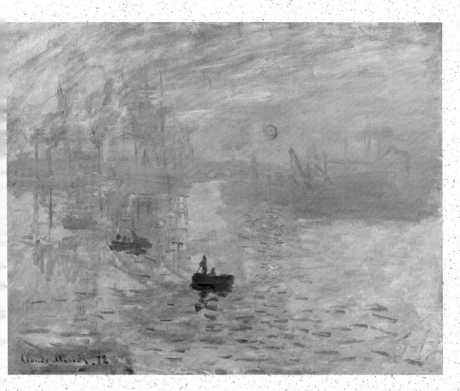

Claude Monet, *Impression, Sunrise*, 1872 (Musée Marmottan, Paris). In his review of the first Impressionist exhibition, the critic Castagnary wrote: 'They are impressionists in the sense that they render not the landscape but the sensation produced by the landscape.' Photo © RMN

During the years 1862-3 two private art schools, the Académie Suisse and the Gleyre Studio, had a number of future Impressionists enrolled among their students: Pissarro, Cézanne, Guillaumin, Bazille, Monet, Renoir and Sisley. Soon Fantin-Latour, Berthe Morisot, Manet and Degas would swell the ranks of this group. After the Salon des Refusés and the scandal surrounding *Le Déjeuner sur l'Herbe*, these artists grouped around Manet. They began to meet regularly at the Café Guerbois at the end of the 1860s, along with writers, critics and other artists, including the photographer Nadar.

It was after the Franco-Prussian war of 1870 and the return from England of Monet, Sisley and Pissarro that the movement began to take shape. Monet settled at Argenteuil with Sisley and Renoir, while Pissarro took up residence in Pontoise (both places are situated on the banks of the Seine to the west of Paris).

Impressionism got its name from a painting by Monet entitled *Impression, Sunrise* (1872, Musée Marmottan, Paris), which was in the first Impressionist exhibition. In his review of the exhibition published in *Le Charivari* on 25 April 1874, the poet and painter Louis Leroy was the first, apparently, to use the term 'Impressionist'. His review was favourable apart from a few minor quibbles.

Not everybody was so favourably disposed towards the movement; indeed quite the reverse was true. Émile Cardon, in *La Presse*, commented scathingly: 'This school of painting does away with two things: line, without which it is impossible to reproduce any form, animate or inanimate, and colour, which gives form the appearance of reality. Smear three-quarters of a canvas with white or black, rub the rest with yellow, dot it with red and blue blobs at random, and you will have an impression of springtime before which supporters of the school will swoon in ecstasy.'

From 1874 to 1886, the Impressionist group organized eight exhibitions. At the beginning of the 1880s, infighting broke out within the group. Monet, Renoir, Caillebotte and Sisley were all absent from the final exhibition.

LANDSCAPE PAINTING: THE
CULMINATION OF A GENRE

of sensation and vision as the basis of human experience. The painter would portray what he perceived 'according to his personal impressions, without paying heed to the generally accepted rules'.

The aim was to render on canvas the fleeting aspects of nature: the damp weather conditions, the bracing air, shimmering or iridescent light, the sea and the horizon, the sun and its rays, the sky and its clouds, a breeze rippling over water, smoke, fog, rain, snow and so forth – all that was sparkling or evanescent in nature, everything that stirred with life and moved. The main purpose of the artist, however, was still the evocation of light, that most ephemeral of elements. This was what drove Monet, following the example of Hokusai, to produce his series of paintings of the same objects (poplars, haystacks, etc), studying the way in which they were transformed by the effect of the changing light at different times of the day and year. It was primarily in the Île-de-France region around Paris and in Normandy, where light changes with amazing swiftness, that Impressionism originated. It developed shortly before the Franco-Prussian war of 1870, but gathered momentum after 1872 and especially in 1874, the date of the first Impressionist exhibition (see 'The Impressionist exhibitions', p.52-3), and continued until 1886.

In order to achieve their aim, the Impressionists had to try to find a technique which would enable them to render quickly the fluctuating rhythms of nature transmitted to them through their senses.

First, painting outdoors where they were dazzled by the intense light, they were inspired to use light, vivid colours. Manet was the first to use a palette of brighter primary colours and to stop mixing colours on the palette as the Romantics had done. He used a deliberately restricted range of colours and played off a variety of light shades against each other with great skill, as exemplified in *Olympia*. He also abandoned relief and chiaroscuro, but it was not until he came into contact with the Impressionists that he dropped black from his palette altogether. Black was rejected as it no longer effectively rendered shadow, as shadows were tinged with colour too. Greys and browns were also dropped.

Next, in order to convey a sense of movement and transformation, the Impressionists began to use broken brushstrokes and juxtapose pure colours. Colours were no longer mixed on the palette, but were allowed to interact according to two principles: the optical blending of colours and the principle of simultaneous contrast. The Impressionists used the three primary colours – red, yellow and blue – as well as their complementary colours – green, violet and orange – and finally white. Applied to the canvas in juxtaposition, primary colours were more vivid: violet, for example, could be suggested by patches of red and blue. By the same token, if two complementary colours, such as blue and orange, or two secondary colours, like orange and green, were applied in juxtaposition, they enhanced each other. However, in accordance with the principle that every colour tinges the area around it with the hue of its comple-

ABRAHAM HUNSE ALERT RECHTNOW VANNUKELE VINN VN NELLE FLUBE ROLL CHALLARD VARKER WALTER WHISTLER ASHGAT NOWLER DU BAZILE BERNARD BONA JA ANS MANDELL GUMEDER WANG REWELL NERS WELLE SULK ERGER EUGENE FANTAN LATELI ANTAN ELANEN MORISON IMPRE MONET MORISOT RED GAM ODILLE DELACROIX GUMELE WEDGE PALL HUNTEN ANTON UNGULAM OFF ADAM WATTS AND CREST KON EST BELLE MONELLE BOMALO LU ERINGER MUREL WANT HODLER HOLM HANN HOKUS

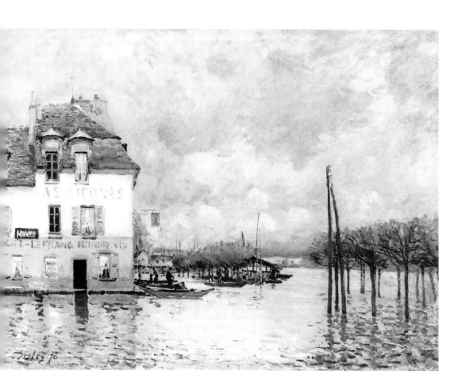

Alfred Sisley,
Flood at Port Marly,
1876 (Musée d'Orsay,
Paris). Sisley strove to
capture the effects of
the sky and light on
water or snow, as in his
painting *The Place du
Chenil at Marly.*
Photo © Agraci/T

mentary colour, the effect of yellow, for example, introduced into a composition dominated by green or orange, was toned down by the juxtaposition of the two colours.

These principles, which the Impressionist painters discovered instinctively but which had already been established scientifically by Isaac Newton and Michel-Eugène Chevreul, represented more than just artistic method. The Impressionist technique, for all its brilliance, should not be allowed to overshadow the thematic content of the landscape genre – the genre of choice for these painters. Their landscapes were meaningful paintings that reflected the transformations in people's lives that had come about as a result of the industrial revolution.

Themes and images

Impressionism was the art of Parisians, city dwellers who appreciated the attractions of urban living but who were equally sensitive to the beauty of the countryside. The countryside in their case meant the countryside of the Île-de-France region, and more specifically the modern suburbs surrounding Paris. Broadly speaking, two main trends can be identified in the way this is depicted in Impressionist paintings: the first consists of images of the modernization of France, as in the work of Claude Monet (1840-1926), Alfred Sisley (1839-99) and Auguste Renoir (1841-1919); while the other consists of images conveying the timeless-

49

THE LANDSCAPE PAINTING: THE CULMINATION OF A GENRE
LANDSCAPE PAINTING: THE CULMINATION OF A GENRE
PAINTING: THE CULMINATION OF A GENRE
THE CULMINATION OF A GENRE
ON OF A GENRE LANDSCAPE
APE PAINTING THE
GENRE LANDSCAPE PAINTING
THE CULMINATION OF A GENRE

LANDSCAPE PAINTING: THE CULMINATION OF A GENRE

Alfred Sisley,
The Place du Chenil at Marly, 1876 (Musée des Beaux-Arts, Rouen).
Photo Ellebé © Larbor/T

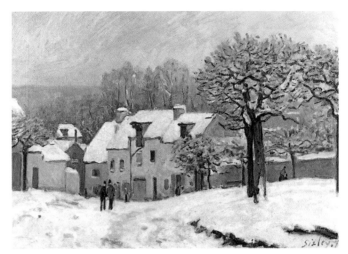

ness of tradition, as in the work of Camille Pissarro (1830-1903) and his disciples Paul Cézanne (1839-1906) and Paul Gauguin (1848-1903).

Reacting to the visible world with disconcerting straightforwardness, the Impressionists chose to paint the places most visited by tourists and that were described in detail in the tourist guides. Richard Brettell, writing in the catalogue for the exhibition Impressionism and the French Landscape (1984-5), comments: 'Sometimes the description in a guide and the scene in an Impressionist picture match so perfectly that it is hard to believe the painter was unaware of it.' However, it was not photographic accuracy that the Impressionists were seeking; rather, they structured their landscapes so as to achieve a balanced composition.

The Impressionists not only portrayed these tourist sites but also the various means of transport that brought the tourists to them. These had developed considerably since the middle of the century: they depicted roads and bridges, rivers, trains and boats – in short, they were interested in everything and anything that involved movement and travel, which in itself involved a sense of time. Thus, Impressionist landscape painting is also evidence of the consciousness of time, in a period when the speed of industrialization was challenging the way people thought.

On the other hand, the image of traditional France presented in the work of Pissarro is characterized by timelessness: fields, orchards, village streets, harvests, peasants with their carts and animals, cottages and so on. This is the image of an agricultural France (in 1846, France had a rural population of 75 per cent, a figure that would drop to 56 per cent by 1911), remote from the modernization process. Pissarro does not show in his paintings any of the technological inventions which were already beginning to make farm work easier. In his pictures, the countryside is seen not so much as an antidote to urban life as a rural culture with enduring traditions, increasingly at odds with a rapidly changing, newly industrialized France. The countryside is viewed in terms of a return to the origins of man, to a simpler way of life – something that would reach

FRANCE LA GUERRE DAUDE DAUMIER DAUMIER DEGAS DELACROIX DETTE ENSOR FANTIN LATOUR FATTORI FLAMENG GAILLE GOTH DER HEIGHT KLIMT KUZLO HANNALK KIRCHEN KELIO MARVILLE METER GRAEFE MEISSONIER MILLNER MODEL MONET MOREL NORMAND HORTES MLALICIAL TRENNBAHOU KLIMER ASHLEY CASTLE GAUDIN GAULLIN KRAZER KUTH HIDRAS DELACROIX EIFFEL ENSOR FANTIN LATOUR FATTORI FLAMENG GAILLE GALLIEN RATEERA GAUDI GAUGUIN GRASSET GUIMARD HARSMAN VAN HODLER HOFFMANN HORN

its culmination in the work of Gauguin.

The countryside might be characterized by time, but the city was characterized by space. As in Dutch 17th-century painting, the urban landscape was depicted in such a way as to be reminiscent of the countryside. In their paintings of Paris, the Impressionists did not show the modernization process as represented by the ubiquitous building sites, but focused instead on the attributes that made the city a modern capital. Before 1890, no historic buildings or monuments feature in paintings of Paris: they might be just glimpsed on the banks of the Seine or picked out in the distance in panoramic views of the city, but that is all. In contrast, it is the recent structures that stand out: railway stations, in particular the seven paintings of Saint-Lazare Station executed by Monet in 1877; bridges, such as the Pont de l'Europe of which Caillebotte was so fond and which Manet also painted; newly constructed or widened boulevards with their long, open vistas, like the Avenue de l'Opéra, which had been inaugurated in 1878 following the completion of the Opera House in 1874, and which was painted by Pissarro; and the main boulevards and squares with their hurrying crowds which so interested Monet and Pissarro. Around 1890, Rouen seems to have become popular with the Impressionists, especially with Pissarro, Sisley and Monet, who produced his series of paintings of the cathedral façade. Although all three artists painted towns and cities, it is Pissarro, the most 'rural' among them, who can nevertheless be considered the 'master of the urban landscape'.

Gardens, part of both city and countryside, are an important theme in Impressionist landscape painting. As with railway stations and roads, their

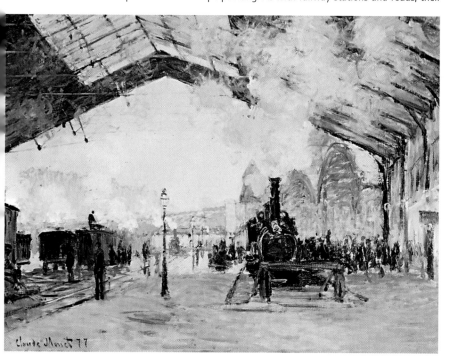

The Impressionist exhibitions

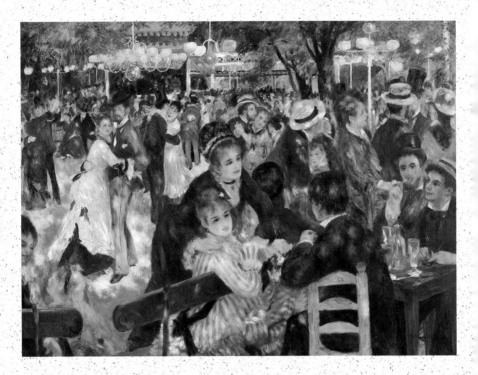

Auguste Renoir, *Dance at the Moulin de la Galette*, 1876 (Musée d'Orsay, Paris). This picture – painted 'entirely in situ' according to Georges Rivière, Renoir's friend and biographer – was shown at the third Impressionist exhibition, after which it was probably bought by Caillebotte. The Moulin de la Galette was a popular Sunday afternoon venue in Paris, and in this painting Renoir conveys the gaiety of the atmosphere there. *Photo © H Lewandowski/RMN*

1874. First exhibition: Artists whose works have been rejected by the Salon form a co-operative and hold an exhibition of their paintings in a studio formerly used by the photographer Nadar at 35 Boulevard des Capucines in Paris. Among the 30 artists whose works are on display are Boudin, Bracquemond, Cézanne, Degas, Guillaumin, Monet, Berthe Morisot, Pissarro, Renoir, Sisley and the Italian de Nittis. Among those who refuse to take part in the exhibition are Corot, Fantin-Latour, Jongkind and Manet.

1876. Second exhibition takes place at the Durand-Ruel Gallery at 11 Rue Le Peletier. Among the 18 artists featured are Caillebotte, Degas, Monet, Morisot, Pissarro, Renoir and Sisley. Cézanne refuses to take part.

1877. Third exhibition takes place at 6 Rue Le Peletier. The 18 artists featured include Caillebotte, Cézanne, Guillaumin, Monet, Morisot, Pissarro, Renoir and Sisley.

1879. Fourth exhibition held at 28 Avenue de l'Opéra. From now on they call themselves 'independents'. The 15 artists featured include Bracquemond, Caillebotte, Degas, Monet, Pissarro and the American Mary Cassatt. Renoir exhibits his work at the Salon, where he enjoys some success.

1880. Fifth exhibition takes place at 10 Rue des Pyramides. The 18 artists taking part include Bracquemond, Caillebotte, Cassatt, Degas, Gauguin, Guillaumin, Morisot and Pissarro. Cézanne, Monet, Renoir and Sisley, who all exhibit works at the Salon, decline to take part.

1881. Sixth exhibition is held at the same address as the first exhibition, but in a vacant apartment in an annexe at the back of the courtyard. It is organized by Degas and Pissarro, who takes over as leader of the group after Monet's defection. The 13 artists featured include Cassatt, Degas, Gauguin, Guillaumin, Morisot and Pissarro. Cézanne, Monet, Renoir and Sisley are among those who decline to take part.

The journalist Jules Claretie, writing in *La Vie à Paris*, remarks: 'The most original aspect of these revolutionaries' work is the white frames around their paintings, the gilt frames having been consigned to the painters of the old school.'

1882. Seventh exhibition takes place at 251 Rue Saint Honoré, in premises

rented by Durand-Ruel. Nine artists exhibit their work: Caillebotte, Gauguin, Guillaumin, Monet, Morisot, Pissarro, Renoir, Sisley and Vignon.

1886. Eighth and last exhibition is held at 1 Rue Laffitte. Impressionist, Neo-Impressionist and Symbolist paintings are all featured side by side. The 17 artists participating in the exhibition include Bracquemond, Cassatt, Degas, Gauguin, Guillaumin, Morisot, Pissarro and his son, Redon, Seurat and Signac. Monet and Renoir do not take part.

The Impressionist exhibitions were not those of a united group: as early as the fourth exhibition one member defected and was to be followed by others when the Salon opened its doors to them. Manet never exhibited with the Impressionists, while Degas was always very much involved in the group.

The exhibitions also provided an opportunity for experimenting with the way paintings were hung and framed. In the Salon as well as in museums, paintings had always been displayed in gilt frames and hung one beside the other so that they covered the entire surface of a wall. Renoir, who was particularly interested in the matter of how pictures should be framed and hung, took charge of the hanging of the first Impressionist exhibition. In 1899, Signac was to write in his book *D'Eugène Delacroix au Néo-Impressionisme*: 'The Neo-Impressionists have rejected the gilt frame, whose garishness either alters or destroys the harmony within a picture. They generally use white frames, which create a clear transition between the painting and the wall on which it is hung, and which enhance the saturated colours without disturbing their harmony. [...] A picture bordered by one of these white frames ... is, for this reason alone, immediately and without any further examination excluded from the official or pseudo-official Salons.'

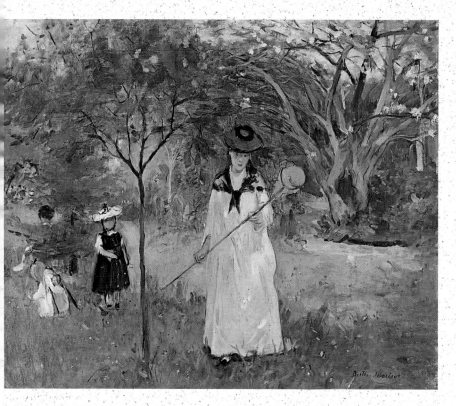

LANDSCAPE PAINTING: THE CULMINATION OF A GENRE

presence in the paintings shows the importance that gardens had acquired in people's everyday lives since the Second Empire. Of all public parks and pleasure gardens, the most famous were the Tuileries, the 'true garden of Paris' and centre of its life, and Giverny, between Paris and Rouen, the 'garden of colours and tones' that Monet had created at his country estate and which he painted from 1883 until his death. Renoir also excelled at painting ornamental gardens both in Paris and in the countryside.

History was no more evident in paintings of urban settings than it was in paintings of rural landscapes. The Impressionists were not concerned with the past; they concentrated on the visible and the present. Their landscapes chronicle the changes wrought by man's influence, not the heroic events of history. It was this focus on real life that earned them the disdain of their contemporaries, but from the beginning of the 20th

Claude Monet, *Water Lilies* (fragment), 1916-22 (Musée de l'Orangerie, Paris). Commissioned for the state by Georges Clemenceau, this painting is displayed in the oval room on the ground floor of the Musée de l'Orangerie. Monet had been living at Giverny since 1883 and was passionately attached to his garden. In the paintings that he did towards the end of his career, flowers were still treated in a Japanese manner, but depicted in a style that some consider tired and others musical. *Photo © Giraudon/T*

century this initial unpopularity was superseded by a triumphant success which has continued to this day.

The 'Macchiaioli'

Of all the schools of landscape painting in Europe in the latter half of the 19th-century, the Italian School appears to have made the most original contribution to the genre. Between 1855 and 1870, a group of artists developed an aesthetic that was distinct from that of the Impressionists but which did share some similarities, specifically the importance accorded to landscape, the practice of outdoor painting and the use of a light palette.

Like their French contemporaries, these artists, who gathered at the

LANDSCAPE PAINTING: THE CULMINATION OF A GENRE

Michelangiolo café in Florence in 1866, rejected academicism, historical themes and sentimentality. They advocated 'a scrupulous and precise observation of the infinite forms and aspects of the contemporary world'. In their landscape paintings – as well as in paintings depicting middle-class life and the history of modern Italy – they used a technique of juxtaposing *macchie* or 'patches' of sharply contrasting colours. This synthetic procedure, originally used by history painters to sketch out their paintings, was totally invisible in the finished painting, as was all trace of the artist's brushwork. The Macchiaioli (those who used *macchie*) developed this technique through direct contact with nature, and created a vigorous style, described at the time as 'purist', to express their original vision.

The two most important painters of this school were Giovanni Fattori (1825-1908) and Silvestro Lega (1826-95), but mention must also be made of Giuseppe Abbati (1836-68), Raffaello Sernesi (1838-66), Odoardo Borrani (1833-1905), Telemaco Signorini (1835-1901) and Vincenzo Cabianca (1827-1902).

The purist aspect of the paintings done by the Macchiaioli derived from the Purismo movement which existed in Florence between 1848 and 1859, and which had itself been influenced by the aesthetics of the Nazarenes, an early-19th-century association of German artists who had settled in Rome. Wishing to create a religious and patriotic foundation for art, the Nazarenes modelled themselves on Dürer, Raphael and the Italian primitives, in particular Fra Angelico. Their influence was important throughout Europe.

Whether the Macchiaioli anticipated the Impressionist movement or

Silvestro Lega,
The Pergola, 1868
(Pinacoteca di Brera, Milan).
Exhibited in the same year it was painted and with the title *After Luncheon,* this is considered to be one of the artist's most important paintings. It is remarkable for the delicate balance it achieves between the purist rigour of the composition and its marvellous evocation of light.
Photo © Fabbri-Artephot/T

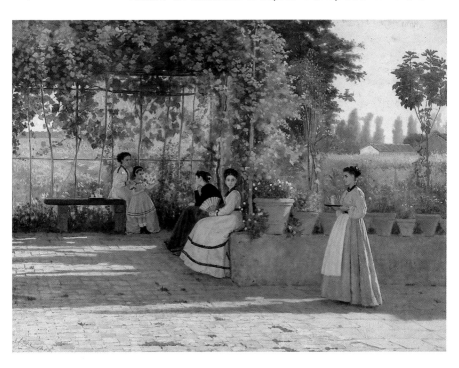

THANE TAGLIE BACCIO DAUM THOMA DEGAS DELACROIX DEGAS DELACROIX NINI CEZANNE GAUGUIN GAUGUIN GAUGUIN GRASSET
CARMEN METZINGER BAKST FRIESZ VLAMINCK MILLET MONET MOREAU MONET MORISOT MIGNON MICHALLON LAGRANGE KUPKA ANGELICO SCHUFFENECKER
RODIN DELACROIX EIFFEL ENSOR MARTIN LATOUR FATTORI FANTIN MILLET GALLE UN LEHMBRUCK GAUGUIN GAUGUIN GROSSET GOYA KEE HASSAM HODLER HOFFMANN HORTA

Giovanni Fattori,
The Palmieri Rotunda,
detail, 1866 (Pitti
Palace, Galleria d'Arte
Moderna, Florence).
The rotunda, now
defaced, is located in
the Villa Palmieri at
Livorno. This painting
is characteristic of the
macchia technique,
employing a harsh,
synthetic style to
render chiaroscuro. The
journalist Diego
Martelli wrote to
Fattori in around 1878:
'The Impressionists
always paint in a range
of light and luminous
colours, but we used
this *macchia* for its
chiaroscuro effect.'
Photo Scala © Larbor/T

followed it is a matter of ongoing debate among art historians. In any event, after 1870 the group broke up, just as the Impressionists were forming their own artistic principles. Only Degas, who had met them in Florence between 1856 and 1860, was acquainted with their paintings. In the 1870s he renewed his acquaintance with the Macchiaioli during their visits to Paris; his portrait of the writer and art critic Diego Martelli (1879, National Gallery of Scotland, Edinburgh) is evidence of this. Martelli was among those who helped to publicize the artistic principles of both the Macchiaioli and the Impressionists.

The art of the Macchiaioli was only discovered by the French public when an exhibition of their work was held in 1978. But it has had a huge influence on Italian film makers, especially Luchino Visconti and Mauro Bolognini, for whom it was an invaluable source of imagery and visual language.

Nature and the mind, or landscape painting after 1880

In the 1880s, and especially after 1885, a new, more cerebral approach to landscape painting emerged, one in which analytical considerations began to prevail over the evocation of visual impressions. Two new

Vincent Van Gogh

Cornfields with Flight of Birds, 1890 (Rijksmuseum, Amsterdam).
This picture was Van Gogh's very last painting, done in July 1890 at Auvers-sur-Oise.
Photo © A Held/Artephot

1853. Vincent Van Gogh is born in Groot-Zundert (North Brabant) in the Netherlands, the son of a clergyman. In 1857 his brother Theo, with whom he would correspond throughout his life, is born.

1880. After working in France, England and the Netherlands, he decides to dedicate himself to art and begins to copy Millet.

1880-6. In the Netherlands, he paints strongly realist paintings (*The Potato Eaters*). From 1883 to 1885, he studies the work of Cormon, Delacroix, Rembrandt and Hals, and produces over 200 oil paintings.

1886. He goes to Paris, where, after spending a few months in Cormon's studio, he meets Toulouse-Lautrec, Émile Bernard and the Impressionists. He lightens his palette and becomes interested in Neo-Impressionist and Cloisonnist techniques, before discovering Japonism.

1887. He meets Signac and makes frequent trips to Asnières, north-west of Paris, to paint with Émile Bernard.

1888. In February he leaves Paris for Arles in the south of France, where he works intensively and discovers, on his walks in the countryside, the motifs that are closest to his heart.

In August, the theme of sunflowers appears for the first time in his paintings. Gauguin joins him at Arles in October. A few months later, they quarrel violently. Van Gogh cuts off his left earlobe; Gauguin goes back to Paris. Shortly afterwards, Van Gogh is hospitalized at the asylum in Saint-Rémy-de-Provence. He paints several self-portraits which show his mutilated ear (*Self-Portrait with Bandaged Ear and Pipe*; *Self-Portrait with Bandaged Ear*).

1889. Van Gogh returns to his lodgings at the Yellow House in Arles. Thereafter he is readmitted to hospital and discharged again at frequent intervals. Following another breakdown, Van Gogh tries to poison himself by swallowing paint. He paints *Irises* and *Starry Night*.

1890. In May, he visits Doctor Gachet at Auvers-sur-Oise. He dies there on 29 July, having shot himself with a revolver two days earlier.

Van Gogh exerted a complex influence both on the artists of his day and on those of the 20th century. He taught the Fauvists how to use vivid colour as a basic element of construction, and bequeathed to the Expressionists the idea of the symbolic role of colour.

Two Little Girls, 1890
(Musée d'Orsay, Paris).
*Photo © H
Lewandowski/RMN*

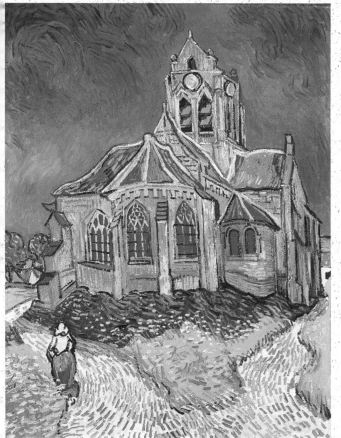

*Church in Auvers-sur-
Oise*, 1890 (Musée
d'Orsay, Paris).
Photo © Dagli Orti

LANDSCAPE PAINTING: THE CULMINATION OF A GENRE

Paul Signac, *The Port of Saint-Tropez*, 1894 (Musée de l'Annonciade, Saint-Tropez). Signac was an early convert to Impressionism and subsequently to Divisionism, becoming its theoretician. In this picture he applies Seurat's method, but uses thicker brushstrokes.
Photo Jeanbor
© Larbor/T

Georges Seurat, *The Bec du Hoc at Grandcamp*, 1885 (Tate Gallery, London). This seascape is typical of Seurat: the sea is calm and the forms are firmly delineated by contours. In this painting he sensitively applies the theory of the simultaneous contrast of colours and forms, and the technique of division using individual brushstrokes – a technique wrongly referred to as 'pointillism'.
Photo E Tweedy
© Larbor/T

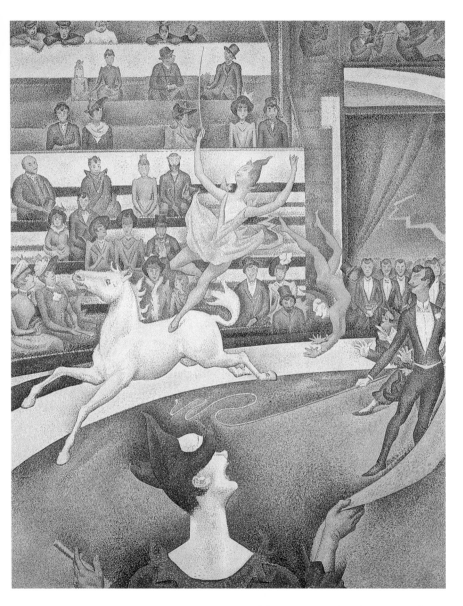

Georges Seurat, *The Circus*, 1891 (Musée d'Orsay, Paris). When *The Circus* was submitted to the Salon des Indépendants in 1891, it was unfinished. It was destined to remain unfinished as Seurat was struck down by illness and died a few days after the exhibition opened. Considered as the leader of the Neo-Impressionist move-ment, Seurat wanted to discover a 'logical, scientific, pictorial' system that would make the compositional lines in a picture correspond harmoniously with the nature of the subject. Here, the diagonal lines in the painting suggest gaiety and movement. *Photo © RMN*

approaches appeared. In the first, belonging to the 'logical' side of Impressionism, artists (the Neo-Impressionists) sought to restore a structured look to landscape and to emphasize its timeless attributes: this was accomplished essentially in the work of Cézanne. In the second, artists saw landscape in terms of the representation of an idea: this would be the approach of the Symbolists.

This new generation of artists did not reject the visible world, rather they looked for the element of timelessness within it. They carried out their experiments far away from Paris and urban life, so they could be more closely in touch with nature; they retreated into isolation and concentrated on their artistic struggle.

The painters concerned were as follows: in the south of France, Vincent Van Gogh (1853-90), Cézanne, Paul Signac (1863-1935) and Henri-Edmond Cross (1856-1910); in Brittany, Georges Seurat (1859-91) and Gauguin; in Norway, Edvard Munch (1863-1944), who withdrew to Asgardstrand on the Oslo fjord in order to paint in seclusion; in Ostend, the Belgian James Ensor (1860-1949); in the Swiss Alps, Giovanni Segantini (1858-99) and Ferdinand Hodler (1853-1918); and in Tahiti, Gauguin, who was eventually to settle there. Their self-imposed exile was regarded by the artists as a return to the very essence of nature. For Gauguin, this interest in the essence of things was not only a return to nature but a return to the origins of man, to the 'primitive'.

In France, it was the painters closest to Pissarro – a great draughtsman, preoccupied with form – who reaffirmed the importance of drawing in landscape painting. Seurat benefited from Pissarro's advice, and Cézanne and Gauguin trained under his mentorship at Pontoise.

As a reaction to the blurring of form that had resulted from the importance given to vibrant colour by the Impressionists, Seurat – one of the great 19th-century masters of black-and-white drawing – reaffirmed the value of drawing, the expressive power of the line and the need for structure. In 1886, at the final Impressionist exhibition, he exhibited *Sunday Afternoon on the Island of La Grande Jatte* (The Art Institute, Chicago), which was immediately hailed as heralding a new movement: Neo-Impressionism. Before this, after his *Bathers at Asnières* (National Gallery, London) had been rejected by the Salon in 1884, Seurat, together with Signac and Odilon Redon (1840-1916), had founded the Society of Independent Artists. He became the leading figure in the Neo-Impressionist movement, which also included Signac and Cross, among others.

In the beautiful and serene seascapes of *Port-en-Bessin* (1888, Minneapolis Institute of Arts), for example, where the forms are closely delineated by contours, he rigorously applied the theory of the simultaneous contrast of colours and the technique of division using individual brushstrokes. Signac learned this technique from Seurat, and referred to it as 'divisionism' in his study published in 1899, *D'Eugène Delacroix au Néo-Impressionisme:* 'Neo-Impressionist painters do not use dots, they

Paul Cézanne

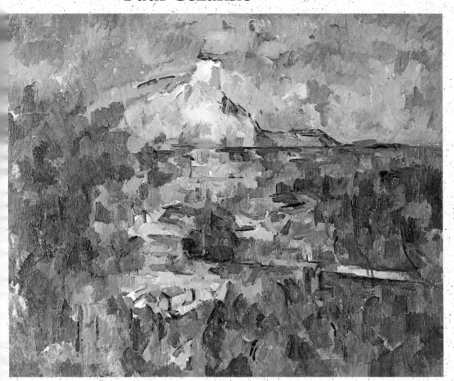

Mont Sainte-Victoire, 1904-6 (Kunstmuseum, Basel). Cézanne was one of the greatest masters of French painting, paving the way for modern art and in particular Cubism and Fauvism. However, he never had any of his paintings accepted by the Salon – much to his regret, for he would have liked to have been acknowledged as a serious painter by Aix society and no longer dismissed as the son of a middle-class family indulging a whim. *Photo © Hinz/T.*

Apples and Oranges, c.1895-1900 (Musée d'Orsay, Paris). Still life offered Cézanne the opportunity to express what he referred to as his 'sensation before nature'. The subjectivity of viewpoint is reflected in the distorted effects of perspective created by the painter. An element of chromatic tension results from the use of pure colours. *Photo © Dagli Ort*

1839. Paul Cézanne is born in Aix-en-Provence, the son of a hatmaker turned banker, who will ensure that his son enjoys financial security for most of his life. At the Collège Bourbon Cézanne becomes friends with Émile Zola but ends the friendship with him in 1886 when Zola's novel *L'Œuvre* is published, having recognized himself in the character of the failed painter.
1861. After starting on a law degree, he decides to dedicate himself to painting and goes to live in Paris.

There he meets the future Impressionists, regularly attends their gatherings at the Café Guerbois and takes part in the first Impressionist exhibition.
1872-82. He lives mainly in Paris or in the Paris region, at Auvers-sur-Oise.
1882. He moves to Aix-en-Provence.
1895. His reputation among younger artists begins to grow.
1904. The Autumn Salon holds a small retrospective exhibition of his work.
1906. Cézanne dies of pleurisy.

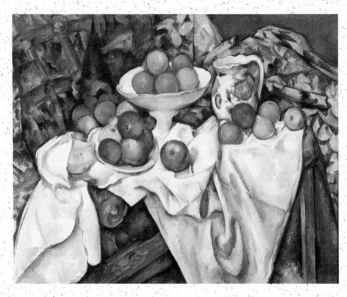

use division. Division provides all the advantages of luminosity, colouring and pure harmony through:

- the optical blending of exclusively pure pigments (all the colours of the prism and all the tones);
- the separation of the various elements (local colours, colours used for lighting effects, colour relationships, etc);
- the balance of all of these elements and their proportions (according to the laws of contrast, the gradation of colours and irradiation);
- the choice of a brushstroke proportionate to the size of the painting.'

This reaffirmation of the importance of form in the representation of landscape, achieved through an intellectual approach and designed to express the dimension of timelessness, was to be Cézanne's overriding concern. As he saw it, 'the eye and the brain [...] need to help each other, you have to nurture them together, but in a painter's way: the eye by looking at things through nature; the brain by the logic of organized sensations which provide the means of expression'. Cézanne continued to work on making the visible 'solid' and 'durable'. He was one of the few painters of his generation to continue to paint outdoors.

Cézanne had a special attachment to Mont Sainte-Victoire near Aix-en-Provence, of which he did a whole series of paintings from 1885. He wanted to 'do Poussin again, from nature', as he put it, and he can thus be seen to belong to the French tradition of constructed landscape painting. His concern with colour, inherited from the Impressionists, was matched by a concern with form: 'When colour is at its richest, form is at its fullest'. In fact, Cézanne, who once said that 'landscape receives its form through my thoughts, and I am its consciousness', dropped the Impressionist technique: he abandoned the division of tones, extended his palette, nuanced his colours and modulated them according to the form of the object and the light falling on it. He used lines of colour to build up the structure and space of the landscape. Cézanne's art, with its rigorous balance between colour and form, was to give rise to two major artistic movements of the early 20th century: Fauvism in terms of colour, and Cubism (Picasso, Braque) in terms of structure.

The Symbolist landscape

Towards the end of the 1870s, at the same time as this new type of landscape painting with its reaffirmation of the values of drawing and structure was coming to the fore, another was developing: Symbolist landscape painting.

The Symbolist landscape was characterized by a subjective relationship to nature, with which the artists sought to achieve union. However, the Symbolists – who, as we shall see, wanted to convey feeling or ideas through symbols – did not attempt to penetrate nature's mysteries in the

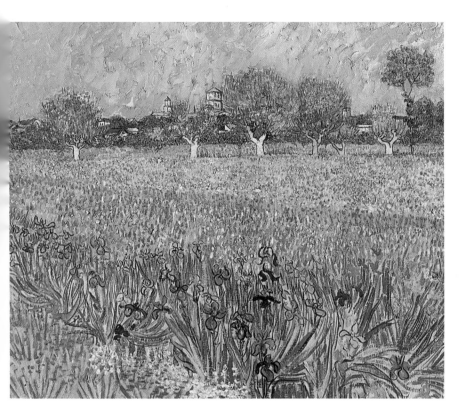

Vincent Van Gogh,
View of Arles with Irises,
1888 (Rijksmuseum,
Amsterdam). Five
months after Van Gogh
moved to Arles,
Gauguin came to join
him. Van Gogh had
moved there because
he wanted to see 'a
different light' in order
to acquire 'a more
accurate idea of the
way the Japanese feel
about things' and to see
colours unaffected by
mist. This central
concern with colour led
him to invest it with a
symbolic meaning.
*Photo © Éditions
Hazan/T*

way the Romantics did. They did not seek to commune with nature in the way that painters of the Barbizon School had done. The latter, while trying to preserve an objective vision of nature, still had a tendency to identify with nature and to project their emotions onto it, emotions which nature in turn reflected back to them. However, although it derived from this concept of nature and recorded a deep bond between the painter and nature which necessitated a kind of asceticism and withdrawal from urban life, the Symbolist landscape did not imply the same sense of communion with nature. Nature certainly remained the basis of experience, but the intellectualization of nature played an increasingly more important role; to such an extent that Gauguin painted 'from his imagination' and Munch was able to declare: 'I painted from memory'. Although artists retained their close contact with nature, they no longer painted out of doors as a matter of course, and they never painted quickly. For them, it was no longer a fleeting impression that painting was intended to convey, but rather an idea, a spiritual experience, something essential. Painting involved a kind of meditation which might lead to an exploration of a metaphysical nature. Beyond the realm of the visible, landscape hinted at a subjective reality rooted in the essence of things and in the innermost identity of the human being. It thus conveyed personal or spiritual meanings, albeit tending towards universality.

In this type of painting, the relationship with nature appears paradox-

ical, especially in comparison with the Impressionist landscape. It is more intimate and more profound in a sense, but at the same time more remote, since the process of intellectualization inevitably creates a distance. While the Impressionist landscape was inhabited by man – even if man did not explicitly feature in it, details such as a bridge or a house indicated his existence – the Symbolist landscape seems to be uninhabited, even if it does sometimes include a human presence. It is a landscape that has been constructed so as to elicit an emotion from the viewer and thus to transmit an idea or a feeling which is part of the artist's world view – a world view which, in the case of the Symbolists, was frequently pessimistic, in contrast to the positivist *joie de vivre* of the Impressionists.

Paul Sérusier, *The Talisman* (*Landscape of the Bois d'Amour, Pont-Aven*), 1888 (Musée d'Orsay, Paris). Maurice Denis described this painting as a 'landscape that seemed crude because of its synthetic formulation in purple, vermilion, Veronese green and other pure colours – straight out of the tube'.
Photo © Giraudon/T

The interaction that takes place between the artist and the viewer of the landscape is, in effect, a meditation on life and death; as for example in Segantini's *Death* (the third painting in the *Triptych of Nature*, 1896-9, Segantini Museum, St Moritz) and *Love at the Fount of Life* (1896, Milan), or Hodler's *Night* (1890, Berne) and *Spring* (1907-10, private collection), which symbolizes the vital forces of nature. The meditation on death is accompanied by silence, the silence akin to death or eternal rest that only the Symbolists defined in this manner, as for example in *The Isle of the Dead* (1880, Leipzig) by Arnold Böcklin (1827-1901).

The silence of nature and the sea echoes man's solitude. Man must face his destiny alone. In this solitude, he experiences the kind of despair portrayed by Böcklin in *Villa by the Sea* (1878, Winterthur) or the anguish of a man who had hoped to fulfil his dreams, as in Munch's *Moonlight* (1895, Oslo).

Sometimes Symbolist landscapes are imbued with a sensibility bordering on the religious, as with the paintings of Segantini, for whom nature offers a means of obtaining salvation. More often, the landscape evokes metaphysical issues: man faced with infinity, his place in nature's scheme, his role in creation.

Apart from such metaphysical concepts, these painters sometimes expressed other themes or concerns: for example, a sense of the poetic, as in the work of James McNeill Whistler, the American artist who moved to Paris, became friends with Courbet, Henri Fantin-Latour and Manet, before settling in London in 1863, and whose *Nocturnes* – views of the Thames heavily influenced by Japanese art – have a subtle and delicate poetic charm; or a purely visual 'sensation of colour', as the artist

Maurice Denis (1870-1943) commented in reference to *The Talisman*, a small landscape painted by Paul Sérusier (1863-1927) at Pont-Aven, under Gauguin's supervision, on the lid of a cigar box. This picture became the emblematic painting of this generation of artists, known as the Cloisonnists, around whom another group was to form: the Nabis or the 'prophets'. Denis quoted Sérusier's exact words: '"How do you see this tree," Gauguin had said, standing in a corner of the Bois d'Amour. "Is it really green? Use green then, the most beautiful green on your palette. And that shadow, blue? Don't be afraid to paint it as blue as possible"'. Denis added: 'Thus we learned that every work of art was a transposition, a caricature, the impassioned equivalent of a sensation experienced.'

Although the stylistic unity that was characteristic of Impressionist landscapes tends to be absent from Symbolist landscape paintings, several common features can nevertheless be identified.

Colour plays a important role, being charged with symbolic value. Towards the end of his life, and especially in the landscapes he painted at Arles, Van Gogh defined the symbolic purpose of colour. He continued to paint from nature while at the same time endeavouring to 'extract the essential from that which constitutes the immutable character of the countryside'. Wrestling with the paint, which he applied to the canvas 'in thick patches, in swirls, in blobs, in dots, in streaks', he assigned an emotive role to colour: 'I have used red, green and blue in an attempt to express the terrible passions of human nature.'

But colour, also described by Ferdinand Hodler (1853-1918) as 'an element charged with emotion', was not generally allowed to take precedence

Ferdinand Hodler,
Evening over Lake Geneva, 1895
(Kunsthaus, Zurich, on loan from the Gottfried Keller Foundation). Although not exclusively a painter of landscapes, Hodler had a fondness for the genre and demonstrated particular originality in it. He believed that 'in a landscape, you can express an elevated human feeling through the immensity of space.'
Photo © W Dräyer/T

over form. It should be remembered that in the last two decades of the 19th
century the major preoccupation of artists was how to mitigate or even do
away with the antagonistic relationship between form and colour; as for
example in the work of Van Gogh, Gauguin, Ensor and Munch.

It was Gauguin and Émile Bernard (1868-1941) who, at Pont-Aven,
found a new solution to this problem: Cloisonnism (from the *cloisonné*
enamelling technique where thin strips of metal are used to define flat
areas filled with coloured enamels). A dark outline enclosed each form
and colour, rather in the manner of the leading in a stained-glass win-
dow. Gauguin contrasted and juxtaposed complementary colours in a
different way from the Impressionists, seeking a 'matt' colour. Under the
influence of Japanese prints, which had shown how synthetic effects
could be achieved, that is, how the essential could be distilled in a pic-
ture – Cloisonnism evolved into Synthetism. Maurice Denis defined this
as follows: 'To synthesize does not necessarily mean to simplify in the
sense of making things intelligible. It means creating a hierarchy, sub-
mitting each painting to a single unified rhythm, to a dominating force,
and sacrificing, subordinating, generalizing.'

Gauguin mastered this technique before his departure for Tahiti in
1891. It increased his receptiveness to 'primitive art [which] proceeds
from the spirit and makes use of nature'.

This need for synthesis was to be experienced to varying degrees and in
diverse forms by the artists of this generation. For example, in 1885, the
Swiss painter Hodler began to use an extremely original structure in his
paintings. He used the principles of what he was to term 'parallelism',
where form and colour are reconciled. He formulated its theory in 1897,
defining it as 'all sorts of repetitions', especially formal patterns which
could convey 'the idea of unity'. From 1904 until his death, he set him-
self 'the goal [...] of expressing the eternal element of nature, and of
drawing out its essential beauty', that is to say the 'overall idea'.

At its height, the French landscape genre had not only provided radically
new creative approaches and techniques, it had also brought about an
upheaval in the hierarchy of genres that had existed since the 17th centu-
ry. Landscape, like any object, was no longer just something that could be
painted, but a source of in-depth intellectual analysis of the art of painting
itself. In this respect, it was close to still life, which (along with landscape)
was the preferred genre of Cézanne and later the Cubists.

Landscape painting, and especially Impressionist landscape painting,
had restored the vital role of colour – pure colour with a value and res-
onance in itself; and the vexed issue of the relationship between form
and colour which exercised artists at the close of the 19th century still
loomed large as the 20th century dawned.

SYMBOLISM

William Holman
Hunt, *Strayed Sheep
(Our English Coasts)*,
1852 (Tate Gallery,
London). At the time it
was painted, this pic-
ture was interpreted as
expressing England's
fear of a foreign inva-
sion, a threat posed at
the time by Napoleon
III of France. The sheep
symbolized volunteers
ready to enlist.
However, in 1855,
when he submitted the
painting to the World
Fair in Paris, Hunt
changed the title to
Strayed Sheep; the
painting could then be
interpreted as a rep-
resentation of human-
ity as God's flock or, in
reference to the parable
of the lost sheep, as a
comment on points of
religious doctrine being
debated at the time.
The extreme realism
and symbolic signifi-
cance of each detail are
characteristic of Hunt's
work. *Photo E Tweedy* ©
Larbor/T

At the same time as realism and Impressionism were evolving, other artists, belonging to a movement known as 'Symbolism', were attempting to express a hidden reality beyond surface appearances. This reality was to be apprehended at the level of 'timelessness, eternal meanings, representations intended to be definitive', to quote the words of Rémy de Gourmont, a Symbolist writer.

Originating in Romanticism and deriving from the Platonic philosophy of ideas, Symbolism in the visual arts was not a style but a rather amorphous movement which existed throughout the whole of the second half of the 19th century. The movement spread throughout Europe between 1885 and 1900, reaching its zenith during the years 1885-95.

From England to Italy, from Spain to Scandinavia, from France to Russia, Symbolism was embraced by a variety of different artists. What united them was not so much an explicit programme of ideas as a common enemy: academicism, realism, Impressionism, materialism, positivism, and an industrial civilization whose advances they saw as detrimental. They preferred dreams, imagination and thought. There was not a school of Symbolism in the way that there had been a 'school' of Impressionism, as not all Symbolists subscribed to the same formal or technical principles. And it would be oversimplistic to see realist or naturalistic artists as totally different from Symbolist artists, for the two approaches could in fact coexist within one artist. Thus, pictures that Courbet painted after 1855 show the Symbolist tendency to suggest interpretations other than the one which springs to mind on first viewing the picture. *The Source* (1869, Musée d'Orsay, Paris) is a good example of this. Indeed, the naturalistic art critic Champfleury criticized Courbet, in his mature period, for being on 'the slippery slope of symbolization'.

Similarly, some of Millet's paintings are more obviously Symbolist than realist. The artist often sought to give the peasant figures in his paintings a symbolic significance by portraying them in poses that emphasized a timeless quality, as for example in *Man with a Hoe* (1863, San Francisco). This characteristic was also to become evident in the work of Puvis de Chavannes.

The revenge of idealism

The tendency to attribute symbolic significance to the subjects of paintings – already observed in the work of French artists like Paul Chenavard (1807-95) around the middle of the 19th century – became apparent in England from 1848 onwards in the work of the Pre-Raphaelites (so-called because they wanted to return to a tradition in painting earlier than Raphael). These painters enjoyed great success in France, first at the Paris World Fair of 1855, and then at the Galerie Anglaise at the Champ-de-Mars in 1867. It was above all the content of their paintings that impressed other artists.

In 1848 the Pre-Raphaelite Brotherhood (PRB) was founded in London by William Holman Hunt (1827-1910), Sir John Everett Millais (1829-96), the Rossetti brothers (Dante Gabriel Rossetti, 1828-82, who was also a poet, and William Michael Rossetti, an art critic), Thomas Woolner, James Collinson and F G Stephens – five painters and two writers in all.

The artistic principles laid down by the Brotherhood between 1848 and 1851 were to have a significant influence in the second half of the century, although all the Pre-Raphaelite painters, with the exception of Hunt, gradually abandoned them after the group broke up in 1854. Their influence can be attributed to two factors. The first was the novelty of their approach to religious, historical and mythological subjects, which created a scandal in Victorian England. This was not because of their technique, which remained in the Renaissance tradition, or their use of perspective, their depiction of anatomy or the highly finished quality of their drawing. It was due to the ordinary, modest, even humble way in which they depicted their subjects, devoid of the Neo-Renaissance pomp of the official artistic style.

They ignored contemporary history, focusing instead on literary or legendary themes – the story of Dante and Beatrice, for example (Rossetti) – and depicting the characters as if they existed in everyday life. Conversely, whenever they did tackle contemporary themes, for example work (Ford Madox Brown, 1821-93), they elevated these to a heroic or epic dimension.

The second reason for their influence was the impact made by certain leading figures in the movement. Among these was John Ruskin (1819-1900), the famous theorist who had already published *Modern Painters*

EY LUCZKIN HULBUS LAURENCE PAULIN VI MUNK S VAN GOGH VIDTHAL LE DIJL MOU LAKOTOVLR VEKRAN IC HANDS ECK ANRAEL FANTIN LA TA ROZALD BORDONE BLAKE BL
LANNE DEGERHEDEALEN DAMGAUGUIN DELPUCT NILLER MULLER MOUTHEK WOOTH JOUSSUT GORDON MILLTU MUNVALLSIGNOUGO MADAK ONEER CROZO GAUGUIN GRASSE LACH
VOLURNER VAN GOGH VUILLER DE DIC MULAND WAGNER WATTS KNNSTUP AS TUE DIMTION NILTON NUM ANT OTOO ISN EN TIV HUNIS
VDLCAS DELACROIX EIFFEL EDISON FANTIN LATAUN WATTU FLAMBERG GALLO GAUTUE RINEK EN GAUDI GAUGUIN GRASSET GEROARD HAUSSMAN HODLER HOFFMANN HURIS

when he came to the defence of the Pre-Raphaelites in 1851. He advocated the revival of Gothic art – in painting specifically the art of Cimabue and Giotto – and endorsed an idealist view of painting by invoking the philosophy of Locke, for whom ideas were nobler than feelings. However, this did not prevent Ruskin – any more than it did the Pre-Raphaelites – from wishing to replace academicism and the official style by the cult of nature, which he saw as a means of ennobling the soul.

Another important figure in the movement was Dante Gabriel Rossetti, who emerged as the leader of the school although he only produced two paintings in the Pre-Raphaelite style before going on to develop his own aesthetic. His achievement in merging painting and poetry, as well as his highly aesthetic approach to art, influenced the second wave of the Pre-Raphaelites: Edward Burne-Jones (1833-98), William Morris (1834-96) and Walter Crane (1845-1915). Rossetti, Burne-Jones and Crane in turn influenced Symbolist artists in particular, like Aubrey Beardsley (1872-98), the Belgian Fernand Khnopff (1858-1921), the German Max Klinger (1857-1920) and the Italians Gaetano Previati (1852-1920) and Giovanni Segantini (1858-99).

However, it was William Morris who was to have the most profound

Dante Gabriel Rossetti, *The Bower Meadow*, 1872 (City Art Galleries, Manchester). The influence of Botticelli can be detected in the faces and figures, and in the flowing robes and fluid movements.
Photo J-L Charmet © Larbor/T

influence. Morris was one of the proponents of the Arts and Crafts move-
ment, which revived decorative arts in Britain and in which Rossetti,
Burne-Jones and Crane were all involved. Morris transformed the ethical
aspirations of the Pre-Raphaelites into a social project: art for all.
Dreaming of a return to the era of the medieval craftsman, he founded a
theory of total art which was to open the way for Art Nouveau.

Around 1880, ideas and idealism began to prevail over nature and real-
ism, and European artists turned to the English movement for inspiration.
It provided them with a rich source of imagery and literary and psycho-
logical material. However, French artists had already found their own
masters within their own national tradition: Pierre Puvis de Chavannes
(1824-98) and Gustave Moreau (1826-98).

These two exponents of history painting, forerunners of Symbolism,
were close friends who shared the ideal of a type of painting that would
be a reaction against realism and academicism. Nevertheless, they dif-
fered sharply with regard to their aesthetic principles: Puvis favoured line
and Moreau colour. Puvis was the greatest French decorative artist of the
second half of the 19th century – his legacy includes paintings and
murals at Amiens, Marseilles, Poitiers, Lyons, Paris (at the Sorbonne, the
Panthéon and the Hôtel de Ville), Rouen and Boston. He developed a dec-
orative aesthetic which he also applied to easel-painting. His themes
were allegorical or had a narrative dimension; the composition and
rhythmic linear pattern of the figures were emphasized; the forms were
simplified, flat and firmly delineated by a synthetic line; the colours were
bright and the colour values well balanced. All his work, in which every
detail was subsumed to the overall effect, was characterized by restraint
and detachment.

In 1884, Puvis completed the mural *The Sacred Wood Dear to the Arts
and Muses*, designed for the staircase of the Palais des Arts in Lyons. This
work was immediately hailed by the Symbolists as an example of the
ideal to which they aspired. His influence had grown after the 1881
Salon, where *The Poor Fisherman* (Musée d'Orsay, Paris) had been
acclaimed, and he had an impact not only on Gauguin who dreamed of
producing 'Puvis in bright colours', but also on the Nabis, Redon, Maillol,
Hodler etc, as well as on Matisse and Picasso in his Blue Period.

Unlike Puvis, who tended towards simplification in his work, Moreau
experimented with two stylistic manners: a very meticulous finished
style, especially in those paintings which he never actually completed,
and an unfinished style in which he experimented radically with colour,
especially in his watercolours. He declared: 'I believe neither in what I
touch nor in what I see, only in what I feel. [...] My inner feelings alone
seem to me eternal and incontestably true.' He assigned a specific role to
colour: its aim was not to reproduce reality, but to interpret it. Appointed
professor at the École des Beaux-Arts in 1892, he taught the following
precept to his students, who included Matisse, Marquet and Rouault:

Edward Burne-Jones,
The Golden Stairs,
1876-80 (Tate Gallery,
London). The subject of
this large canvas
(276cm x 117cm) is
music, represented by
the figures who appear
to be angel musicians
carrying instruments.
The vague and
ambiguous quality of
the painting, open to
diverse interpretations,
indicates Burne-Jones's
links with both the
aesthetic movement in
England and the
Symbolist movement.
Photo © AKG, Paris.

Pierre Puvis de Chavannes, *The Sacred Wood Dear to the Arts and Muses*, 1884 (The Art Institute, Chicago). Puvis, who had an immense influence on the Cloisonnists, was to declare: 'I wanted to be more and more sober and more and more simple. I condensed, pared down, schematized. I made sure that every gesture expressed something. I tried to say as much as possible in few words.' And elsewhere he said: 'If I think about the work that I have done before now, I see in it the need for synthesis.' *Photo © Musées Nationaux/T*

'Colour should be thought, dreamed, imagined.' He bequeathed all of his works as well as his house at Rue de La Rochefoucauld in Paris to the state so that the Gustave Moreau Museum could be created. His famous painting *Salome Dancing Before Herod* (1869-76), which can seen there today, and his *Apparition* (1876, watercolour, Musée d'Orsay, Paris) were to haunt the imagination of des Esseintes, the hero of J K Huysmans' quintessential Symbolist novel, *À Rebours* (1884).

In 1886, the existence of Symbolism became official: on 18 September, Jean Moréas published its manifesto in the literary supplement of *Le Figaro*. The same year saw the last Impressionist exhibition, in which Seurat, Gauguin and Odilon Redon (1840-1916) took part. All of these artists were opposed to academicism, of course, but also to naturalism. The whole of Europe was affected by the Symbolist movement, which was remarkable in that it was not an exclusively artistic movement but was first and foremost a literary one and therefore more liable to form close links with poetry and music.

An art of transposition

Everything conspired to spread Symbolism throughout Europe: new methods of transport which encouraged artists to travel to other parts of the continent (although there were some artists who preferred to live in seclusion); the relationships that they formed amongst themselves and with poets, musicians and writers; the publication of art magazines (see *'The main Symbolist art magazines'*, p.76-7), which became more and more numerous and to which writers, poets and artists contributed; the national and international exhibitions held in Paris, Ghent, Munich and

Gustave Moreau, *Orpheus on the Tomb of Eurydice*, 1890 (Musée Gustave-Moreau, Paris). The theme of Orpheus recurs frequently in painting. In the 17th century, artists were fond of depicting the tale of Orpheus charming the animals. In the 19th century, this same theme was predominantly treated by Symbolist painters, who chose instead to depict the tragedy of Orpheus, inconsolable after his descent into the underworld and the irretrievable loss of Eurydice. *Photo J-L Charmet © Archives Larbor/T*

The main Symbolist art magazines

Alphonse Mucha, cover
for the magazine
La Plume, 1898
(Bibliothèque Littéraire
Jacques-Doucet, Paris).
Photo R Lalance
© Archives Larbor/T
© ADAGP 1999

Art magazines and periodicals played an important role in the development of the Symbolist movement.

Published in small print runs, these magazines typically expressed sympathy for anarchist ideas and an opposition to naturalism and industrial civilization, showing a tendency towards aestheticism, snobbery and abstruseness. They articulated the cult of beauty and featured enthusiastic articles on mystical and esoteric ideas. Their style might often be affected, but the publications were full of new ideas.

Art et Critique, edited by Jean Jullien.

L'Art Moderne (1881-1914), founded by Octave Maus, Edmond Picard and Émile Verhaeren; this was the official organ of the Brussels-based 'Groupe des XX'.

La Conque (1891-2), founded by Pierre Louÿs.

Le Décadent (1886-9), founded by Anatole Baju, was first known as *Le Décadent Littéraire et Artistique*. It brought together Parisian literati who were opposed to the status quo, and took as its model the hero of J K Huysmans' novel *À Rebours*.

Le Mercure de France (1889-1965), founded by Alfred Vallette and a group of writers. This magazine played a very important role in the history of the Symbolist movement.

Le Moderniste (1889, eight issues), a weekly publication edited by G Albert Aurier, who also wrote for *Le Mercure de France*.

Pan (1895-1900), founded by Julius Meier-Graefe in Berlin. This lavishly produced magazine, published three times a year, helped to circulate Symbolist ideas, although it was in fact primarily devoted to Art Nouveau.

La Plume (1889-1914), founded by L Deschamps, open to Symbolism and all arts, and worthy of note for its special issues.

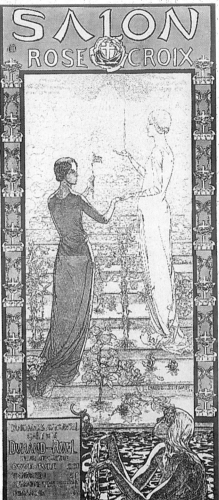

La Revue Blanche, a Franco-Belgian magazine published in Brussels between 1889 and 1891, and founded by P Leclercq, J Hogge and A Jeunhomme. The magazine was published in Paris between 1891 and 1900, where it was given a new lease of life by Thadée Natanson, playing a vital role in the Symbolist movement until 1900. In 1896, Felix Fénéon became the driving force behind the publication.

La Revue Indépendante (1884–92), or to give it its full title Revue Indépendante Politique, Littéraire et Artistique (November 1884 to May 1885), founded by Félix Fénéon and open to Symbolist ideas. Taken over by the critic and poet Édouard Dujardin, and edited by Teodor de Wyzewa from 1886 to 1888, and then by Gustave Kahn from 1888 to 1889. From the beginning of 1889, it was edited by François de Nion and Georges Bonnamour, with a more naturalistic slant.

La Revue Wagnérienne (1885–8). Edited by Édouard Dujardin and with the aim of introducing Wagner to a wider public, this publication brought together the artists of the Symbolist movement.

Le Symboliste (October 1886, four issues). A weekly art magazine edited by Gustave Kahn, Jean Moréas and Paul Adam, whose main aim was to engage in polemical debate with Le Décadent.

Van Nu en Straks ('Of Now and Olden Times'). Founded in 1893, it spearheaded the Symbolist movement in Flanders. Between 1896 and 1901, it broadened its scope to include foreign literature.

Ver Sacrum ('Sacred Spring'). Published in 1898 in Vienna, and subsequently in Leipzig in 1899, this was primarily a Secessionist magazine, but it also disseminated Symbolist ideas.

La Vogue. Founded in 1886. Between 1887 and 1889, it developed a markedly Symbolist bias.

La Wallonie. Edited by the poet Albert Mockel in Liège, from 1886 to 1892, this was the most important Belgian Symbolist art magazine.

The Yellow Book. An English publication founded by John Lane. It was famous for the illustrations by Aubrey Beardsley that it featured between 1894 and 1897.

As well as these art magazines, other publications contributed to the spreading of Symbolist ideas; for example, Literatorul in Romania, founded in 1880; Nyugat ('The West') in Hungary from 1910 to 1914; Prometeo in Spain from 1908 to 1913; and in Russia, Mir Iskusstva ('The World of Art') from 1889 to 1904 and Vesy ('The Scales') from 1904 to 1909.

Henri Fantin-Latour, *Tannhäuser in the Venusberg,* 1864 (County Museum of Art, Los Angeles). This picture is typical of the compositions of Fantin-Latour, who was inspired in them by Wagnerian music. He was a friend and advocate of modern painters, as demonstrated in paintings considered to herald the modern movement: *Homage to Delacroix* (1864) and *Studio in the Batignolles Quarter* (1870). He is also well known for his numerous sober still lifes. *Photo © the Museum. Archives Larbor/T*

Berlin; the non-official Salons and group exhibitions – for example, in Brussels, the 'Groupe des XX', from 1884 to 1893, the 'Libre Esthétique' group which took over from them in 1894, and the Salon of Idealist Art in 1896; in Paris, the Salon des Indépendants in 1884 and the Rosicrucian Salons held from 1892 to 1897 by Sâr Péladan, the head of the Rosicrucian sect in France; and in Vienna, the Secessionist exhibitions organized under the aegis of Gustav Klimt (1862-1918) in 1897. The most fertile period of the Symbolist movement was between 1885 and 1900, although individual offshoots from the movement continued until 1914.

The Symbolist approach to art was essentially an intellectual one. Taking as its point of departure an idea, sensation or emotion, it sought in nature associated rhythms, forms and colours. Symbolist artists wanted to suggest through analogy rather than depict; their task was to portray thought and feeling by an image or symbol. This approach, dominated by the quest for concrete equivalents, was similar to the way in which poets worked. Art was not a reproduction, or even a representation, of reality, but a transposition of what Baudelaire and mystics referred to as 'correspondences': 'It is this admirable and immortal instinct for beauty that makes us consider the Earth and its sights as a glimpse of heaven, a correspondence with it.' Artists could now move away from reality; their role and main concern was to express their intuitions and their feelings. Painting in the outdoors was no longer relevant for them. Some artists stated that they painted from memory (Gauguin,

Munch) – an indication that they considered reality should not be a representation of external appearances, as in Impressionism, but rather a suggestion of what one saw.

Based on a process of transposition, Symbolism was closely linked to text and music. Consequently, literature past and present became its principal source of inspiration. The Romantics had already used literature in this way, but the Symbolists chose different writers and subject matter. The Pre-Raphaelites Rossetti and Burne-Jones preferred Keats and Tennyson to Wordsworth and Byron. Victor Hugo, whose *La Légende des Siècles* was published in 1859, set himself up as visionary and seer, a role in which he was acknowledged by some Symbolists, especially Eugène Carrière (1849-1906) and Auguste Rodin (1840-1917). However, most artists turned to Baudelaire, who inspired Félicien Rops (1833-98), Carlos Schwabe (1866-1926) and Rodin (*The Gates of Hell*), or to Mallarmé, Rimbaud and Maeterlinck.

However, no 19th-century writer enjoyed such a huge degree of success as Edgar Allan Poe. Translated into French by Baudelaire, Poe's works were illustrated by many artists (for example Redon, Alberto Martini, Previati, William Degouve de Nuncques and Frantisek Kupka). In accordance with tradition, artists took their subjects from the literary classics: for example from the works of Dante, Shakespeare and the visionary poet

Odilon Redon, *The Cyclops*, c.1898-1900 (Rijksmuseum Kröller-Müller, Otterlo). Until 1890-1900, Redon specialized in black-and-white drawing using charcoal or lithography. Thereafter, he gradually stopped using blacks and greys and introduced colour into his work. In this picture, the figure of the Cyclops behind the rock, observing but not interfering with the young woman in the picture, symbolizes the destructive forces within himself which Redon had overcome. *Photo © the Museum/T*

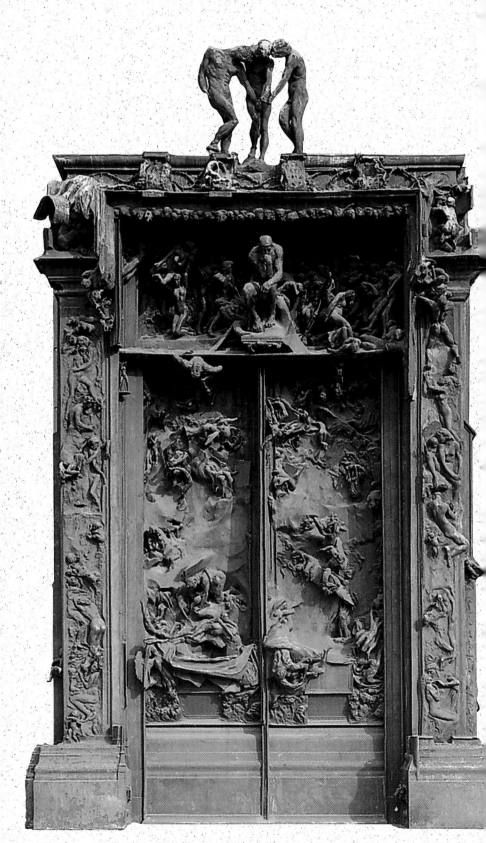

...e *Gates of Hell*, plaster,
...80-1917 (Musée
...Orsay, Paris).

...though the general
...eme is taken from
...ante's *Divine Comedy*,
...e pessimistic view of
...ve and existence is
...rongly influenced by
...audelaire's *Les Fleurs du*
...*Mal*. The style bears the
...allmarks of eclecticism.
...he piece was modelled
...n Ghiberti's *The Gates of*
...*aradise* in the bapistry
...Florence and on the
...oor of the Église de la
...Madeleine in Paris,
...esigned by Triqueti and
...nished in 1841. The
...ominant style is
...lassical Renaissance,
...ut with elements
...orrowed from late
...Gothic.
Photo © B Amano/
Artephot/T

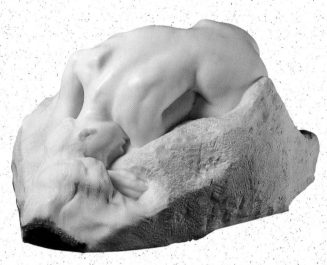

Danaide, marble, 1889
(Musée Rodin, Paris).
Photo © Adam Rzepka
© Musée Rodin

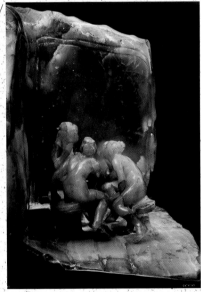

Camille Claudel,
The Gossips, onyx and
bronze, 1897 (Musée
Rodin, Paris).
Photo © Eric and Petra
Hesmerg © Musée Rodin
© ADAGP 1999

1840. Auguste Rodin is born in Paris to a lower middle-class family. He studies under Horace Lecoq de Boisbaudran, but fails to get into the École des Beaux-Arts.

1864. While in the employment of Carrier-Belleuse, a well-known sculptor, he meets Rose Beuret, who is destined to become his lifelong companion. After the Franco-Prussian War in 1870, he goes to work in Brussels. He spends time in Italy in 1875 and returns to France in 1877.

1880. He obtains the commission for *The Gates of Hell*, upon which he continues to work for the rest of his life.

1881-2. He begins an affair with his pupil and fellow-sculptor Camille Claudel (sister of the writer Paul Claudel). Sixteen years later, following the end of their affair, she becomes mentally unstable and finally goes insane. Rodin obtains several important commissions, including *The Burghers of Calais* and statues of Victor Hugo and Balzac. The two latter works are subsequently rejected.

Around 1900, Rodin becomes highly successful. In 1905 the poet Rainer Maria Rilke becomes his secretary and encourages him to rent the Hôtel Biron in 1908, a mansion in Paris which is today the Musée Rodin.

1916. He donates all of his works and his entire collection to the state.

1917. Rodin dies in poverty.

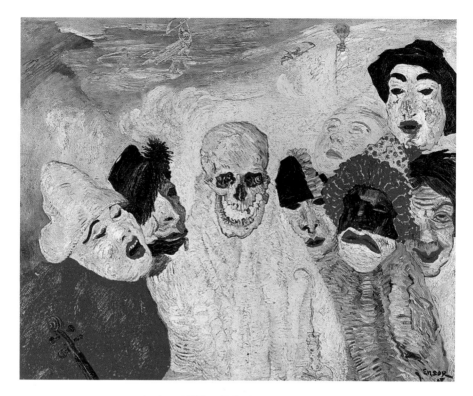

James Ensor,
Masks and Death, 1897
(Musée des Beaux-
Arts, Liège).
Ensor's family owned a
shop which sold
theatre masks. Ensor
was inspired by these
and assigned to them a
symbolic significance
which invites the
viewer to reflect on the
masquerade of life in
the face of death. This
combination of irony
and tragedy in his work
make him a forerunner
of Expressionism.
Photo Giraudon/T
© *ADAGP 1999*

and painter William Blake. Instead of the male protagonists of *The Divine Comedy* or *Hamlet*, however, they preferred to depict the female figures of Beatrice (Rossetti) and Ophelia (Millais).

The tendency towards mysticism and philosophical thought was reflected in the use of sacred texts and legends. This new trend pervaded all Symbolist art. Artists sought inspiration in the Bible (attested by the popularity of the story of Salome as a theme in the work of Puvis, Moreau, Redon and Lucien Lévy-Dhurmer), in classical mythology (Moreau, Redon, Böcklin, Hans von Marees, 1837–87) or Nordic sagas (the Norwegian artist Egedius, 1877–99, and the Finnish artist Gallen-Kallela, 1865-1931), and in the Christian religion (Puvis) and the 'primitive' (Gauguin). Artists also evoked the conflict between classical mythology and Christianity (Klinger).

In this interplay of correspondences, music performed a role that it had never played before in art. Despite the antagonism provoked by his music and nationality, Richard Wagner – whose *Tannhäuser* was performed in Paris in 1860 – was something of a demi-god for the Symbolist movement. Depicting figures such as Tristan, Siegfried and Parsifal, painters took up the theme of love and passion consummated in death. Fantin-Latour, Whistler, Burne-Jones, Jean Delville (1867-1953), Henri de Groux and, through his influence, Ensor and Klinger participated in this phenomenon which, from 1880 onwards, was referred to as 'Wagnerism' (a term coined at Mallarmé's Tuesday evening salons). Wagnerism was con-

solidated in 1885 with the appearance of the magazine *La Revue Wagnérienne*, one of whose founders was the writer Villiers de L'Isle-Adam. Wagner, with his repertory of clouds and shadows, gods and men, good and evil, desire and death, provided enough ecstasy and terror to fuel the most extravagant fantasies.

The self and the universe

However, themes drawn from music or literature only interested Symbolist artists to the extent that they allowed them to explore personal concerns in the guise of universal themes. In the world of Symbolism, the artist eschewed storytelling and focused instead on the fundamental metaphysical questions: life and death (Böcklin, Ensor, Munch, Hugo Simberg, 1873-1917), sexual desire and love (Segantini, Hodler, Rodin), nature, divinity, the passage of time and the seasons (against a backdrop of sea or forest).

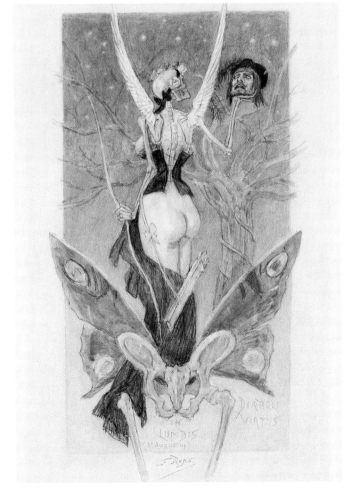

Félicien Rops, *Sentimental Initiation*, 1897 (Cabinet des Dessins, Musée du Louvre, Paris). Rops's reputation is based essentially on his engravings, etchings and lithographs. These reflect the literary climate of the era, on the cusp between Romanticism and Symbolism. Rops had close links with the author Sâr Péladan, who combined Christian mysticism with the occult in his work. In Rops's work, women are a recurrent theme: depicted as triumphant figures, witches or prostitutes. *Photo © M. Bellot/RMN*

Gustav Klimt,
The Kiss, 1908
(Österreichische
Galerie Belvedere,
Vienna). The technique
of covering the entire
picture surface with the
same repeated motifs
and superimposing
planes without
perspective, and the
intrusion of elements
such as birds, whose
symbolic significance is
rather obscure, are
characteristic of Klimt's
art during this period.
Photo Photostudio Otto
© *Archives Larbor/T*

In contrast to themes such as man's harmonious relationship with nature (Hans von Marees), artists also treated themes such as unrequited love (Moreau, Maurice Denis, Redon), masks (Ensor), monsters (Klinger), evil in general and the fallen angel in particular (Redon, Mikhail Vroubel, 1856-1910).

Women featured as a dominant motif because they symbolized the ambivalence of sexual desire and death (Gustav Klimt). Young women are depicted as a mixture of innocence and sensuality (Franz von Stuck, 1863-1928, Sir Joseph Noel Paton, 1821-1901, Rossetti, Burne-Jones, Whistler), portrayed as enchanted creatures (Alphonse Mucha, 1860-1939), as chaste maidens (Puvis), as seductive *femmes fatales* (Burne-Jones, Khnopff, von Stuck), or even as perverse creatures (Rops) or dangerous beings (Munch).

Artists explored the nature of existence between the extremes of happiness and anguish, dream and nightmare, in an ambiguous and mysterious world that all but crossed over into the subconscious. At the same time as modern psychoanalysis was developing, artists were discovering the subconscious and attempting to understand it, or at least to give it

expression through an exploration of the world of sleep and dream. And so we have the dreams depicted in the work of Puvis, Klinger's nightmares, and Redon's dreamscapes. The work of Redon, called 'the prince of dreams' by Natanson, was based on 'docile submission to the subconscious'. In his diary *À Soi-même* (written between 1867 and 1915), Redon acknowledged Poe as his master. Poe himself said: 'The only certainty is in dreams'. Before producing a series of lithographs entitled *To Edgar Allan Poe* (1882), Redon painted a series of pictures in 1879 significantly entitled: *In Dream*.

The more introspective they became in their focus, the more artists discovered solitude (Moreau, Harald Sohlberg, Khnopff, Munch), silence (Redon, Khnopff) and melancholy. Self-expression was often informed by a philosophical meditation that was highly pessimistic in tone and close to the vision of German philosophers such as Schopenhauer and Nietzsche. However, the means employed in taking 'the road that leads to the interior' (to quote Mallarmé) were less important than the end. The lack of a common style and the artists' openness to different technical and formal approaches – ranging from meticulous analysis to a more synthetic approach – are the most striking characteristics of Symbolism.

The aesthetics of Symbolism

Some artists were not concerned with finding an original set of aesthetics. They were content to use those already created by other artists: for example, Seurat's pointillist technique was adopted by Previati, Segantini, Osbert, Martin and Masek; Crane adopted realism; and the work of Lévy-Dhurmer shows a mixture of academic precision and Impressionist experimentalism. Whether they reworked the same motif (Jan Toorop, Henri de Groux, Léon Frédéric, Charles Maurin, Ensor),

Fernand Khnopff, *I Lock My Door Upon Myself*, 1891 (Neue Pinakothek, Munich). Inspired by a poem ('Who Shall Deliver Me?') by Christina Rossetti, the sister of the Pre-Raphaelite painter, this picture conveys the sense of loneliness, anguish and pessimism that was a hallmark of the Symbolist movement. *Photo © The Museum Archives Larbor/T*

SYMBOLISM

George Watts, *Hope*,
1885 (Tate Gallery,
London).
According to the artist,
the young woman is
trying to play music
with the sole string left
on her broken lyre.
Photo E Tweedy
© Larbor/T

**Lucien Lévy-
Dhurmer**, *Eve*, pastel
and gouache, 1896
(Michel Perinet
collection, Paris).
Léon Thévenin, who
analysed the artist's
inspiration, explains
the choice of theme
thus: 'Exiled from the
garden of Eden, [Eve]
is the symbol of the
pagan world, the
kingdom of nature and
the senses.'
Photo © Bulloz-DR/T

CRINTOSH MACKMURDO MAYBELLE MANET TYROLLE MALLERUANES MAUSSOYER VELOCYTEN MY CEMDNET AND TESHEY ARSEN MONROE MILLES LAMER GLUES HA
ANEE LUNNAIS LAGUERRE DE LIER FRETA NAVELLU BURNSYAN AARGRU THREE LEZOU EN VELENY MATINEE MATIE WENSTER NORGU MERBOD ROURDA JEKM STGM
MEE MONHEE POLRES DANGE DANTER MENS DRIEV VUE MURE MILLEE MONTIS MURNER MORGAIL ROPRE MALGVN MUREVE VGERNE MADAN OSBEM ISAULT BARLIN VERASGUE
VEN DEGAS DELACROIX LIEFLE UNSUR PAUT INVENATION PATTORI FLAMENG SCALLE GALLEN KAETLSGAUDI DAGOGIN GRASSET GUIMARD HAUSSMAN HODLER HOFFMANN FECE

Alphonse Osbert, *Evening in Antiquity*, 1908 (Musée du Petit Palais, Paris). Osbert was one of the most ardent devotees of the Rosicrucian Salons. These young women dreaming in the sunset are a common motif in his work. *Photo Bulloz/T ADAGP, 1999*

whether the paintings were crammed with detail, or whether they focused on an essential truth by means of simplification (Whistler, the Scandinavian artists), the aim was always to suggest something other than the visible through the use of symbolism.

Nevertheless, a set of principles of sorts did emerge from international Symbolism. Prominent among these were: circular composition, flowing or writhing rhythms, sinuous contours, form suggested by patches of flat colour, and a tendency to eliminate perspective and thus to negate the impression of space either by filling the background or foreground with shapes and figures, or else by cutting off figures within the painting.

Other artists began to develop a new technique which was to be known as 'Cloisonnism' and later as 'Synthetism'. This development originated in 1888, at Pont-Aven in Brittany, in the work produced by Émile Bernard and Gauguin, whose first painting done in this new style was *The Vision After the Sermon* (1888, National Gallery of Scotland, Edinburgh). This painting was emblematic of the new aesthetic: a simpler composition – showing the influence of Japanese art – and the use of tones without relief. Bernard gave the following definition of Cloisonnism: 'Dujardin had christened this first experimental phase "Cloisonnism" because of the outline that enclosed each colour which gave a compartmentalized appearance to the picture ["cloisonné" in French means "compartmentalized"]. In fact, it was a great stained-glass window rather than a painting, with the decorative elements of colour and line.' Then, influ-

SYMBOLISM

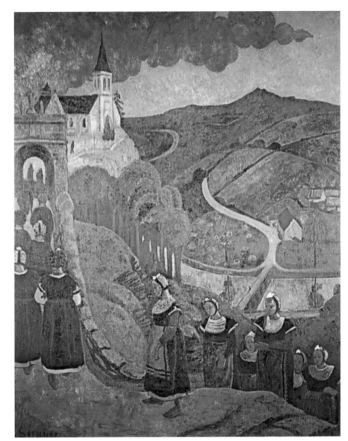

Paul Sérusier,
Le Pardon de Notre-Dame-des-Portes à Châteauneuf-du-Faou, c.1896 (Musée des Beaux-Arts, Quimper). Sérusier, who was interested in Theosophical doctrine, was the enthusiastic theorist among the Nabis. Brittany – which he once described as 'my true home since it is my spiritual birthplace' – was the artist's favourite setting for expressing his beliefs. He perceived eternity in its scenery and a timelessness about the people and the way they dressed. This he blended with his taste for decorative art, which had an important place in his work. From 1893, he designed stage scenery in collaboration with the theatre director Aurelien Lugné-Poe at the Théâtre de l'Œuvre.
Photo E Legrand
© Archives Larbor/T

enced by the Japanese style, Cloisonnism evolved into Synthetism.

Bernard and Gauguin attracted other artists, leading to the formation of the Pont-Aven School. One of these artists, Paul Sérusier, painted a landscape scene on the lid of a cigar box, *The Talisman* (1888, Musée d'Orsay, Paris), which he showed to his friends at the Paris art school, the Académie Julian. With these artist friends he would go on to form the Nabis (from the Hebrew word for 'prophets'). This group included Henri-Gabriel Ibels, Bonnard, Vuillard, Paul Ranson and Ker Xavier Roussel, and their art was dominated by decorative and Japanese-style elements.

The following year they held their first exhibition, at the Café Volpini within the World Fair venue. The art critic Aurier wrote enthusiastically about Gauguin's work in *Le Mercure de France*; and Maurice Denis, a painter and Symbolist art theorist, published what was effectively a manifesto in the review *Art et Critique*: 'Remember that a picture, before being a war horse, a naked woman or whatever, is essentially a flat surface covered with colours which have been arranged in a certain order.' By emphasizing that the picture is above all an object, made up of a set of visual elements among which colour played a vital role, Denis had put into words Gauguin's idea of painting. It was a concept that was destined

to become famous and would be crucial to an understanding of 20th-century art.

In 1891, Aurier – in an article published in *Le Mercure de France* on 'Symbolism in Painting' and with specific reference to Gauguin – summed up the salient features of a work of art:

'1. *ideist*, as its sole ideal will be the expression of the idea;

2. *symbolist*, for it will express this idea by means of forms;

3. *synthetist*, for it will present these forms, these signs, according to a method which is generally understandable;

4. *subjective*, because the object will never be considered as an object, but as the sign of an idea perceived by the subject;

5. (it is consequently) *decorative* – since decorative painting in its proper sense, as the Egyptians and, very probably, the Greeks and the Primitives understood it, is nothing other than a manifestation of art at once subjective, synthetic, symbolic and ideist.'

Between 1891 and the turn of the century, the French movement developed and became integrated into the European Symbolist movement. Particularly influential were its art magazines, of which the most famous was the Natanson brothers' *La Revue Blanche*, its meetings at the Café Voltaire over which Mallarmé presided, its publications, including the art critic André Mellerio's *Le Mouvement Idéaliste en Peinture*, and its submissions to art exhibitions held abroad.

Thus, reality had no intrinsic value in itself, but was perceived as a veil, a mask on the world of ideas, distorted by illusion. This reality was nevertheless invisibly and mysteriously connected to a hidden reality whose meaning the artist was able to discover by virtue of his unique sensibility. The artist became, in a sense, the high priest of this world on the threshold of mystery, a world which was often mystical or esoteric. He did not seek to represent an objective viewpoint but advocated subjectivity. However, the notion of the self that re-entered the equation was not the self of the Romantics. The Romantics had sought to express their inner selves in relation to nature by using it as a mirror. For the Symbolists, nature was a reservoir into which they could dip and find the right image onto which they could then, by analogy, transpose the abstract idea.

In relation to positivist values, the Symbolist generation of artists were concerned not so much with modernity, or with defining a style, as with realizing the Wagnerian dream: a synthesis of the arts that could be achieved by transposing literature, poetry and music into painting or sculpture. But it was not until the next generation, and the Art Nouveau movement, that the scope of this ambition would be broadened to the integration of all the arts.

Paul Gauguin

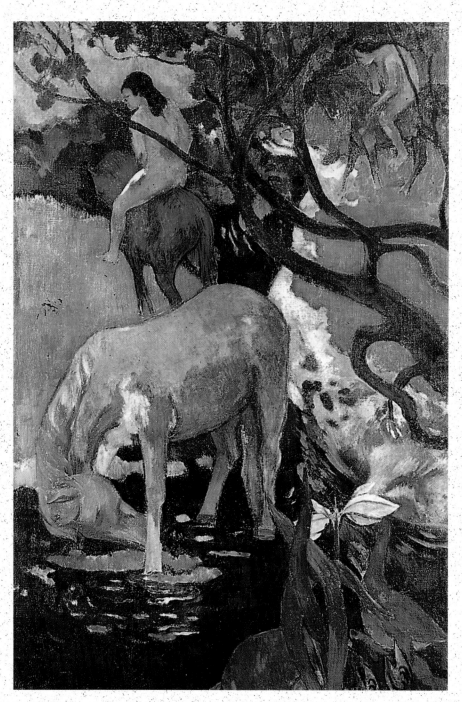

The *White Horse*, 1898
(Musée d'Orsay, Paris).
This painting, copied
from a carving on the
Parthenon, shows how
Gauguin had broken free
from the constraints of
realism in his treatment
of colour: in particular,
the areas of orange with
which the blue water is
dappled show how colour
no longer has any
descriptive function.
Gauguin once said, with
regard to this painting:
'I have gone far back,
farther back than the
horses of the Parthenon,
back to the hobby-horses
of my childhood.'
Photo © Giraudon/T

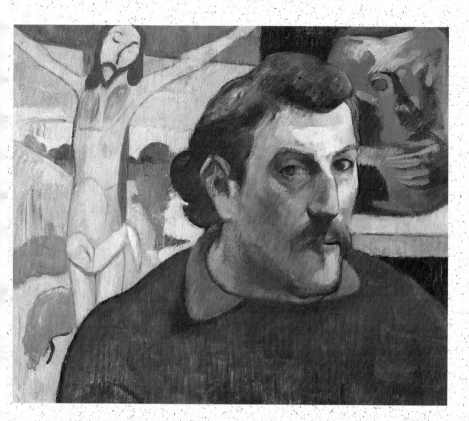

Self-Portrait with Yellow Christ, 1890-1 (Musée d'Orsay, Paris).
This picture, painted in Le Pouldu in Brittany, is one of a series of self-portraits done by Gauguin between 1889 and 1891. His self-portrait is flanked by two symbolic representations of the artist: on the left, the figure of the crucified Christ is a transfigured image of the artist, while on the right a photograph of the stoneware pot that he once gave as a gift to Madeleine, the sister of Émile Bernard, serves as a reminder that he is also 'the Savage'.
Photo © R G /RMN

1848. Paul Gauguin is born in Paris, the son of an anti-royalist journalist and the grandson of Flora Tristan, the French feminist and socialist. The family subsequently emigrate to Peru, his father dies and his mother, Aline Chazal, decides to stay on in Lima with her children.
1855. The family return to France. After performing poorly at school, Gauguin heads off to sea on several occasions. In India he learns of the death of his mother (1867).
1871. He settles in Paris, where he finds employment in a stockbroker's office, and takes up drawing and painting.
1873. He marries a Danish woman, Mette Gad, with whom he will have several children. Later he becomes acquainted with Émile Schuffenecker (1874) and Pissarro (1877).
1879, 1881, 1882. Gauguin takes part in the Impressionist exhibitions.
1883-7. He gives up his job in order to concentrate on painting. For a period of two years, in Rouen and Copenhagen, he tries to find a balance in his life, but fails. This nomadic existence eventually culminates in the break-up of his family and in poverty.
1887. After visiting Copenhagen (1884) and spending a summer in Pont-Aven (1885), he goes to Panama and Martinique.
1888. Back in Pont-Aven, he meets up with Émile Bernard. Their discussions about art culminate in the birth of Cloisonnism and Synthetism.
1888-9. He shares a short-lived utopian dream of setting up an artists' colony with Van Gogh. In Arles, the two men argue and separate. Gauguin returns to Paris before going to stay in Brittany for the third time.
1891. He goes to Tahiti and remains there for two years. In 1895, knowing that he has syphilis, he returns there, and settles in the Marquesas Islands in 1901.
1903. Gauguin dies, his health ravaged by disease and alcohol. The Autumn Salon, created that year, holds a retrospective exhibition of his work, which makes a big impression on young artists.

ECLECTICISM

I n post-1830 Europe, the main concern of architects was finding a modern style. What would be the style of the 19th century? Could they find a distinctive architectural language that would be unique to this era – a new style? The modernity of the second half of the 19th century in the areas of town planning, architecture, sculpture and the decorative arts is evident from the materials, techniques and building projects of the time. These were all marked by innovation and corresponded to the social, economic and scientific configuration of the period. Paradoxically, however, this era also forged its modern identity through a relationship with the past – expressed in the use of older styles – which is generally described as 'eclecticism'. Thus, officially commissioned buildings were constructed against the backdrop of a tense and violent clash between the architectural styles of the past and the present. Paris is an example of this tension, which can be found, with many variations, in all the great European cities.

Avenue de l'Opéra, Final Demolitions, 1875 (Bibliothèque Nationale, Paris). The extensive renovation and rebuilding of Paris undertaken by Baron Haussmann during the Second Empire continued during the Third Republic (from 1870). *Photo Jeanbor* © *Archives Larbor/T*

The development of town planning

The urban landscape depicted by the Impressionists is that of the new Paris. Their paintings show no trace of the extensive demolition and renovation work that transformed the capital into a vast building site. As was the case for most large European cities, the modernization of Paris was begun around 1830 and reached its climax during the Second Empire (1852-70). The Emperor took an active personal interest in this: he wanted, for political reasons, to be seen to be introducing social

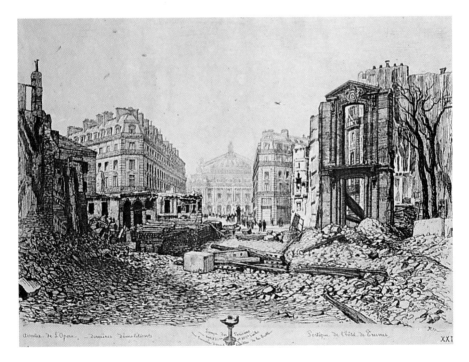

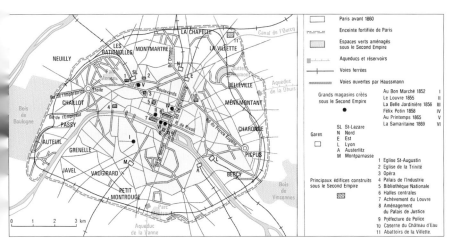

Map showing the redevelopment of Paris under the Second Empire.

improvements, and he wanted to turn Paris into a truly modern capital. The appointment of Baron Haussmann (1809–91) as Prefect of the Seine, and thus overseer of the urban renewal project, did not prevent the Emperor from intervening in it directly, at least until 1860.

The principal strength of town planning as developed under the Second Empire – and which contributed to its success in the French provinces and abroad – lay in its unity of design and execution. This unity was the result of a centralized urban renovation scheme which, in Paris but not in other cities, was overseen throughout by one man: Haussmann. The scheme involved applying a unified plan to the city, modelled on the dynamic and open concept inherited from Baroque architecture. It was built high, with neatly laid-out streets and avenues with commanding vistas, and with grand buildings representing the various administrative, commercial and cultural roles of the city. At ground level, a network of thoroughfares linked the various neighbourhoods; while the mains and sewerage infrastructure of the city was constructed underground.

The need to modernize Paris stemmed not so much from political or strategic considerations – which have often been cited as reasons for the redevelopment but which were really side effects of it – as from two main factors: public sanitation and traffic, issues resulting from the expansion of the city. Since the 1830s health officials had repeatedly condemned the living conditions in a city where more and more workers were living in ever-closer proximity, both in the centre and on the out-skirts. The overcrowded conditions led to outbreaks of disease, such as the cholera epidemics which hit the city in 1832, 1848 and 1849. People needed air and light, both essential requirements for a healthy life. So, while painters headed off to Barbizon or to the Normandy coast to experiment with *plein air* painting, the French capital was being made more spacious by the building of squares, parks, gardens and tree-lined boulevards.

The dramatic rise in the city's population meant that roads had to be

built across the city to cope with increased traffic. The advent of the railways meant the building of stations, a need for open areas and streets for the crowds to come and go, and more new roads to connect the stations: all this was essential to prevent parts of the city from becoming completely congested. In their street scenes the Impressionists, and Pissarro in particular, carefully observed the crowds of Parisians, whose journeys around the city the planners tried to make more easy.

A characteristic of town planning under the Second Empire was the creation of a new network of wide boulevards and streets, superimposed on the old street pattern. Haussmann unhesitatingly demolished existing buildings in order to lay out new, straight streets, which were much wider than the old ones. These new streets were flanked by five-storey apartment buildings, built to a high standard, whose chief merit was their perfect alignment with one another. The old medieval districts of the city were demolished to make way for a vast market complex in Les Halles and an administrative centre in the Île de la Cité. The east of Paris became very built-up, developing somewhat chaotically into a working-class area, while the west was dominated by affluent neighbourhoods.

Taking their cue from the British model, the Parisian planners built squares and tree-lined boulevards to give the city a more spacious feel, and large public parks and gardens were laid out under the supervision of the engineer Adolphe Alphand (1817-91): to the east the Bois de Vincennes, to the west the Bois de Boulogne, to the north the Buttes-Chaumont and to the south the Parc Montsouris.

The limits of the city were extended to include the outlying villages located between the city's fortifications and the ring of tollbooths. The number of *arrondissements* (municipal districts) was increased from twelve to twenty, and some administrative functions were devolved to each of the twenty town halls. Planners also sought to make the city salubrious and functional: overseen by François-Eugène Belgrand (1810-78), the number of street gaslights trebled, as did the number of buildings supplied with running water, the mains system expanded to twice its previous size and the sewerage system expanded fivefold. The new Haussmann apartment buildings bore plaques proclaiming: 'running water and gas on every floor'.

The public transport system was restructured and in 1854 it was taken over by the Compagnie Générale des Omnibus, which obtained a 50-year monopoly in 1860. One idea in particular emerged that was to have major implications: the creation of urban railways to decongest the roads. The first of these railways was the Petite Ceinture (1851-5), which was built before the first Métro line opened in 1900. The work that Haussmann began was completed and enhanced under the Third Republic.

Like Paris, French provincial cities were also revamped to take account of their increasing size, with old city walls being levelled and transport links set up with the new railway stations. In Lille the Rue Faidherbe (as

it is called today) and in Marseilles the Rue de la Republique were laid out, while in Lyons between 1854 and 1864 the Prefect, Claude Vaisse (1799-1864), sought to emulate what Haussmann had done in Paris.

Paris, a modern capital city, became a model for other European cities. In Rome, which had become the capital of the newly united kingdom of Italy in 1871, the Viviani urban expansion scheme was implemented between 1883 and 1901. This involved building the streets Corso Vittorio Emanuele, the Via Nazionale and the Via Cavour, as well as the development of the Victor Emmanuel district in the west of the city and the Prati district in the east. Both of these districts were laid out in the orthogonal pattern common in the 19th century. In Brussels, great boulevards were built which focused the city centre on the Place De Brouckère and the Place de la Bourse. Indeed, the Parisian model was so influential in Brussels that planners even introduced Haussmann-style apartment buildings, despite the fact that these were not really compatible with the lifestyle of the city's residents. In Barcelona, an urban plan described as 'the most systematic in Europe' was unveiled, which was to become the prototype for American cities: the grid street pattern devised in 1859 by the Spanish engineer Ildefonso Cerdá (1815-76), with diagonal streets designed to make traffic flow more quickly. In Vienna, by contrast, planners took the opposite approach to Haussmann: instead of building new roads within the existing urban structure, which they refused to alter in any way, they built on the site of the old city walls, whose demolition had begun in 1857. After 1870 Germany also adopted this strategy: in

Metz, Strasbourg, Mainz and other cities, the old city walls were demolished and public gardens were built in their place. The city boundaries were extended while ensuring that the new neighbourhoods were connected to the original centre by roads which preserved the historic vistas, as for example in Strasbourg, where the Cathedral remained a dominant focal point.

Building programmes

Paris's modern identity did not derive only from its urban planning designs, but also from its building programmes. Like most other cities, Paris was now provided with a whole series of public buildings. The concept of the public building and the role it played in the life of the city – a concept which originated in the 18th century – had been developed by architects during the years of the revolution and the Napoleonic Empire. However, it was not until the second half of the 19th century that their theories were brought to fruition. Whereas in the past public services had been housed rather haphazardly in former townhouses, now new purpose-built edifices were designed for them. Town halls were built in every *arrondissement* of Paris and in every provincial town in France. Libraries, museums, public record offices and courts were built if the size of the town warranted them. Since they had to be built quickly and in large numbers, these buildings became increasingly standardized in design.

Hospitals, prisons and schools were built according to a precise architectural formula. Furthermore, entirely new types of building for which there were no pre-existing models were built: for example, railway stations, shopping arcades (the earliest dates from 1810), department stores and museums. Even in cases where models did exist, such as for libraries, the services which the new buildings had to provide were so different from those previously provided that architects had to come up with new designs. New churches, whose design now had to incorporate rooms for the teaching of the catechism, were built in proximity to these public edifices, especially during the Second Empire, when the government relied heavily on Catholics for political support.

All of these building programmes are characteristic of the second half of the 19th century: firstly, in their sheer number – hundreds of railway stations were built, as well as tens of thousands of schools and town halls – and secondly, in the consideration of the purpose of these buildings, and the attention paid to their interior layout. Hospitals were built with separate wings so as to minimize the risks of infection; prisons were built with a view to greater security. Generally, the public areas in these buildings were of vast proportions: railway stations and town halls, for example, were built with immense concourses and monumental staircases.

These buildings were constructed in very different styles. Some, such as

RT CÉZANNE DALI LÉGER PICASSO BAUM HAMMER BACON DELACROIX LA TOUR ENSOR FRA ANGELICO BRITON RIVERA VAN EYCK GAUGUIN LEONARDO DA VINCI KLEE RAPHAEL DAVID GAUDÍ DONATELLO
DÜRER MONDRIAN KANDINSKY FRIEDRICH MICHELANGELO GOYA MOREAU MORANDI CHAGALL MIRÓ MUNCH MANET BRAQUE KLIMT CARAVAGGIO ROTHKO DÜRER TURNER ARP TITIAN
RUBENS DELACROIX EIFFEL ENSOR BACON TINTORETTO TURNER MATISSE VAN GOGH LE GALLIÉN LE NAIN ERNST BOLDY GAUGUIN GROSZ CÉZANNE CASSATT HUNT KLIMT VAN HODLER BONNARD HUNT

Henri Labrouste,
the reading room in
the Bibliothèque
Nationale, 1854-75,
Paris. Labrouste, a
pupil of Antoine
Vaudoyer and
Hippolyte Lebas,
rebuilt and extended
the national library. For
the interior he used
slender cast-iron
columns, as he had
done for the
Bibliothèque Sainte-
Geneviève (1838-50);
here they support
domes which allow
natural light to flood in
from above.
Photo Jeanbor
© Larbor/T

railway stations, were built using modern materials, perhaps to acknowl-
edge how modern they were; others were built in the traditional style, or
at least appeared to be. But they all incorporated modern construction
techniques and features such as central heating, metal floors and gird-
ers in public buildings, and glass roofs which let in natural light in muse-
ums. Modern materials were even used in the restoration of old build-
ings: the dome in the Église du Val-de-Grâce in Paris, for example, was
restored using a metal frame similar to the one used for the dome in the
Paris Opera House, which was under construction at the time.

Despite these modern structural features, these buildings still harked
back to the past in appearance. However, even where the reference to the
past bordered on pastiche, the way in which the former styles were adapt-
ed was always specific. Scale was modified, ornamental motifs were ampli-
fied and the interiors of the buildings were laid out with a view to practi-
cality. Consequently, all town halls built during this period look alike
because of their massive baroque dimensions, although the styles adopted
– Louis XIII and Louis XIV styles, for example – are different. Nevertheless,
in the better public buildings of the era, the idioms of the past were suc-
cessfully transformed and reinterpreted, and the result was 'eclecticism'.

ECLECTICISM

Émile Vaudremer, the Prison de la Santé in Paris, 1864. The star-shaped layout emerged as one of the most effective designs from a security point of view. (From Narjoux F, *Paris, Monuments Élevés par la Ville, 1850-80*, 1881)

Facing page: **Frédéric-Auguste Bartholdi**, The Statue of Liberty (*Liberty Enlightening the World*), inaugurated in New York in 1886. This statue, designed as a colossal Second-Empire-style statue of the Virgin, has two replicas in Paris, one in the Luxembourg Gardens and one at the Pont de Grenelle. A gift from France to America, the Statue of Liberty stands on an island at the entrance to Manhattan harbour. It was originally a design for a monu-mental statue, *Egypt Carrying the Light to Asia* (1867), which was to have been erected at the mouth of the Suez Canal. Photo © Hoa Qui/Grandadam S.

The new civil and religious buildings erected were therefore integrated into the new urban landscape of Paris. Never before had so much building taking place in the city, and this was accompanied by a profusion of sculpture and decorative work that featured both in the interiors and exteriors of the new buildings, especially those buildings designed to showcase middle-class society (the Opera House) or those which already had a historical component (the extension which the Emperor had built between the Louvre and the Tuileries; the Hôtel de Ville rebuilt after the fire in 1870). This phenomenon was extended to the city as a whole (for example, the monumental sculptures of the Third Republic), and to private houses (French furniture design, although treated with disdain by many French people, was widely acclaimed abroad).

These various urban planning initiatives were all officially commissioned. The construction of so many buildings was made possible by the stability that France enjoyed under two successive regimes, allied to a fast-expanding economy. The building programmes contributed to a sense of national pride, and the eclecticism which characterized them was to give its name to this period in art history.

A new code

The underlying principle of eclecticism was to select the best from the past in order to create something modern and new. People in the 19th century were passionately interested in history, and their cultural horizons were widening. Models for inspiration were taken not just from

antiquity, but from all eras of the past, recent or remote, as well as from the contemporary world both at home and abroad. This led to an intermingling of historical and international styles. At the same time, a new awareness of the different styles emerged, together with a clearer appreciation of their distinctive characteristics, and this was important for the development of a national style in individual countries. By the middle of the century, artists and architects who wanted to invest their work with vitality and colour had a whole range of styles to draw on that had been rediscovered one after the other: the rather severe Classical Greek style; the graceful style of the Italian Renaissance (Palladio, Raphael) and the French Renaissance (Francis I and Henry II); then the majestic Louis XIV, the elegant Louis XV and the restrained and delicate Louis XVI styles. After 1860, in the wake of the vogue for neoclassicism, came the Baroque style and its Rococo elements. Artists picked and chose among the various styles available to them with extraordinary freedom, not hesitating to use them side by side within a single work. Eclecticism revealed itself to be both a practice and a system.

The practice consisted in allusion to the architecture of the past. What Claude Mignot says in his book *L'Architecture au XIXᵉ Siècle* can be applied to the other arts: 'In order to understand this architecture, we have to try and recapture this taste for allusion, for evocation, for historical reminiscences and affective associations, which constituted the appeal of their architecture for the people of the time, and interpret this, as we nowadays interpret the art of earlier epochs, as a loose manipulation of forms and images whose ultimate effect [...] can be either successful or unsuccessful.' To allude was not to

imitate, rather it was an act of remembrance or evocation. This was not a new practice: Renaissance artists had interpreted the art of Classical times, while neoclassicism had reinterpreted the monuments of ancient Greece and Rome. But it reached a culmination around 1860 because of the growth in the aesthetic of the picturesque.

The cult of the picturesque can be traced back to the landscape gardens from the end of the 18th century, adorned by decorative follies placed next to each other: Chinese pagodas, Gothic chapels, Italianate casinos and so on. This picturesque aesthetic had flourished during the Romantic period. To the deployment of forms, a trait specific to Classicism, it added the use of imagery; and to the purely visual aesthetic impact it added 'the representation of an idea by a symbolic image' (François Loyer), which created an emotional impact.

Linked to the growth of this aesthetic was the practice of allusion. This was based on a typology of styles dominated by such archetypes as the Italian palazzo and the Dutch town hall, the Henry II sideboard, the Renaissance bookcase and so forth. The various public buildings built between 1872 and 1888 on the Ringstrasse in Vienna on the site of the old city walls are a striking example of this: the Parliament was built in the neoclassical style to evoke the revolutionary spirit of 1789, the Neo-Gothic town hall was modelled on the traditional style favoured by the burgomasters in the Netherlands; the university was built in the Louis XIV style in a reference to the French universities; and the theatre, in an Italianate Baroque style, was inspired by the Venetian Opera House.

In each design – and this is characteristic of this period in Europe – a link was made between the purpose of the work and the historical era when the idea associated with this purpose was most dominant. For example, the neoclassical style became the image of the French

Pierre-Charles Simart, cradle of the Imperial Prince, rosewood, vermeil, silver and metal, 1856 (Musée Carnavalet, Paris). This magnificent cradle, which was completed in three months, is highly typical of the art of the era. Its design reflects the neoclassical and eclectic tastes of the architect and artist Victor Baltard. Baltard asked Simart to execute the great figure of the City of Paris as well as the two genies, and the sculptor Henri-Alfred Jacquemart (1824-96) to do the eagle, while the bronze fittings were cast in the Froment-Meurice foundry. *Photo L Joubert © Archives Tallandier/T*

Late 19th-century bandstand (in the public park of the Villa Berlin in Catania, Sicily). *Photo © L-Y Loirat-Explorer/T*

Revolution, with a rather more severe note being struck by the addition of the Greek style. The same principle applied to furnishings: a dining room would be furnished in the Renaissance Henry II style, for example; a drawing room would be decorated with Louis XV gilt panelling, thus combining elegance with the spirit of the Enlightenment, or alternatively in the Louis XVI style, adding a more subdued and delicate note; a Louis XVI boudoir might be deliberately reminiscent of Marie Antoinette's boudoir at Versailles; or anthropomorphic Moorish figures serving as lamps might echo the Venetian style. In short, only familiar stylistic idioms were employed, so that they would be readily understood by large numbers of people. As regards the use of allusion, although the approach was history-based (in so far as it was the past that provided the sources of the references), the mindset was rationalist, as new techniques and materials were being used. This gave a modern dimension to the buildings constructed during this period. The use of a metal framework enabled Victor Baltard (1805-74) to achieve the required size in his construction of the Église Saint-Augustin (1860-71). The same technology enabled Frédéric-Auguste Bartholdi (1834-1904) to erect the Statue of Liberty (1886) at the entrance to New York harbour and John Wolfe Barry and Horace Jones to build Tower Bridge in London (1886-94). The new electroplating process developed by Charles Christofle enabled him to undertake less costly commissions for works in silver, even for the French Emperor. This same process was used for the Statue of Liberty and for all the large statues of the Virgin which were erected in French towns and cities during the Second Empire.

Charles Garnier

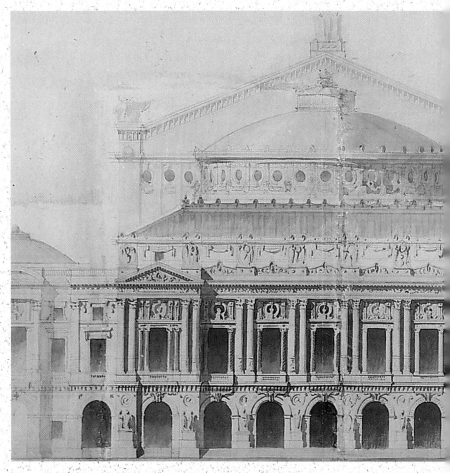

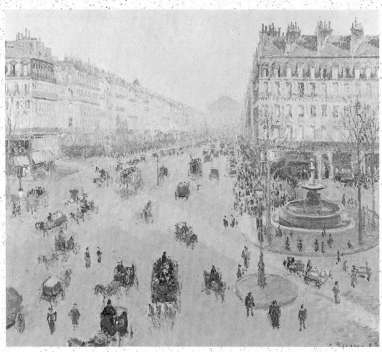

The foyer of the Paris Opera House in 1878, colour lithograph (Bibliothèque Nationale, Paris). *Photo Jeanbor © Larbor/T*

Sketch of the façade of the Opera House: this initial plan, drawn up between 1860 and 1862, shows the colonnaded gallery surmounting the arcade (Bibliothèque de l'Opéra, Paris). Paris's new Opera House was built on the orders of Napoleon III. This 'fashionable cathedral' of the Second Empire, as Théophile Gautier called it, is the most important and most successful example of the unity of artistic creation. In Garnier's view, this unity was essential in order to allow all the artistic elements to be harmoniously distributed throughout the building. For this reason he integrated all the arts into his buildings, seeing the role of the architect as that of director and co-ordinator. *Photo M Didier © Archives Larbor/T*

Camille Pissarro, *Avenue de l'Opéra: Morning Sunshine*, 1898 (Musée Saint-Denis, Rheims). From the Hôtel du Louvre, Pissarro painted around 15 paintings with views of the Avenue de l'Opéra, the Place du Théâtre Français and the Rue Saint-Honoré, 20 years after Haussmann's famous avenue had been built. Pissarro was portraying an image of modern Paris. Photo © Giraudon/T

1825. Charles Garnier is born in Paris to a poor family. He later enters the École des Beaux-Arts as a student in the studio of Hippolyte Lebas.
1848. Having been awarded the Prix de Rome, he studies at the Villa Medici for five years. While there he undertakes a study of the polychrome decorations in the Temple of Jupiter at Aegina, which gives rise to great controversy at a time when the debate about the use of polychrome in Ancient Greek and Roman architecture is at its height. Back in Paris, he is appointed architect for the fifth and sixth *arrondissements*.
1861. Having won the competition for designing the new Paris Opera House, he works on this project exclusively until the building is finally completed in 1874, and writes two books on the subject: *Le Théâtre* (1871) and *Le Nouvel Opéra de Paris* (1878-81). During this time he is also involved in building the stage-scenery store for the Opera House.
After 1875, Garnier designs other buildings, most notably the Cercle de la Librairie building in Paris (1878-9), the Monte Carlo Casino (1878-81), the Nice Observatory (1880-8) and several buildings at Bordighera in Italy, including his own villa.
1898. Garnier dies in Paris.

ECLECTICISM ECLECTICISM ECL
SM ECLECTICISM ECLECTICISM
ECLECTICISM ECLECTICISM ECL
SM ECLECTICISM ECLECTICISM
ECLECTICISM ECLECTICISM ECL
SM ECLECTICISM ECLECTICISM
ECLECTICISM ECLECTICISM ECL
ISM ECLECTICISM ECLECTICISM

ECLECTICISM

Eclecticism was a coherent system based on the functional use of different styles: a style mirroring each function, but also a style corresponding to each idea. These styles could be distributed in different works or juxtaposed within a single work, depending on their geographical or social environment or the purpose for which they were intended. The medieval style was usually reserved for buildings with a religious function: this usually took the form of the Gothic style for churches, but larger cathedrals such as the Cathedral of Marseilles (1852-93) by Léon Vaudoyer (1803-72) or the Sacré-Coeur in Paris (1876-1919) by Paul Abadie (1812-84) – inspired by the pilgrims' church at Saint-Front-de-Périgueux in south-western France – were built in the Romanesque-Byzantine style. There was also a strongly Gothic influence in the monumental statues of the Virgin Mary, although other, secular monuments and buildings were inspired by medieval styles. The classical style (either Italian or French) was reserved for public buildings such as the stock exchange, courthouses, museums, libraries, etc, whereas the Italian Baroque style was used for buildings designed to showcase the grandeur of the city: for example, the Paris Opera House completed in 1874 by Charles Garnier (1825-98), the Viennese Opera House, and the fountain at Saint-Michel in Paris (built in 1856-60 by Gabriel Davioud).

For buildings with a purely utilitarian function the modern style was used, a style which can be considered as one of the components of eclecticism. Examples of this style are to be found in greenhouses, most strikingly the Royal Greenhouses at the Laeken park near Brussels, which were built in 1875-6 by Alphonse Balat (1819-95); markets (the Saint Quentin market, 1866); shopping arcades; covered food markets (the

Eduard Van der Null and August von Siccardsburg, the new Viennese Opera House ('Staatsoper'), an etching by Charles Fichot after M L Kaiser (Bibliothèque Nationale, Paris). Vienna's Imperial Opera House was inaugurated on 25 May 1869 with a performance of Mozart's *Don Giovanni*. *Photo © Bibliothèque Nationale/Archives Larbor/T*

The main World Fairs

Joseph Paxton's Crystal Palace (interior), watercolour by David Roberts (1796–1864) (Bibliothèque Nationale, Paris). An international competition was held to select a building design for a venue to house the first World Fair in 1851. There were 245 entrants, and the French architect Hector Horeau won the first prize with a design for an iron and steel structure; however this was not taken up, as it did not take account of what use the building would be put to after the exhibition. Paxton then drew up a design which he submitted to the committee. Although overall his building was not far removed from Horeau's design, in its details it was similar to the conservatories Paxton had previously designed. After the World Fair, the Crystal Palace was taken down and rebuilt at Sydenham, South London. It was destroyed by fire in 1937. *Photo © Bibliothèque Nationale/Archives Larbor/I.*

In 1850, France lowered its trade barriers and was soon followed by other countries. As a result, trade fairs and exhibitions – which had encouraged the development of new industries in an exclusively national context during the first half of the 19th century – became international, illustrating the growth in international trade.

1851. The first World Fair takes place in London's Hyde Park, where the Crystal Palace is built by Joseph Paxton (1801–65), a horticultural expert and engineer. This new type of building is a big success and serves as a model for the buildings constructed in Munich and New York for the Turner exhibition.

1855 (Paris). The Palais de l'Industrie is built on the Champs-Élysées by Jean-Marie-Victor Viel: with its iron roof supported by stone walls, it serves as the permanent venue for all future World Fairs in Paris until the end of the century. (It is demolished in 1900 to make way for the Grand Palais.) On the fringes of the exhibition, near the Place de l'Alma, Courbet's exhibition Realism is held in a separate pavilion.

1867 (Paris). The Galerie des Machines is built at the Champ de Mars, its metal framework having been manufactured at the Eiffel-Krantz factory.

Nearby, again at the Place de l'Alma, private exhibitions of Courbet's and Manet's works are held.

1873 (Vienna). Financial crisis. A private exhibition of Courbet's work takes place on the fringes of the World Fair.

1878 (Paris). Two important buildings are built. The first is a temporary construction, at the Champ de Mars; the other, a permanent construction, at Chaillot: this is the Palais du Trocadéro, designed by Gabriel Davioud (1824–81) and Jules Bourdais, later to be demolished to make way for the Palais de Chaillot. The work of Louis Comfort Tiffany, the famous American glassmaker, is exhibited.

1889 (Paris). The most important World Fair of the century. The Galerie des Machines is built by the architect Charles Dutert (1845–1906) and the engineer Victor Contamin; this would later be destroyed in 1910. The Eiffel Tower is built to mark the main entrance to the fair. An exhibition of paintings by the Synthetists takes place at the Café Volponi.

1897 (Tervueren in Brussels). The Belgian Art Nouveau movement is officially sanctioned, with the architects Paul Hankar, Gustave Serrurier-Bovy and Henry van de Velde commissioned to decorate three rooms of the Congo Palace.

1900 (Paris). The Grand Palais and the Petit Palais are built, as is the Alexander III Bridge. Triumph of the Art of 1900 exhibition. The glassmaker and designer Emile Gallé enjoys huge success. The invention of reinforced concrete is announced. An exhibition of Rodin's works takes place on the fringes of the fair.

Halles Centrales designed by Baltard in 1854); department stores (Au Bon Marché (1872-4) by Louis-Charles Boileau (1837-1914), Au Printemps (1882-9) by Paul Sedille (1836-1900)), exhibition halls, especially those designed for the World Fairs; bridges (the Forth Bridge near Edinburgh, 1882-90, designed by Sir Benjamin Baker, Sir John Fowler and Sir William Arrol); viaducts (the Kaiser Wilhelm viaduct at Müngsten, 1893-7, by Anton von Rieppel, still the highest viaduct in Germany today); and railway stations (St Pancras Station in London, 1865-7, designed by W H Barlow and R M Ordish, and the stations in Budapest: the Nyugati or Western station, 1874-7, by Gustave Eiffel, with its prominent gabled roof in the main hall, and the Eastern station, 1881-4, designed by Gyula Rochlitz, where the gable forms a monumental arcade as in the Parisian train stations).

Moreover, architects and artists used specific styles depending on the idea that they wanted to express. The Baroque style, which originated in Rome just when the papacy had set about re-establishing its grip on Christianity after the upheaval of the Reformation, expressed the idea of triumph. The Neo-Baroque façade of the Paris Opera House expressed not only imperial splendour – in this regard it was intended to rival the Louvre and the Tuileries – but also the triumph of middle-class society during the Second Empire. As for sculpture, following the amnesty granted to the Communards in 1879, *Triumph of the Republic* (1879-89), erected at the Place de la Nation in Paris by the sculptor Jules Dalou (1838-1902) was directly inspired by Rubens's *Triumph of Religion*: its Baroque style, the sculptor felt, was best suited to 'put all the glorious pomp of the century of Louis XIV at the service of democracy'. The corners of the roof of the Paris Opera House were adorned with statuary featuring horses straining against their handlers: this idea was inspired by the *Horses of Marly*, sculpted by Antoine Coysevox, which today have been replaced by copies at the entrance to the Champs-Élysées in Paris. Other examples were: the left acroterion of the Opera House, which featured *Fame Restraining Pegasus* (1866-70) by Eugène Lequesne (1815-87); at the Guichets du Carrousel, the *Genius of the Arts* (1877) by Antonin Mercié (1845-1916); at the north-western pier of the Alexander III bridge, *Fame of the Sciences* (1898-9), by Emmanuel Frémiet (1824-1910); and at the corner of the Cours La Reine at the Grand Palais, *Harmony Triumphing over Discord* (1900) by Georges Récipon (1860-1920).

But it was in the 18th century that the elegant, delicate and infinitely subtle rhythms of dance were most successfully captured in sculpture. Jean-Baptiste Carpeaux (1827-75), the greatest sculptor of the Second Empire, produced one of the masterpieces of the century: *Dance* (1869). Its modernity created a scandal at the time, but this sculpture is, like the Opera House itself, the most perfect work of art of the period and the one which best represents it.

In contrast, the realist style, generally used by animal sculptors, was

Jean-Baptiste Carpeaux, *Dance*, 1869 (Musée d'Orsay, Paris). This sculpture, which originally adorned the right-hand façade of the Paris Opera House, has today been replaced by a copy. Garnier, like Charles Le Brun in the Versailles of Louis XIV, 'dictated to [his] artists', as he put it himself, 'not only the exact measurements, but even the subjects, the silhouettes, the general colour scheme, the manner and the style of the design'. Carpeaux, who was commissioned by Garnier after Pierre-Jules Cavelier withdrew from the project, created a masterpiece. *Photo © Lagiewski/RMN*

ECLECTICISM

suited to expressing the idea of historical reality. This was the style used by Dalou for the high relief of his *Mirabeau Replying to Dreux-Brézé* (1883-91, bronze, Palais Bourbon, Paris) and his *Monument to Workers* in the 1890s; it was also used by Frémiet in his *Gallic Chieftain*, his *Roman Knight* (1864 and 1866, both bronze, Saint-Germain-en-Laye), and his *Joan of Arc* (1874, Place des Pyramides, Paris). Historical realism, which began to feature more and more in sculpture in the 1870s, had become its official language by 1880, as demonstrated by the sculptures of the Hôtel de Ville in Paris, which was rebuilt after having being burnt down during the Paris Commune. It replaced the more classical style which prevailed in the mid-1850s, the period when the Louvre was being decorated under the direction of Hector Lefuel (1810-81).

The style inspired by the Renaissance expressed the ideas of humanism and secularism. It was in order to associate the town hall of the first *arrondissement* in Paris (1857-61) with these ideas and give it a 'civil' aspect that Jacques Ignace Hittorff (1792-1867) resorted to the Early Renaissance style, while at the same time retaining an overall Gothic plan. He also used flamboyant decorative elements, for example in the rose window and the balustrade, which correspond to the style of the neighbouring church of Saint-Germain-L'Auxerrois. The same principle applied to the furniture: the Renaissance style of the bookcase made by cabinet-maker Alfred Beurdeley (1867, private collection), with its curvilinear pediment and its cornice derived from architectural models, recalls the same humanist spirit and the era when the first great libraries of printed books were founded. The Renaissance style was used more and more by sculptors after the defeat of France in the Franco-Prussian War of 1870 and the Paris Commune. It attracted them because it expressed the drama of human existence in a way which reflected their patriotic sentiments. *The Age of Bronze* (1875-6, Musée Rodin, Paris) by Rodin (1840-1917) uses the nude to illustrate this theme. This work was originally called *The Vanquished*, and the figure carried a spear; in 1877, at the Brussels World Fair, Rodin removed the spear and retitled the statue so as to emphasize its human and universal nature.

It was not unusual for an artist to use a variety of styles. The architect Théodore Ballu (1817-85) built a Romanesque church, Saint-Ambroise (1865), in the working-class eleventh *arrondissement* in Paris, but used a florid Renaissance style for the Église de la

Jules Dalou, *Triumph of the Republic*, 1879-99 (Place de la Nation, Paris). Dalou produced a sculpture in the Baroque style which epitomized his personal, artistic and political concerns. Located at the former Place du Trône, where Louis XIV and his queen made their triumphal entry into Paris in 1660, this monument faces towards the centre of the city. Its site is also in the working-class area of Paris where the 1848 revolution originated, and thus the statue celebrates the Republic at peace following the amnesty granted to the Communards, from which Dalou himself benefited.
Photo J-L Charmet © Larbor/T

Trinité (1861-7), which was in a more fashionable business district of Paris.

The sculptor Dalou operated in much the same way. The sculptor and designer Albert-Ernest Carrier-Belleuse (1824-87) created flamboyant *torchères* in the form of human figures for the grand staircase of the Paris Opera House, but he chose a graceful, discreetly Neo-Renaissance style for his 'high-class *objets de luxe*', for example the pair of candelabra (c.1867) in Minneapolis.

Several styles could be found within the same work. Thus, in the case of the Paris Opera House, the main façade is in the 'extravagant style' of the Venetian Renaissance (inaccurately termed 'Baroque') while, at the sides of the building, the twin rotundas which provided separate entrances for the Emperor on one side and regular attendees on the other are in a more classical style. The rear elevation of the building, housing the administrative offices, is in the more sober and restrained Louis XIII style. Inside, the François I style used in the basement contrasts with the Baroque grand staircase, thus creating tension through the opposition and enhancement of styles.

The same mixture of styles was to be found in sculpture. Antonin Mercié said of his *Gloria Victis* (1874, Petit Palais, Paris): 'The perfection of the bodies evoked the Renaissance, while the composition, the Baroque image of abduction and the entire spirit of the work evoked a heroic Deposition from the Cross.' The sculptures by Auguste Clésinger (1814-83) on the façade of the Gare du Nord in Paris were executed in the neoclassical style in order to show how seriously this new type of architecture was being taken and to reinforce the image of the railway station as a modern temple.

Although today eclecticism can be understood as a coherent system, it is nevertheless easy to see why it was

Auguste Rodin, *The Age of Bronze*, bronze, 1876 (Musée Rodin, Paris). This statue was sculpted just after Rodin had returned from a journey to Italy, where the work of Michelangelo had made a big impression on him. Using a life model, Rodin rendered anatomy in a way that was totally different from the approach sanctioned by the art schools of the time.
Photo L Joubert
© *Larbor/T*

109

disparaged for so long. Apart from some first-class works, most of the buildings and designs which the movement produced were mediocre. Furthermore, building and interior-decoration schemes were being commissioned at an unprecedented rate, and so countless works were produced across all the arts and using all kinds of different techniques. With the exception of the work of Puvis de Chavannes, decorative painting was typical of this mediocre work: themes and images referred to the past, allegory was the device most commonly used and the representational style was academic. However, some mural paintings, such as those created by Paul Baudry (1828-86) for the Opera House and in the tradition of the great 17th-century Baroque Italian artists Carracci or Pietro da Cortona, belong to an architectural and decorative idiom that can be defined as typical of the second half of the 19th century. Baudry's contribution, like that of so many painters who decorated the interiors of public buildings and churches, was to embrace the principles of eclecticism and, in this way, to enhance the unity of the finished building.

As well as these official commissions, mention must also be made of private commissions which were similarly influenced by eclecticism and its references to the past, but which made use of construction techniques that were entirely new. At the same time that significant developments were being made in the design of chateaux and aristocratic mansions – for example, the Château de Pierrefonds which was restored by Viollet-le-Duc, or the castles built by Ludwig II of Bavaria – significant developments were happening in the architecture of apartment buildings and the private houses of the upper classes. Great strides were made in house design, especially in England where architects played a pioneering role, while apartment buildings, which were subject to height restrictions, altered the scale and skyline of cities like Paris, Vienna and Berlin and gave the centres of these cities a unified appearance.

In America, where there were no restrictions on how high architects could build, commercial buildings began to soar higher and higher. In a radical departure from the European scale, a new phenomenon emerged: the skyscraper, a term invented in 1889 at the time the Eiffel Tower was inaugurated. Skyscrapers would give the cities of New York, Boston, Chicago and Detroit a new look which was to be that of all Westernized cities in the 20th century.

Facing page:
Pierre Bonnard, *The Dressing Gown*, c.1890 (Musée d'Orsay, Paris). Art Nouveau originated partly among painters who had links with the Symbolist movement and who had dreamed of achieving a synthesis of painting, literature and music. The next generation of artists broadened the scope of this ambition to include all of the arts. This was the aim of the Nabis, although they did not themselves manage to realize it.
Photo © Jean/RMN © ADAGP, 1999

ART NOUVEAU : THE
SYNTHESIS OF THE ARTS

The search for a modern style that would constitute a 'form of art appropriate to our times' – to quote Eugène Viollet-le-Duc (1814-79) – as well as the idea of an art which would form a bond between art and society, seemed to find a response in Art Nouveau at the end of the 19th century. This was an art that sought to eliminate all stylistic references to the past. It developed in Europe between 1892 and 1910, and especially between 1896 and 1904. It became known by a variety of names because it developed in several centres, none of which emerged as the clear leader of the movement: in Britain it was known as 'Modern Style'; in Italy as 'Stile Floreale' (Floral Style), 'Stile Inglese' (English Style) or 'Liberty'; in Germany as 'Jugendstil' (Youth Style); in Spain as 'Arte Joven' (Young Art) or 'Arte Modernista' (Modern Art); in Austria as 'Sezessionsstil' (Secession Style); and in France and Belgium it became known as 'Art Nouveau'. However, the Belgian term had a different origin from the French term. In Belgium, Maus and Picard – the founders of the journal *L'Art Moderne* (1881) – rejected the incorporation of elements from the past into art and described themselves as 'believers in the new art [*l'art nouveau*]'; while in France, the well-known Parisian art dealer and specialist in Oriental art, Samuel Bing, reopened his shop at 22 Rue de Provence in 1895 and called it 'La Maison de l'Art Nouveau'.

A new role for art

In the sense in which they were generally understood, these terms referred primarily to architecture and the decorative arts, even though it was painters who had invented them. However, painting was not to play a dominant role in the development of Art Nouveau. Quite the opposite, in fact: painting lost the supremacy it had enjoyed throughout the second half of the 19th century and was reduced to a decorative element.

The artist Jan Verkade, spokesman for the

Nabis, declared that 'painting should not usurp a freedom that separates it from the other arts'. Architecture was no longer revered as the mother of all the arts: under the new aesthetic the decorative arts predominated over other art forms. However, it was architects themselves who developed painters' ideas and, anxious to achieve a unity of design in their buildings, began to take an interest in interior decoration, going so far as to design even the smallest items of furniture and ornamentation.

Of all the arts, sculpture was least affected by the Art Nouveau style, which was essentially linear and two-dimensional. On the other hand, the visual arts – including engraving, lithography, posters, book illustration and design, typography and bookbinding – blossomed.

Art Nouveau emerged at the same period as Symbolism. Although the two movements sometimes coexisted or followed on one from the other in the work of a few artists and were promoted by the same magazines, they did not derive from the same artistic principle. Symbolist and Art Nouveau artists were, nevertheless, very closely connected: their works were sometimes exhibited together at the same exhibitions, such as the exhibition held by the 'Libre Esthétique' group in Brussels, which opened its doors to practitioners of all the arts. They mixed in the same anarchist or socialist circles. They also mixed with the more progressive sections of the middle classes who were open to new ideas and who expressed their interest in modern art by commissioning work, thereby becoming the driving force behind Art Nouveau.

The distinctive nature of Art Nouveau lay in its theoretical foundation, embodied in two key ideas: the unity of art and art for all. The first idea encapsulated an artistic project: the synthesis of all the arts and their integration into everyday life by applying the principle of art for all, with attention paid to the design of even the smallest decorative items. This project was a response to the examination of the relationship between art and technology, a subject over which artists and philosophers had long deliberated. The Greeks had resolved this problem by separating the 'liberal arts' from the 'manual arts'. Then a distinction had been established between 'major arts' and 'minor arts'. Since the industrial revolution and the advent of the machine age, the problem of the relationship between the 'intellectual' arts and the 'manual' arts had taken on a new intensity, in the form of the relationship between art and industry. It was in the context of this relationship that debates concerning the collaboration between artist and artisan and between aesthetics and functionality were articulated.

The idea of art for all, which had come about with the rise of new classes within society, related to the general issue of what links connected (or did not connect) art and society, and was the slogan of the project to help bring about the birth of a new society. From the middle of the century onwards, and especially during the 1880s, more and more people throughout Europe – under the growing influence of socialism –

Arthur Heygate
Mackmurdo,
frontispiece from the
book *Wren's City
Churches*, 1883. This
illustration is a good
example of the
emergent Art Nouveau
style, with its
characteristic swirling,
undulating lines.
Ph. © DR/T

embraced the ideal of creating a better society. Artists contributed to this by trying to improve the design of everyday household objects and by developing the concept of a 'total work of art' which would have an impact on all areas of life. These objectives were essential to Art Nouveau.

The Arts and Crafts movement in Britain

Britain was the first country to come up with solutions for achieving these two objectives, and these were to have a decisive influence on European art in the last two decades of the 19th century. They were formulated by William Morris (1834-96), the founder of the Arts and Crafts movement, from which Art Nouveau was to develop. The solutions that Morris proposed put him in a paradoxical position, however, as they were predicated on the idea of a return to the past, with which the proponents of Art Nouveau sought to break.

As a Ruskin disciple (see p.70-71), an art historian and an aesthete, Morris favoured the use of the Gothic style and espoused the cult of nature. He rejected the mechanization of society, and advocated a revival of craftsmanship in an attempt to recreate the fusion between the roles of artist and artisan such as had existed in the Middle Ages. In 1861, he set up a firm for the production of furniture and furnishings which was the first of its kind. The Pre-Raphaelite artists Rossetti, Burne-Jones and Brown participated in this venture, describing themselves as 'Fine Art Workmen in Painting, Carving, Furniture and the Metals'. The firm was dissolved in 1875, and Morris became involved in chintz manufacture in 1881, before setting up a printing works in 1891. In 1888 he founded the Arts and Crafts Exhibition Society, which was taken over by Walter Crane after Morris's death. He based his idea of a synthesis of the arts on socialist ideals; indeed, in 1882 Morris became a socialist and went on to found his own political movement, the Socialist League.

In the 1880s, the nascent Arts and Crafts movement was essentially based on a revival of the Gothic style, with numerous guilds being created as in medieval times. Some of these were led by architects who had been involved in the Domestic Revival, and who Morris had attracted into the Arts and Crafts movement. Of these, some of the most important were: Arthur Heygate Mackmurdo (1851-1942), who, for the cover design of a book on Wren's churches (1883), used the first of the floral motifs which were to become so characteristic of Art Nouveau; Charles R Ashbee (1863-1942), notable for his strong interest in the education of the working classes; M H Baillie Scott (1865-1945), who was to work with Ashbee on the ducal palace at Darmstadt; and Charles Annesley Voysey (1857-1941), remarkable for the simplicity and restraint of his designs. In the work of all these architects, medieval themes and Morris's ornate craftsman-like finish gave way to a new aesthetic design which favoured simple interiors adapted to their domestic function.

Furthermore, in the work of graphic artists and illustrators (in particular Crane), Gothic-style motifs were gradually superseded by motifs influenced by the work of the poet and painter William Blake, as well as by Japonism, which was introduced into England by Whistler.

A rational aesthetic in France

Morris's ideas were exported to the continent, where they combined with the revival of art and design flourishing in Europe and the architectural theories of Viollet-le-Duc to form the basis of a new aesthetic.

The influence of Viollet-le-Duc's architectural theories can be traced primarily to his *Dictionnaire Raisonné de l'Architecture Française du XI^e au XVI^e Siècle* (1854) and *Entretiens sur l'Architecture* (first volume 1863, second volume 1872), and to the exhibition devoted to his work in 1880

Eugène Grasset, *Spring,* stained glass window, 1884 (Musée des Arts Décoratifs, Paris). Grasset was one of the most important artists to play a part in the early development of Art Nouveau. In his work he strove to achieve a synthesis between Gothic Revival elements and the use of ornamental lines inspired by nature and Japanese art.
Photo L Joubert
© Larbor/T

at the Hôtel de Cluny in Paris. Viollet-le-Duc's central idea was to sub-ordinate the form, function and materials used in a building to the over-riding objective being pursued. In his view, form was dictated by func-tion and materials, not by aesthetic principles. Ornament should not be something extraneous or added on, but should reveal the true nature of the construction. Decoration, he once famously said, 'covers a building not like a garment, but in the same way that muscles and skin cling to a man'.

Viollet-le-Duc offered a concrete solution to the question of architec-tural unity by articulating the relationship between structure, materials and ornament, and this was the basis on which Art Nouveau architects were to found their aesthetic principles. In his book *Dictionnaire Raisonné du Mobilier Français de l'Époque Carolingienne à la Renaissance* (1858-75) he also outlined his concept of a total art, including furniture; an art for everyone, combining quality with accessibility.

Viollet-le-Duc paid particular attention to the study of nature and, as was done in the Middle Ages, he used motifs and imagery drawn from the natural world for ornamental purposes. He had a direct influence on artists, and on Eugène Grasset (1841-1917) in particular. Grasset was responsible for designing the figure of the sower, accompanied by the motto '*Je sème à tout vent*' (I sow in the wind), as the distinctive logo for the Paris publishing house Larousse; he also designed furniture, plans for stained glass windows, posters, book and catalogue covers and decora-tive panels – all of this bearing ample testimony to the principle of 'art in all aspects of life'. His influential book *La Plante et ses Applications Ornementales* (1897) had a considerable influence on artists and design-ers working in the late 19th century.

Japonism also contributed to the renewed interest in nature. Japanese art, in its depiction of nature, was characterized by the prolific use of flowing arabesques and fluid lines and rhythms. This made a strong impact on almost all artists, among them Felix Bracquemond (1833-1914), who was an engraver and painter before becoming a ceramist.

The desire to be at one with the modern world – a defining character-istic of Art Nouveau – was reflected in the attempt to create a new form of art. This experiment was based on a broad concept of living space. The essentially rationalist approach taken by artists was characterized by the desire to adapt structures to the functions they were supposed to fulfil; by the use of new materials such as iron and steel, for example, which were allowed to remain visible (when it came to the use of iron, Ruskin and Viollet-le-Duc did not see eye to eye, the former seeing it as herald-ing the end of architecture and the latter seeing it as a rich source of architectural possibilities); by the use of new technology, including – and this ran counter to Morris's precepts – machines which reduced the cost of the manufacturing process; by a perfectionist approach to detail which corresponded with Morris's beliefs and with the revival of crafts-manship; by a desire to breathe new life into forms by using new tech-niques and materials; and finally by a specific concept of ornamentation.

Ornament now emerged organically from the building materials, which it no longer concealed. It corresponded to the function of the building or room, was integrated into the overall structure and applied to the space as a whole, resulting in a total unity of structure and design.

This essentially decorative style was characterized by its emphasis on line, either floral or geometric, by a fluid rhythm and by its treatment of surfaces in a one-dimensional style rather than in depth, whether these were the façades of buildings or the frontispieces of magazines, posters, illustrations and so on. In short, architects and designers were attempting to create a modern and utilitarian style.

Art in the home

Henry van de Velde, Bloemenwerf House, 1895, in Uccle, a suburb of Brussels. As Morris had done with the Red House at Bexleyheath, most architects built their own homes. Here, unconstrained by having to work to the specifications of a client, van de Velde went for a sober, restrained style. Photo © F Loze/ Archipress

Experimental investigations into structure, building materials and ornament; the definition of a common style; and a concern for social reform are all characteristic of Art Nouveau and distinguish it from the 1900 style, which was a big success at the World Fair and was the commercial version of Art Nouveau. In Europe, experimentation took place in various artistic centres, of which Brussels was the most important. At this time the Belgian capital was enjoying unprecedented prosperity due to the fabulous riches it extracted from the Congo, and was a very active centre of intellectual and artistic life. It was open to the ideas of the most avant-garde artists and played a vital role in the development of Art Nouveau through the work of four architects: Victor Horta (1861-1947), Henry van de Velde (1863-1957), Paul Hankar (1859-1901) and

Victor Horta

Grand staircase of the Hôtel Solvay, 1895-1900, Brussels (the property of L Wittamer Decamps). A Neo-Impressionist painting was chosen to adorn this staircase. It was painted by the Belgian painter Théo van Rysselberghe (1862-1926), a founding member of the 'Groupe des XX'. Photo © the collector DR/T

he dining room of the
ôtel Solvay, 1895-1900,
russels (collection of
Wittamer Decamps).
rmand Solvay, an
ndustrial magnate,
ommissioned 'the most
xpensive architect in
ne city' to design his
own house. Horta
ntroduced open floor
lans and fluid spatial
rrangements with rooms
vhich opened out into
ne another and fulfilled
ll the domestic
equirements of an
pper-class household.
hoto © the collector
)R/T

1861. Victor Horta is born in Ghent,
the son of a shoemaker.
At twelve years of age, he becomes a
student at the Conservatory of Music,
and at 15 he begins to study
architecture. Between the ages of 17
and 19 he lives in Paris, where he
works in the studio of the architect
and designer Jules Debuysson.
1880. He takes up residence in
Brussels, and continues his studies at
the Académie des Beaux-Arts under
the supervision of Alphonse Balat, the
architect of King Leopold II, who,
despite his fondness for classical
architecture, was responsible for the
building of the famous Royal
Greenhouses in the gardens of the
castle of Laeken.
1886. He builds three adjoining three-
storey houses in Ghent, in the Rue des
Douze-Chambres. For a period of
almost seven years, he concentrates
exclusively on developing a new
stylistic vocabulary for architecture.
1890. Thanks to Balat, he obtains the
commission for a monument designed
to showcase the bas-relief *The Human
Passions* by the Belgian sculptor Jef
Lambeaux in the Parc du
Cinquantenaire in Brussels.

1893. He designs the Hôtel Tassel (12
Rue de Turin, Brussels), the
culmination of his architectural
development, which dismays Balat and
scandalizes public opinion, but which
soon attracts the interest of architects
and designers from all over Europe. A
spectacular stairwell is the centre
point of the house's layout. His
painstaking attention to detail leads
Horta to provide his own designs,
inspired by the plant kingdom, for the
luxuriant decoration of the building.
The mosaic floors, ironwork
balustrades, walls painted with
frescoes and stained glass windows all
combine to make this house a
showpiece of Art Nouveau
architecture.
In another town house built just after
this, the Hôtel Solvay, even the
smallest details and items are
conceived as a function of the overall
design and produced according to the
architect's specifications.
After 1900, Horta returns to a more
conservative style of architecture
dominated by classical references, and
he even goes so far as to attack the
experimental architects of the 1920s.
1947. He dies in Brussels.

Gustave Serrurier-Bovy (1858-1910). In 1893 Horta finished the first Art Nouveau building: the Hôtel Tassel, a Brussels town house. The architect's innovative design was expressed in an extensive and versatile floor plan, and a fluid open-plan arrangement of the interior space, made possible by the bold use of new materials. Inside, the 'whiplash' or 'Horta line' was used throughout, and in particular on the famous staircase. The Hôtel Tassel was followed by other commissions in which Horta used a combination of iron and glass to spectacular effect in both interiors and exteriors: for example, the Hôtel Solvay (1895-1900); the Maison du Peuple (1895-9, demolished 1965), which was commissioned by the Workers' Party; Horta's own private residence (1898-1900); the Hôtel Aubecq (1899-1900); and the À L'Innovation department store (1901, demolished 1966-7). In each of these typically Art Nouveau buildings, Horta took charge of the design of all the interior décor and furnishings. From items of furniture down to the most minute ornamental details, the signature whiplash curve that characterized Horta's linear design gave a dynamic appearance to the whole structure.

Unlike Horta, who was never an architectural theorist, van de Velde was actively concerned with conceptualising the foundations, experiments and methods of the new style, a style which would help architects to purge their work of references to the past. In 1890, he abandoned painting to concentrate on architecture and applied arts. Like Morris, he took the view that art should permeate all aspects of the everyday environment, and that the role of the architect-designer was to help transform the world through the logic of structural forms – although he did not share Morris's wholesale rejection of mechanization. The first building that van de Velde designed was Bloemenwerf House (1895), his private residence at Uccle, in the Brussels suburbs, where he developed a simple and functional scheme which, as with Horta's design for the Hôtel Tassel, proved controversial. For the interior of the house, he designed low-key, sober furniture which contrasted with the fluid lines of the candelabra,

Henry van de Velde, desk of Julius Meier-Graefe, c.1899. The structural and functional aspects of this piece of furniture are emphasized at the expense of decorative elegance. Photo © Lauros-Giraudon/T

FLAMENG GHÉRÂME SEURAT ANTAL HOFFMANN MOREAU DE MORNY MILLES FECHNER WALTER WILLIAM MACKINTOSH DAVIES WHISTLER AGHEIM FANTIN DE MAZADE RENARD BOYER BLANCHE
LOMMER VALLÉE MEUNIER LE FUEL VAN NOKUM MILLER MORIN LE HUBREN FONTASIT MOHAS MUGUM MOHIN LE IN MUGH ROUGE VADAR GOSSIET J BAYON PERSELL ORSARGET MATH
NOGINTEN WATELET DETAILLE LE TER ELÉN DERFLER VAN DUOR DETOR HERREN AV BRET MATHODELIRZA GLAEREDT ERKODING ROXXE PEIXON FLANTEN NUMANN TURN
X DUGAS DELACROIX LE TY EL ENSOR FANTIN-LATOUR FATINI FLAMENG GAELE GAELEN MAELELA GAUDI GAUGUIN GRASSET GUIMARD HAUSSMAN HOLDEN HOFFMANN HOUN

Hector Guimard, front entrance of the Castel Béranger apartment building, 1894-8, Rue La Fontaine, 16th arrondissement, Paris. This gate has a florally inspired design which is asymmetrical, dynamic and extremely stylized. *Photo © F Eustache/Archipress*

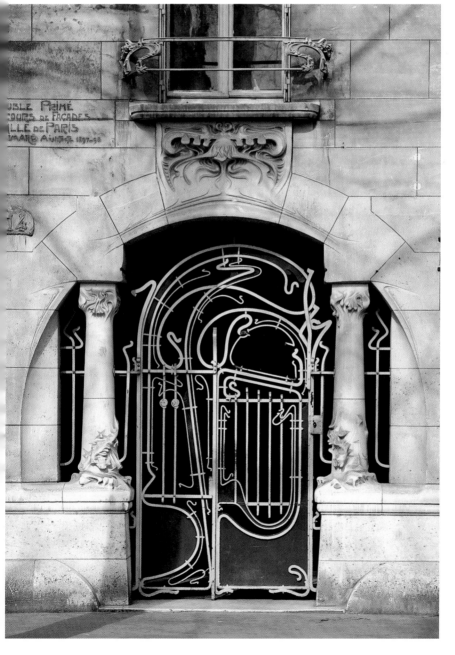

door handles and so forth. The house earned him the admiration of the art dealer Samuel Bing, who asked him to design furniture with more dynamic lines. Then the German art critic Julius Meier-Graefe, whose desk (c.1899, Nuremberg) he would later design, invited him to Berlin in 1899. In 1901-2, at the request of the Grand Duke of Saxe-Weimar, van de Velde settled in Weimar to 'improve the standards of the art industries'. There, in 1908, he founded the School of Arts and Crafts, where no formal instruction in architectural or decorative styles was given. In 1919, he chose the architect Walter Gropius (1883-1969) to succeed him. Gropius would go on to found the Bauhaus, on which van de Velde can be seen to have had a seminal influence.

Apart from Horta and van de Velde, two other less famous architect-designers contributed to the definition of Art Nouveau. As early as 1893, Paul Hankar designed the façade of his own house as a decorative whole, assimilating elements of Japanese art which also inspired his linear, unadorned furniture designs. Serrurier-Bovy, who was the first to put Belgian artists in contact with the English Arts and Crafts movement, abandoned architecture so as to concentrate on designing furniture with 'gently undulating lines'. Then, after 1905, he designed a form of cheap furniture which, capable of being manufactured for and by the people, anticipated prefabricated designs.

In the early years of the 20th century, Belgian Art Nouveau suddenly died out: in 1901 Hankar died, while van de Velde left Belgium to live in Germany; and in 1903, Victor Horta turned to a form of academicism, while Serrurier-Bovy developed a new aesthetic style. Although the reign of Belgian Art Nouveau had been short-lived, the buildings and furniture it produced were admired throughout Europe, especially in France.

Art for all and in all aspects of life

Paris and Nancy were the two main centres of Art Nouveau in France. In Paris, the new style was promoted largely by the art dealer Bing, who played a vitally important role in this regard: by passing commissions on to artists, he ensured that the style spread not only throughout Europe but even as far as the United States. Among other things, he commissioned the American firm of Louis C Tiffany (1848-1933) to produce stained glass windows based on plans executed by French painters, and commissioned van de Velde to design suites of furniture. In this way he opened up Art Nouveau internationally, while in Europe, particularly in Germany, the new style was promoted by the shop La Maison Moderne, which Julius Meier-Graefe (1867-1935), the director of the Berlin art magazine *Pan*, opened in 1897 (see 'The main Art Nouveau magazines', p.126).

The French architect and designer Hector Guimard (1867-1942) stands out as one of the leading artistic figures of the era. His name was to

become virtually synonymous with Art Nouveau in Paris due to his famous Métro entrances (1899-1904), with their floral motifs and pagoda-style appearance. Following a visit to England in 1894, and after seeing the Hôtel Tassel in Brussels in 1897 and receiving a message from Horta who explained that he had 'completely banished foliage and floral motifs and that he now concentrated exclusively on the stem', Guimard altered his plans for the Parisian Castel Béranger apartment building (1894-8). When it won the award for the finest façade in Paris in a municipal competition, this building made him famous overnight.

Guimard's work was based on three principles: logic, harmony and feeling. He tried to implement these principles in the Maison Coilliot (1898-1900) in Lille and, in Paris, in the Humbert de Romans concert hall (1898-1901, now destroyed), in the Castel d'Orgeval (1905), in his own residence at 122 Avenue Mozart (1910) and in the Hôtel Mezzara at 60 Rue de la Fontaine – all of which rank among his finest buildings. Like his Belgian counterparts, Guimard paid meticulous attention to the most minute details of the construction and furnishings, whose distinctive style can be identified by a kind of 'picturesque exasperation'.

In Paris, along with Guimard, the architect Frantz Jourdain (1847-1935) set himself the task of disseminating the ideas of the Art Nouveau movement in an essay, *L'Art dans la Rue* (1892). His major building, the Nouvelle Samaritaine department store (second store, 1905) was built after Guimard had finished his major building commissions. Its chief architectural merit lies in the way the structure and the materials are

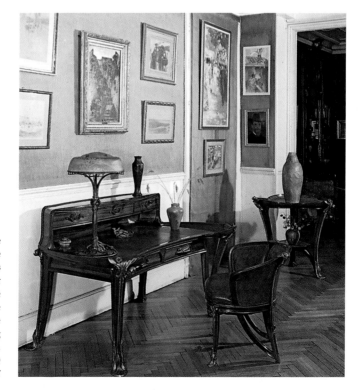

Louis Majorelle, suite of furniture (Musée de l'École de Nancy). This master cabinetmaker liked to embellish the corners of his furniture with gilded bronze mounts representing water lilies or orchids.
Photo G Mangin © Larbor. DR/T

Émile Gallé, piece of glassware created specially for the 1900 Paris World Fair (private collection, Paris). A member of the Nancy School, Gallé drew his inspiration from botany and Symbolist imagery. *Photo J-L Charmet © Larbor/T*

René Lalique, comb with cock's head, in gold, enamel, amethyst and horn, 1898 (Gulbenkian collection, Lisbon). *Photo © Hansmann, by permission of Lalique SA/T © ADAGP, 1999*

presented as aesthetic features in themselves, rather than in its interior decoration, most of which was destroyed in 1935.

Artist-craftsmen also subscribed to the architects' and designers' avowed objectives to create an art that would permeate all areas of life and that would cater for all classes of people. Although in their case this did not extend to a concept of the living space as a total visual environment, they did share the same functionalist approach to décor.

In Paris, these artist-craftsmen included: the painter Georges de Feure (1868-1943), who also designed, among other things, furniture and tapestries; the ornamentist Alexandre Charpentier (1856-1909), who designed a dining room for the Villa de la Champrosay (1901) which is today preserved in the Musée d'Orsay; the furniture designer Eugène Gaillard (1862-1933); the Czech painter and designer Alphonse Mucha (1860-1939), famous for his theatre posters featuring Sarah Bernhardt and his decoration of the Fouquet jewellery store (1900-1, Musée Carnavalet, Paris); and the jewellers and goldsmiths René Lalique (1860-1945) and Georges Fouquet (1862-1957) who designed new types of jewellery based on floral motifs.

In Nancy, a school of artists formed which was to be of major importance in the Art Nouveau movement. Émile Gallé (1846-1904) – known for his multilayered glass vases with gold inclusions and symbolist decorative motifs of flowers, animals and insects – became involved in the manufacture of furniture after 1884. He provided the focus for the creation, in 1901, of the École de Nancy association or 'Alliance Provinciale des Industries d'Art', whose chief inspiration was naturalistic. Louis Majorelle (1859-1926) designed furniture that was simple and plain in structure and often decorated with bronze; Eugène Vallin (1856-1922), formerly a specialist in church furnishings, designed furniture with massive outlines; the Daum brothers, Auguste (1853-1909) and Antonin (1864-1930), were glassware designers who were both influenced by Émile Gallé; Victor Prouvé (1858-1943) worked in collaboration with all of these artists as a decorator; while René Wiener (1859-1939), who specialized in bookbinding, acquired a reputation for his illustrations and designs.

All of these artists, and especially Gallé, played a key role in the transformation of the domestic environment. They were to be followed by architects who would not focus on the issues of materials or structure but who would go on to develop their own ornamental concept of architecture.

FTHAUGHEN GUERT GRASSE GROSS LNEA FILE BEN A SAN MANIER MLLE ANGRAN DOMESER MAC LE ASIER GITBAUER ILL HOENER BAU HILD OL RAZE HERN VALL BOH BLANC
FEMADO EDS DE GTE GRASSE CRNSS UNER FILE DEN MILLE ALIRI EMBRAU DRANTL ARAIG BEAU EASTON VILLAGE GELGE SOLAU GOBERT ISSCH PERTEN GRASS GLT
KUELOS BELACRIA EIFFEL ENSOR FANTIN LATOUR FATTORI FLAMENG GALLE VALLEN KAELLEN GAUDI GAUGUIN GRASST GUIMARD HAUSSMAN HODLER HOFMANN HOLUS

The spread of Art Nouveau throughout Europe

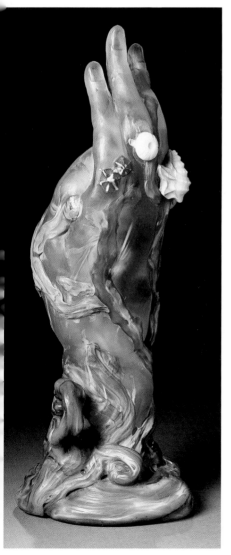

Émile Gallé, Hand with Seaweed and Shells, engraved crystal with inclusions and applications, 1904 (Musée d'Orsay, Paris). Photo © H Lewandowski/RMN

While in France and Belgium Art Nouveau designs were dominated by naturalistic decorative motifs based essentially on flowers and plants, in Anglo-Saxon countries there was a preference for abstract, linear and geometric motifs, although this did not preclude the use of naturalistic elements. Floral motifs were predominant at the 1900 World Fair in Paris, but at the first International Exhibition of Modern Decorative Art in Turin in 1902 linear and geometric forms were to the fore. In the intervening period the most active centres of Art Nouveau were to be found in Britain, where the tendency towards abstraction and geometrical severity was stronger.

In England, where Art Nouveau had originally developed, the designs and ideas of the movement continued to be disseminated through art magazines, especially *The Studio* (1893), which played a vital role in this context. It was, however, in the Scottish city of Glasgow that the most creative group of artists was formed – the Group of Four, which grew up around the architect and designer Charles Rennie Mackintosh (1868-1928). Their art attempted to combine geometric lines, especially vertical lines, with very delicate curves, as for example in the interior of Hill House (1902-3, Helensburgh), in Miss Cranston's first Willow Tearoom (1903), or in the Glasgow School of Art (1897-1909), which is their most accomplished work.

Mackintosh was not much emulated either in England or in France, but his work met with acclaim in Austria and Germany. In Vienna, he was a major influence on the architect Josef Hoffmann (1870-1956), who developed a spare, restrained style based on orthogonal forms. Hoffmann was an admirer of Ruskin and Morris, and was very attracted to the ideas of the Arts and Crafts movement, drawing inspiration from British architects and designers. In 1900, he invited Mackintosh to design the interior of a room for the eighth Secessionist exhibition in Vienna.

Secession was the Austrian branch of the Art Nouveau movement. It was formed in

The main Art Nouveau magazines

Journals and magazines played a key role in spreading Art Nouveau theories and designs throughout Europe. More than was the case with Symbolist art magazines (which performed a similar role and some of which were common to both movements), they disseminated the Art Nouveau style in print and pictures, being the perfect medium for solid-colour art. The publications *Pan* and *Ver Sacrum* always emphasized the association between writing and graphic design. In its first year, *Jugend* employed 175 illustrators.

René Wiener, binding for *Salammbô*, c.1890-3 (Musée de l'École de Nancy). Reflecting the principle of 'art in all aspects of life', it was not just bookbinders like Wiener who showed an interest in book design, but also architects like Mackmurdo and van de Velde. *Photo G Mangin © Larbor, DR/T*

Germany
BERLIN
Die Insel ('The Island'), 1899.
Pan, 1895, founded by Julius Meier-Graefe and Otto Julius Bierbaum, characterized by its openness to new European movements and ideas.
DARMSTADT
Deutsche Kunst und Dekoration ('German Art and Decoration'), 1897, founded by Alexandre Koch.
Kunst und Dekoration ('Art and Decoration'), 1897.
Zeitschrift für Innendekoration ('Journal of Interior Design'), 1889, founded by Koch.
MUNICH
Dekorative Kunst ('Decorative Art'), 1897, the German edition of *l'Art Décoratif*.
Jugend ('Youth'), 1896, the journal from which Jugendstil derived its name.

Simplicissimus, 1896, a publication with a satirical slant.

England
LONDON
Evergreen, 1895.
Hobby Horse, 1894, founded by Selwyn Image (1849-1930). The journal of the Century Guild edited by Mackmurdo, it prefigured the important role played by art publications in the Art Nouveau movement.

The Studio, 1893, the most important publication in an international context.
The Yellow Book, 1894, also a Symbolist publication.

Austria
VIENNA
Das Andere ('The Other'), 1903, a short-lived publication, designed as 'an introduction to Western culture in Austria'.
Das Interieur, 1900.
Kunst und Kunsthandwerk ('Arts and Crafts'), founded in 1898 by Arthur von Scala.
Ver Sacrum ('Sacred Spring'), 1898, also a Symbolist publication.

Belgium
BRUSSELS
L'Art Moderne, 1881, and *Van Nu en Straks* ('Of Now and Olden Times'), 1893, both also Symbolist publications.

Spain
BARCELONA
Joventut ('Youth'), 1900, the equivalent of Jugend.
MADRID
Arte Joven ('Young Art'), 1901, a short-lived publication, founded by Pablo Picasso.

France
PARIS
Art et Décoration, 1897, 'a monthly journal of modern art'.
L'Art Décoratif, 1898, 'an international journal of industrial art and design'.
La Revue Blanche, 1889, also a Symbolist publication.
Revue des Arts Décoratifs, 1880, founded by the Central Union of the Decorative Arts. It played an important role in the 1890s.

Italy
BERGAMO
Emporium, 1895, edited by Vittorio Pica (1866-1930). Close in spirit to *The Studio*.
TURIN
Art Decorativa Moderna, 1892.
Il Giovane Artisto Moderno ('The Young Modern Artist'), 1902.

* The years shown are those in which the magazines were founded.

Charles Rennie Mackintosh, interior of Hill House, 1902-3, Helensburgh, near Glasgow. Miss Catherine Cranston, who had already commissioned him to design four tearooms, asked Mackintosh to redesign her house. Although the architect had previously used both floral and geometric motifs in his work, here the entire interior décor is based on the rigorous simplicity of a rectilinear style; curved lines inspired by naturalistic motifs feature for the most part only in the textiles and light fixtures. *Photo J Maryniak © Larbor (courtesy of the Royal Incorporation of Architects in Scotland), DR/T*

1897 as a reaction against the all-pervasive influence of eclecticism. Moving in 1898 into a building built by Joseph Olbrich (1867-1908), who like Hoffmann was a disciple of the architect Otto Wagner (1841-1918), the Secessionists held numerous exhibitions and published a magazine, *Ver Sacrum*, from 1898 to 1903, before being dissolved in 1905. The two leaders of the movement were Gustav Klimt, the director, some of whose work does indeed come under the category of Art Nouveau, and Wagner, who, after designing mainly historicist-style buildings, in 1895 articulated the principles of a 'modern architecture' and began to take his work in a new direction.

It was Hoffmann – who already possessed all of the Art Deco vocabulary which would make such a huge impact in the mid 1920s – who designed the Wiener Werkstätte (Vienna Workshops, 1903-19), which were inspired by the English Arts and Crafts model. The most perfect example of their work is the Palais Stoclet in Brussels (1905-11), designed as an 'organic entity' down to the smallest detail. However, this revival of craftsmanship was happening at a time when the Werkbund foundation (1907) in Germany was about to propose an alliance of art and industry.

In Vienna, Art Nouveau was causing great scandal and some of its prac-
titioners were obliged to leave Austria: Hoffmann moved to Brussels,
while Olbrich left for Darmstadt in 1899. Darmstadt was, along with
Munich, the most important artistic centre of the Jugendstil movement,
although various other centres in the German empire attracted artists to
their workshops.

There were several distinctive aspects to the German contribution to
the movement: the role played by art magazines, which were illustrated
by the best artists and were even more influential than their counter-
parts in England and France; the influence of van de Velde, who in 1899
began a lecture tour of the major artistic centres; and the importance of
artists' studios. The most famous of these studios was the
Künstlerkolonie (artists' colony) at Darmstadt. Under the patronage of
the Grand Duke of Hesse, each artist was invited to build a house to their
own design, and to furnish and decorate it according to their taste: in
this way each artist could create a 'total work of art'. Olbrich was respon-
sible for overseeing this scheme. Because of the simple, linear Viennese
style that he introduced, combined with the influence of the British
designers employed, as van de Velde was, to work on the New Palace, the
Darmstadt style is generally sparer and plainer than the Munich equiva-
lent. The house of Peter Behrens (1901) shows this influence.

However, the most active group was formed in Munich, where artists
abandoned painting in order to take part in the United Workshops for
Arts and Crafts. These artists included: Hermann Obrist (1862-1927), the
leader of the group; Otto Eckmann (1865-1902), who specialized in flo-
ral motifs; and Richard Riemerschmid (1868-1957), whose key concerns
were uniformity of space and rational, efficient design in furnishing.
August Endell (1871-1925) built the Studio Elvira in Munich (1897-8,
now destroyed), a photographer's studio where the solid-colour and
asymmetrical design of the ornamented façade, somewhat reminiscent
of Japanese art, gave a foretaste of the interior configuration of the
house. In these German studios, art was opening up not only to crafts-
manship, but also to industry. Furthermore, various scissions within this
group led to the creation of breakaway groups, whose role in the birth of
20th-century art would be crucial.

Despite being on the periphery of these major artistic centres,
Barcelona experienced Art Nouveau thanks to Antonio Gaudí (1852-
1926), who was to emerge as the most original and imaginative archi-
tect of the movement. His work had its roots elsewhere: in the vernacu-
lar Catalan tradition of lavish ornamentation, exuberance and symbol-
ism; in a Neo-Gothic style influenced by the rationalist spirit of Viollet-
le-Duc, whose architectural principles Gaudí implemented in the Casa
Batlló (1904-6); and in a consummate handling of natural materials (for
example, the façade of the Güell Palace, 1885-9), which he used with
idiosyncratic verve (for example, Park Güell, 1900-14). He gradually
abandoned historical architectural styles in favour of a concept of the

Josef Hoffmann, the dining room of the Palais Stoclet, 1905, Brussels, with mosaic work by Klimt. The interior of this house, a country residence belonging to a rich industrialist, was designed by a team from the Vienna Workshops founded by Hoffmann. It was only when in exile that the architect was able to eliminate all traces of historicism from these workshops.
Photo © Top. DR/T

work as a unified whole, in the same spirit as other Art Nouveau architects and designers. The Sagrada Família church in Barcelona, on which he started work in 1884 but left unfinished at his death, vividly demonstrates this, and reveals the importance of visual imagery derived from the aesthetics of Art Nouveau.

An ambiguous legacy

Art Nouveau brought to a close a century infatuated with history. By drawing on the Gothic Revival ideas and the motifs of Morris and Viollet-le-Duc, its practitioners had tried to introduce a style appropriate to the times. But did this style really correspond to the new socio-economic order? The result seems ambiguous. Art Nouveau certainly helped artists to break free from eclecticism. But the importance given to ornamentation revealed inherent contradictions within the movement.

The artistic and social ambitions of the movement – art for all and art in all aspects of life – were only partly realized. By placing such a strong emphasis on aesthetic principles, architects and designers were unable to deliver social objectives because they had an excessive concern with ornament. Art Nouveau thus revealed itself to be the invention of individual designers who maintained a tradition of quality craftsmanship

while recognizing the need to make the transition to a new age of industrial production. Art Nouveau perfectly illustrates this transition between two eras: from a relationship between art and craftsmanship to a relationship between art and industry. Van de Velde personified this transition and paved the way for the Werkbund and the Bauhaus.

The Art Nouveau style, which was partly founded on ornament, quickly degenerated into a purely decorative style. Some architects and artists thought that to appear 'modern' it was enough simply to abandon eclecticism and graft the new architectural and stylistic vocabulary onto buildings or objects. By not subordinating ornament to the logic of materials or structure, they did a disservice to Art Nouveau: this was now confused with the 'art of 1900' or '*le style nouille*', as the French nicknamed it (literally 'noodle style', because of its characteristically swirling, intertwined lines).

In the importance which it attached to ornament, Art Nouveau reveals itself as the final embodiment of the picturesque; while in its incorporation of new structural designs and materials, it can be seen as heralding the art of the 20th-century.

Antonio Gaudí, the Sagrada Família, 1883-1926, Barcelona. Commissioned by the Association of the Worshippers of Saint Joseph, this church was begun in 1882. The following year, Gaudí took over as director of operations and set up a studio-workshop on the site that enabled him to solve problems as they arose. This studio served as the creative nerve centre for his work and also as a school of architecture.
Photo © Phedon-Salou, DR/T

HELENE NAGLER GALLEN BATIK DAUM DAUM DAUM DEGAS DELACROIX ETTEL ENTOR FANTIN LATOUR BATIK FLAMENG GALLE HOLLEN NAGLEN GAUDI GAUGUIN BRASSENS
HELENE NAGLEN GALLEN DAUM DAUM DAUM MULLER MULLER MORIAN MORIAN BRASSEN MORIS MEDIUM MEDIUM FLAMENG ROUGE RADAR ARBEL BATIK BABEL DESARE BUT
BUENTIN BATIK DAUM DAUM DAUM MULLER ENTOR DELACROIX ETTEL ENTOR FANTIN LATOUR FLAMENG GALLE GALLEN NAGLEN GAUDI GAUGUIN GROSSEN GOLIONKI HENSSEN VAN HODLER HOHMANN HONS
BUENTIN DELACROIX ETTEL ENTOR FANTIN LATOUR FLAMENG GALLE GALLEN NAGLEN GAUDI GAUGUIN GROSSEN GOLIONKI HENSSEN VAN HODLER HOHMANN HONS

Antonio Gaudí, façade of the Casa Batlló, 1904-6. Having been refused planning permission for a new building, Gaudí was only able to undertake a renovation of the existing structure. Leaving the old rectangular windows intact, he revamped and embellished the building according to the principles of Viollet-le-Duc. *Photo © L Boegly/Archipress*

131

A RETURN TO THE ORIGINS OF MAN

No era in history has been so vilified or so extolled as the second half of the 19th century. Today it appears as a period of contrasts and subtle nuances, richer and more complex than either its detractors or its adulators have ever been willing to acknowledge.

This half-century brought something to art that no other era before had brought: a recapitulation of the entire history of art. This involved going back to the origins of man, a return to the imagery and icons of the past that had already begun in the first half of the 19th century, a journey back to the most primitive times, the most archaic period of human history. Gauguin was aware that he was paying for this quest with his life, and perhaps today we are in a better position to understand the question he formulated in the title of his painting *Whence Do We Come? What Are We? Where Are We Going?* (1897, Museum of Fine Arts, Boston). His life, his odyssey and his work, which would have such an impact on artists at the beginning of the 20th century, belong to the half-century 1848-1903.

With the death of Gauguin – who would become a symbol of this era – the 19th century ended and the 20th century began. Gauguin had deliberately sought out 'primitive' forms of artistic expression which later led painters to the 'discovery' of the African masks whose role was vital in the development of Cubism. In 1904, Picasso moved to Paris, three years before he painted *Les Demoiselles d'Avignon* (1907, MOMA, New York), a picture which marked the birth of Cubism. In 1905, Matisse,

132

Paul Gauguin, *Whence Do We Come? What Are We? Where Are We Going?*, 1897 (Museum of Fine Arts, Boston). In this monumental work, Gauguin communicates both an aesthetic and a spiritual message. It is a meditation on humankind, destiny and art, epitomizing the fundamental concerns of the era while at the same time anticipating those of the 20th century. *Arthur G Tompkins Residuary Fund. Photo © Museum of Fine Arts, Boston/T*

who had been profoundly influenced by Gauguin (and more specifically by Paul Sérusier's *The Talisman*), became the leader of the Fauves, who shocked the Salon by their use of pure colours. In Germany, the Fauves were mirrored by the Dresden-based group of artists known as 'Die Brücke' (The Bridge).

During this time, sculptors sought to escape from the shadow of Rodin with radically contrasting works: Aristide Maillol unveiled his *The Mediterranean* at the town hall in Perpignan and Constantin Brancusi (1876-1957) exhibited his *The Kiss* several years later.

The advent of reinforced concrete was the signal for architects to break both with eclecticism and with the picturesque. The first buildings in France to be constructed using this new material were the Ponthieu garage (1906) and the apartment building at 25a Rue Franklin in Paris, designed in 1903-5 by Auguste Perret (1874-1954).

Paris was still one of the most vibrant cultural centres in the world. But although the city had become the modern capital that Napoleon III had dreamed of – the 'city of light' admired by so many foreign visitors – it had lost its role as leader of the art world. It remained the capital of painting in the early 20th century, but this was due to its realist and, above all, Impressionist schools. From the 1890s onwards, the influence of the (essentially Parisian) Impressionist movement spread not only across France but also across the world, and more than a century later its success is still unquestionable. In contrast, the Symbolist movement

133

which succeeded it was ultimately less significant in France and the Latin countries of Europe than it was in Britain, Germany, Austria, Scandinavia and Belgium. With the Symbolist movement, Europe saw for the first time the development of close links between artistic communities, the internationalization of artistic life and the proliferation of active and influential artistic centres.

These characteristics, which were also true, albeit to a more limited extent, of the short-lived Art Nouveau movement, were to become an integral part of 20th-century artistic life. But Europe gradually lost its dominant position and found it had a rival to contend with: the United States.

Despite the great diversity of the works of art and buildings produced in the late 19th century – a period when artists and architects experimented in all kinds of ways while vigilantly maintaining standards of quality we might well envy today – France retains a special significance when compared with other countries. This is particularly true in the field of painting: the prices which Impressionist paintings can command today is ample testimony to this. But will the studies that have been carried out over the past 25 years into architecture, sculpture, the decorative arts and other trends in 19th-century painting – together with our enhanced knowledge of international movements – lead to a reappraisal of this point of view and a change in our tastes? Or is Impressionism truly one of the seven wonders of the world, and destined to remain so?

Today, over a century later, the art of the 19th century is being rehabilitated. It is true that academic art, which France rediscovered after other European countries, could demonstrate sophistication and a certain adaptability. But was this form of art not devitalized and drained of meaning by its constant repetition of tired conventions? Some art historians may criticize the Impressionists for their lack of interest in history, but it cannot be denied that these painters brought a new vision and authenticity to art – something that is still felt today.

Chronology

Dates	Politics	Culture and Science	Art
1848	Proclamation of the Second Republic in France. February Revolution takes place in France and revolutionary uprisings in Europe.	Birth of Gauguin. Founding of the Pre-Raphaelite Brotherhood. Marx and Engels: *The Communist Manifesto*. The Purismo aesthetic movement is formed in Florence.	
1849		Millet settles in Barbizon.	Courbet: *Burial at Ornans* (p.13)
1851	Coup d'état staged by Louis-Napoléon Bonaparte.	Ruskin: *Pre-Raphaelitism*. First World Fair in London. Auguste Comte: *Système de Philosophie Positiviste*.	Paxton: Crystal Palace, London (p.105).
1852	Proclamation of the Second Empire in France. Count Cavour appointed prime minister in Italy.		Vaudoyer: Marseilles Cathedral, 1852-93. William Holman Hunt: *The Light of the World*.
1853	Baron Haussmann, Prefect of the Seine, 1853-70.		Courbet: *The Bathers* (p.30).
1854	Outbreak of Crimean War. Charge of the Light Brigade.	Viollet-le-Duc: *Dictionnaire Raisonné de l'Architecture Française*. The Honfleur School is established.	
1855		World Fair in France. Exhibition of Courbet's paintings: the first realist exhibition. Beginnings of the *Macchiaioli* movement in Italy. Hector Lefuel takes charge of the extension of the Louvre featuring decorative sculptures.	Courbet: *The Artist's Studio* (p.11); *The Grain Sifters*.
1857		Champfleury: *Le Réalisme*. Baudelaire: *Les Fleurs du Mal*. In Vienna, the old city walls are demolished. Discovery of spectrum analysis by the Germans Kirchhoff and Bunsen.	Millet: *The Gleaners* (p.43). Le Gray: *The Great Wave*.
1859	Formation of the kingdom of Italy, 1859-61.	Hugo: *La Légende des Siècles*, 1859-83. Darwin: *The Origin of Species by Means of Natural Selection*. J S Mill: *On Liberty*. Gounod: *Faust*.	Guigou: *The White Road*. Cerdá: plan for the expansion of Barcelona.

Dates	Politics	Culture and Science	Art
1860	Annexation of Nice and Savoy by France.	Wagner: premiere of *Tannhäuser* in Paris. Burckhardt: *The Civilization of the Renaissance in Italy.*	Garnier: The Paris Opera House, 1861–75 (p.102).
1861	Outbreak of American Civil War.	The firm Morris, Marshall, Faulkner & Co is founded for the production of furniture and furnishings.	
1863	Abraham Lincoln abolishes slavery. Gettysburg Address.	Salon des Refusés. Viollet-le-Duc: *Entretiens sur l'Architecture, Vol. 1.* Berlioz: *The Trojans.* Death of Delacroix.	Manet: *Olympia* (p.9); *Le Déjeuner sur l'Herbe* (p.16). Cabanel: *The Birth of Venus* (p.15). Baudry: *The Pearl and the Wave.* Millet: *Man with a Hoe.*
1864	Coronation of King Ludwig II of Bavaria.	Chevreul: *Mémoire sur les Couleurs.*	Meissonier: *Napoleon on Campaign, 1814.* Frémiet: *Gallic Chieftain.*
1865		Lewis Carroll: *Alice's Adventures in Wonderland.* Taine: *Philosophie de l'Art* (1865-9). Wagner: *Tristan and Isolde.*	Barlow and Ordish: St Pancras Station, London, 1865-7.
1866	Prussia defeats Austria at Sadowa.	Dostoevsky: *Crime and Punishment.* Birth of Kandinsky.	Manet: *The Fifer.* Frémiet: *Roman Knight.*
1867	Coronation of Emperor Franz Joseph of Austria as King of Hungary.	World Fair in Paris. Courbet and Manet hold private exhibitions. Marx publishes the first volume of *Das Kapital.* Johann Strauss II: *The Blue Danube.* Gounod: *Romeo and Juliet.*	
1868	Gladstone becomes British prime minister.	Dostoevsky: *The Idiot.* Lautréamont: *Les Chants de Maldoror,* 1868-9.	Manet: *Luncheon in the Studio.*
1869	Opening of the Suez Canal.	Tolstoy: *War and Peace.* Flaubert: *L'Éducation Sentimentale.* Birth of Matisse.	Carpeaux: *Dance* (p.107). Courbet: *The Source.* Moreau: *Salome Dancing Before Herod,* 1869-76.
1870	The Franco-Prussian War; abdication of Napoleon III; proclamation of the Third Republic in France.	Excavation of Troy by Heinrich Schliemann. Verlaine: *La Bonne Chanson.*	

Dates	Politics	Culture and Science	Art
1871	Paris Commune. Wilhelm I becomes emperor of a united Germany. Rome becomes the capital of the new kingdom of Italy.	Verdi: *Aida*. Rimbaud: *Le Bateau Ivre*. Nietzsche: *The Birth of Tragedy*.	Whistler: *Arrangement in Grey and Black – Portrait of the Artist's Mother*.
1872	Congress of the First Socialist International in the Hague.	Viollet-le-Duc: *Entretiens sur l'Architecture, Vol. 2*.	Monet: *Impression, Sunrise* (p.47). Construction of the Ringstrasse in Vienna, 1872-88.
1874	Gladstone is replaced by Disraeli as British prime minister. Stanley leads an expedition to Africa.	First Impressionist exhibition is held in Paris. Flaubert: *La Tentation de Saint Antoine*. Verlaine: *Romances sans Paroles*.	Eiffel: Western Station, Budapest, 1874-7. Frémiet: *Joan of Arc*. Mercié: *Gloria Victis*.
1875	Constitution of the Third Republic in France.	Bizet: *Carmen*.	Rodin: *The Age of Bronze*, 1875-6 (p.109)
1876		Second Impressionist exhibition. Alexander Graham Bell invents the telephone.	Moreau: *The Apparition*. Abadie: the Sacré-Coeur in Paris, 1876-1919.
1877	Queen Victoria is proclaimed Empress of India.	Third Impressionist exhibition. Flaubert: *Trois Contes*.	Monet: seven paintings of *Saint-Lazare Station* (p.51).
1878		World Fair in Paris. Morris: *The Decorative Arts: Their Relation to Modern Life and Progress* (lecture).	Davioud and Bourdais: the Trocadéro Palace in Paris. Böcklin: *Villa by the Sea*.
1879		Fourth Impressionist exhibition. Meredith: *The Egoist*. The first electric locomotive is invented in Germany.	Bouguereau: *The Birth of Venus*. Chapu: *La Reconnaissance*. Degas: *Portrait of Diego Martelli*. Redon: *In Dream*.
1880	Jules Ferry is elected President of the Conseil de France.	Fifth Impressionist exhibition. Soirées at Zola's house in Medan. Maupassant's story *Boule de Suif*.	Dalou: *Triumph of the Republic*, 1880-9 (p.108). Böcklin: *The Isle of the Dead*. Rodin: *The Gates of Hell*, 1880-1917 (p.80).
1881	Fall of Jules Ferry.	Sixth Impressionist exhibition. Verlaine: *Sagesse*. Birth of Picasso.	Puvis, *The Poor Fisherman*. Rochlitz: Eastern Station, Budapest, 1881-4.

Dates	Politics	Culture and Science	Art
1882		Seventh Impressionist exhibition. Cézanne at l'Estaque.	Rochegrosse: *Vitellius Dragged through the Streets of Rome.* Redon: *To Edgar Allan Poe.*
1883		Rome, implementation of the Viviani urban expansion plan. Nietzsche: *Thus Spoke Zarathustra.*	Mackmurdo: cover design for book on Wren's churches.
1884		First Salon des Indépendants. Huysmans: *À Rebours.* The 'Groupe des XX' is founded in Brussels, 1884-93. Morris founds the Socialist League.	Seurat: *Bathers at Asnières.* Puvis: *The Sacred Wood Dear to the Arts and Muses* (p.74). Gaudi: Sagrada Família, 1883-1926 (p.130).
1886		Moréas: Symbolist manifesto. Eighth and last Impressionist exhibition. Rimbaud: *Les Illuminations.* Founding of *La Revue Wagnérienne* in Paris.	Seurat: *Sunday Afternoon on the Island of La Grande Jatte.* Bartholdi: The Statue of Liberty erected in New York (p.99).
1888	Wilhelm II is crowned emperor of Germany.	Samuel Bing publishes *Le Japon Artistique*, 1888-91. Morris creates the Arts and Crafts Exhibition Society.	Sérusier: *The Talisman* (p.66). Gauguin: *The Vision after the Sermon.*
1889	Colonialism at its height. First International Socialist Congress takes place in Paris. Founding of the Second International.	World Fair in Paris. Symbolist exhibition at the Café Volpini. Maurice Denis: 'Manifeste du Symbolisme'. Bergson: *Les Données Immédiates de la Conscience.*	Gustave Eiffel: The Eiffel Tower. Dutert and Contamin: *La Galerie des Machines.*
1892		Rosicrucian Salons, 1892-7. Frantz Jourdain: *L'Art dans la Rue.*	
1893			Von Rieppel: the Müngsten viaduct. Horta: Hôtel Tassel.
1894	Dreyfus imprisoned.	Death of Caillebotte, who bequeaths his art collection to the state. In Brussels, the 'Libre Esthétique' group begins to hold exhibitions.	Guimard: Castel Béranger, 1894-8 (p.121).
1895		Invention of cinematography by the Lumière brothers. Samuel Bing reopens his commercial gallery in Paris and calls it La Maison de l'Art Nouveau.	Munch: *Moonlight.* Van de Velde: Bloemenwerf House (p.117).

Dates	Politics	Culture and Science	Art
1897	Zionism is founded in Basel.	World Fair in Brussels. In Vienna, the Secessionist movement is born. Grasset: *La Plante et Ses Applications Ornamentales.*	Gauguin: *Whence Do We Come? What Are We? Where Are We Going?* (p.132).
1899	Trades Union Congress endorses the Independent Labour Party in England.	Signac: *D'Eugène Delacroix au Néo-Impressionisme.*	Van de Velde designs desk for Julius Meier-Graefe (p.120).
1900		World Fair in Paris. Exhibition by Rodin. Freud: *The Interpretation of Dreams.*	Mucha designs the Art Nouveau interior of the Fouquet jewellery store in Paris.
1901	Edward VII succeeds to the British throne.		Charpentier designs the dining room for the Villa Champrosay.
1903		Death of Gauguin. Van de Velde moves to Weimar. The Autumn Salon is established.	Perret builds the Ponthieu garage and the apartment building at 25a Rue Franklin in Paris, 1903-5.
1905		Matisse become leader of the Fauves. Serrurier-Bovy begins to design cheaper furniture. Einstein formulates Special Theory of Relativity.	Hoffmann: Palais Stoclet, 1905-11 (p.129). Gaudi, Casa Batlló, 1904-6 (p.131). Aristide Maillol: *The Mediterranean.*
1906		Death of Cézanne.	

Index

This index lists the painters, architects and sculptors of the period covered in this book (with a reminder of their dates), together with other influential figures in the art world at the time and all titles of works mentioned in the text.

The page numbers in italics refer to the captions to the illustrations.

Bibliography

General

etell, Richard R, *Modern Art 1851-1929: capitalism and representation*, Oxford University Press, Oxford, 1999

ark, Timothy J, *The Absolute Bourgeois: Artists and Politics in France 1848-1851*, Thames and Hudson, London, 1982

ark, Timothy J, *The Image of the People: Gustave Courbet and the 1848 Revolution*, Thames and Hudson, London, 1987

arke, Michael and Thomson, Richard, *Monet: the Seine and the Sea*, National Galleries of Scotland Publications, dinburgh, 2003

senman, Stephen *et al*, *Nineteenth Century Art: A Critical History*, Thames and Hudson, New York, 1984

ochlin, Linda (ed), *Impressionism and Post-Impressionism, 1874-1904: Sources and Documents*, Prentice-Hall, Englewood Cliffs, NJ, 1966

ochlin, Linda (ed), *Realism and Tradition in Art, 1848-1900: Sources and Documents*, Prentice-Hall, Englewood Cliffs, NJ, 1966

osenblum, Robert and Janson, H W, *Art of the Nineteenth Century: Painting and Sculpture*, Thames and Hudson, London, 1984

Realism

aunce, Sarah and Nochlin, Linda, *Courbet Reconsidered*, Brooklyn Museum with Yale University Press, New Haven, CT, 1988

eedham, Gerald, *Nineteenth Century Realist Art*, Harper and Row, New York, 1989

ochlin, Linda, *Realism*, Penguin, Harmondsworth, 1971

Landscape

retell, Richard R, *A Day in the Country: Impressionism and the French Landscape*, Harry N Abrams Inc, New York, 1984

lark, Timothy J, *The Painting of Modern Life: Paris in the Art of Manet and his Followers*, Thames and Hudson, London, 1999

age, John, *J M W Turner, 'A Wonderful Range of Mind'*, Yale University Press, New Haven, CT, 1987

erbert, Robert L, *Impressionism: Art, Leisure and Parisian Society*, Yale University Press, New Haven, CT, 1991

saacson, Joel, *The Crisis of Impressionism, 1878-1882* [catalogue of an exhibition held at the University of Michigan Museum of Art], The Museum, Ann Arbor, MI, 1980

arris, Leslie, *Constable: pictures from the exhibition*, Tate Gallery, London, 1991

ewald, John, *The History of Impressionism*, revised edn, Museum of Modern Art, New York 1990

he New Painting: Impressionism, 1874-1886*, National Gallery of Art, Washington, 1986

homson, Belinda, *Impressionism: Origins, Practice, Reception*, Thames and Hudson, London, 2000

Post-Impressionism

homson, Belinda, *The Post-Impressionists*, Phaidon, London, 1990

ouse, John and Stevens, Mary Anne (eds), *Post-Impressionism: Cross-Currents in European Painting*, RA, Weidenfeld and Nicolson, London, 1979

Symbolism

reches-Thory, Claire and Terrasse, Antoine, *The Nabis: Bonnard, Vuillard and their Circle*, Thames and Hudson, London, 2003

French Symbolist Painters: Moreau, Puvis de Chavannes, Redon and their Followers, Hayward Gallery, Arts Council of Great Britain, London, 1972

Jullian, Philippe, *Dreamers of Decadence: Symbolist Painters of the 1890s*, translated by Robert Baldick, Phaidon, London, 1974

West, Shearer, *Fin-de-siècle*, Bloomsbury, London, 1993

Pre-Raphaelites

Hilton, T, *The Pre-Raphaelites*, Thames and Hudson, London, 1970

Treuherz, Julian, *Hard Times: Social Realism in Victorian Art* [exhibition catalogue], Lund Humphries with Manchester City Art Gallery, London, 1988

Art Nouveau

Greenhalgh, Paul (ed), *Art Nouveau, 1890-1914*, V&A Publications, London, 2000

Hardy, William, *A Guide to Art Nouveau Style*, Chartwell, Secaucus, NJ, 1986

Nuttgens, Patrick (ed), *Mackintosh and his Contemporaries in Europe and America*, Murray, London, 1988

Varnedoe, Kirk, *Vienna 1900: Art, Architecture and Design*, Museum of Modern Art, New York, 1986